THE WHITE REV

33

Interview SARA AHMED 8

Poetry FAHAD AL-AMOUDI 15

The Inheritors ARIEL SARAMANDI 25

Interview MONIRA AL QADIRI 34

The Dream Laboratory of Nicolae Vaschide
MIRCEA CĂRTĂRESCU *tr.* SEAN COTTER 57

Pocket Theory FRANCIS WHORRALL-CAMPBELL 73

Crooked Plow ITAMAR VIEIRA JUNIOR *tr.* JOHNNY LORENZ 83

Poetry MARY MUSSMAN 97

Interview BANI ABIDI 106

The Court Case GINA APOSTOL 127

Poetry EDWARD DOEGAR 137

Let Them Know by Signs ROSA CAMPBELL & TAUSHIF KARA 147

Interview SIRI HUSTVEDT 158

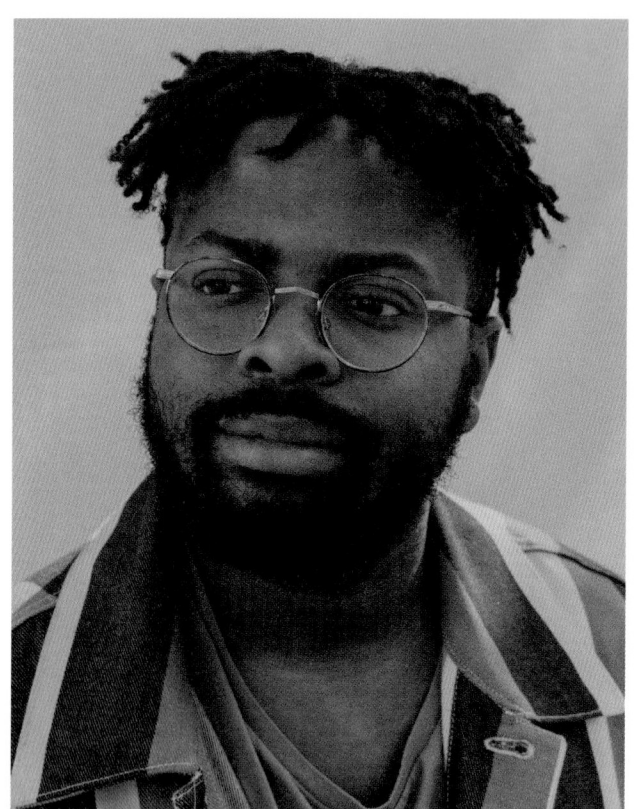

Gboyega Odubanjo, featured
in Granta 156: Interiors.
Photographed by Lewis Khan.
Subscribe today for £32

GRANTA

MAUREEN PALEY

LONDON

ALASTAIR MACKINVEN

Numble Bound To A Stripped Standing Tree

9 June – 31 July 2022

STUDIO M

LONDON

TOM BURR

detention/suspension/expulsion

9 June – 31 July 2022

MORENA DI LUNA

HOVE

ESTHER PEARL WATSON

An Apparent Brightness

21 May – 28 August 2022

HALF PRICE OFFER

A YEAR'S SUBSCRIPTION TO THE IDLER FOR £27
HALF SHOP PRICE
PLUS FREE BOOK WORTH £8.95

Go to idler.co.uk/join, select PRINT and use code **WR22**
Or call 01442 820581

SLOW DOWN. HAVE FUN. LIVE WELL.

UK DD offer only. Price reverts to standard £39.95 annual rate after six issues. Cancel any time.

Tenant of Culture
8 Jul/18 Sep

Camden Art Centre
Arkwright Road
London NW3

camdenartcentre.org

Tenant of Culture, *Flash s/s* (series), 2020. Courtesy of the artist and Soft Opening Gallery, London. Photo: Theo Christelis.

'Superb.'
Sunday Times

'Stunning.'
Guardian

'A masterpiece.'
Daisy Johnson

'Non-stop glorious.'
Anne Enright

Burntcoat

The new novel from Sarah Hall

Out now in paperback, ebook and audiobook

faber

EDITORS	Rosanna McLaughlin, Izabella Scott, Skye Arundhati Thomas
ART DIRECTION & DESIGN	Thomas Swann / Atelier Zegris
MANAGING EDITOR	Theodora Danek
EDITORIAL ASSISTANT	Samir Chadha
PROOFREADER	Rose Green
FOUNDING EDITORS	Ben Eastham, Jacques Testard
FOUNDING ART DIRECTOR	Ray O'Meara
CONTRIBUTING EDITORS	Lawrence Abu Hamdan, Deborah Anzinger, Kevin Brazil, Kayo Chingonyi, Orit Gat, David Hayden, Jennifer Hodgson, Roop Majumdar, Daniel Medin, Sandeep Parmar, Sam Solnick, Preti Taneja, Alok Vaid-Menon, Francisco Vilhena, Stanley Wolukau-Wanambwa, Jay G. Ying
SUPPORTERS	Ahsan Akbar, Charles Asprey, Rahul Bery, Joanna Biggs, Elise Blackwell, Anthony Brown, Mikaella Clements, Alvar Closas, The TS Eliot Estate, Maeva Gonzalez, John Gordon, Melissa Hobbs, Agri Ismail, Caroline Langley, Paddy Langley, Daniel Lessner, Robert McLaughlin, Anna Metcalfe, Ben Petrovsky, Rocking Chair Books Literary Agency, Rebecca Servadio, Jacques Testard, Stefan and Tara Tobler, Francesca Wade, Dr Gilda Williams, Caroline Younger
PARTNERS	Charles Asprey, Cheerio, Fitzcarraldo Editions, RCW
BOARD OF TRUSTEES	Ben Eastham, Tom Morrison-Bell, Ray O'Meara, Jacques Testard, Francesca Wade, Kishani Widyaratna

Published by The White Review, June 2022 Edition of 1,200 Typeset in Nouveau Blanche Printed in Lithuania
ISBN No. 978-1-9160351-6-4 The White Review is a registered charity (number 1148690)

Copyright © The White Review and individual contributors, 2022. All rights reserved. No reproduction, copy or transmission, in whole or in part, may be made without written permission.

The White Review, 8–12 Creekside, London SE8 3DX www.thewhitereview.org

EDITORIAL

'The interior of a pocket is hidden away', writes Francis Whorrall-Campbell in the speculative manifesto 'Pocket Theory', a response to Ursula K. Le Guin's 1986 essay 'The Carrier Bag Theory of Fiction'. 'Tucked inside we might find weird lives and weird literature.' Secretive, suggestive, intimate: the pocket, Whorrall-Campbell argues, is a fitting home for chimerical, hard-to-define narratives.

Issue 33 of *The White Review* contains a number of slippery and illuminating subjects, from the inner cosmos of the sleeping psyche to the murky world of inheritance. 'The Dream Laboratory of Nicolae Vaschide', an extract from Mircea Cărtărescu's surrealist novel *Solenoid* (2015), translated from the Romanian by Sean Cotter, describes the hallucinogenic awakening of a child prodigy who becomes a psychologist and dream scientist. 'His thoughts, until then unsettled and cold like crystal vials, now burst open', Cărtărescu writes, 'the way a lily bud bursts, arching and turning in a brilliant efflorescence'. In an interview with Noga Arikha, the author Siri Hustvedt discusses her polymathic practice, the problems with mind/body dualism and her experiences of working across literature and the sciences. 'Let Them Know by Signs', an essay by Rosa Campbell and Taushif Kara, traces the strange histories and causes of the conspiracy theory, from the Kenyan belief that British colonisers were stealing the blood of Africans to strengthen anaemic Europeans, to QAnon and Pizzagate.

'There's a family tree that my uncle was able to recover,' Ariel Saramandi writes in the 'The Inheritors'. 'Some of the branches were drawn to look like fingers; at my great-grandfather's name there's an amputation, a cut to mark the place where whiteness ends'. 'The Inheritors' combines essay and fiction to piece together an account of land dispossession in Mauritius, where Creole heirs were routinely cut off and land documents buried in archives or destroyed. The weight of inheritance is also explored in Gina Apostol's new fiction 'The Court Case', in which a flamboyant mother chases after a lost family estate in the Philippines. In Brazilian writer Itamar Vieira Junior's excerpt from the novel 'Crooked Plow', translated from the Portuguese by Johnny Lorenz, two young sisters raid their grandmother's suitcase and discover a mysterious knife that renders them silent.

Issue 33 also includes poetry by Edward Doegar, Mary Mussman and Fahad Al-Amoudi, winner of The White Review Poet's Prize 2022, in partnership with CHEERIO. Feminist scholar Sara Ahmed discusses what it means to be 'willful', and the flaws in the moral imperative to be happy, and artist Bani Abidi considers the performance of patriotism and darkly comic nationalisms. The cover art was made by Monira Al Qadiri, who, in an interview, discusses her grandfather, a singer on a Kuwaiti pearl-diving ship, and the histories of pearls and oil in the Gulf. In her film *Diver* (2018), stills from which feature on the cover, swimmers dance in black, iridescent water to the sound of an old pearl-diving song.

INTERVIEW SARA AHMED

Consider the exclamation mark. Medieval in origin, this blink of ink has a gift for controversy. A single point can signal a moment of joy or incredulity. Use two or more, though, and risk being dismissed as shrill or shouty, especially if you are a woman.

Feminist thinker and independent scholar Sara Ahmed has written 11 books, but her latest, *Complaint!* (2021), is the only one to employ an exclamation in its title. Yet to immerse oneself in her body of work – which also includes several public lectures, seminars and workshops – is to feel an intensification of everyday experience. Her works are all attuned to affect, wilful subjects and the phenomenology of trying to make yourself heard while living in a marked body: as an 'unhappy queer', a 'melancholic migrant', a woman and/or person of colour. As Ahmed wrote in *What's the Use? On the Uses of Use* (2019), 'Sometimes, I feel like I am an exclamation point, as if in being I am shrieking.'

In that book, a roving work of phenomenology, she examines 'use as technique' by closely studying a constellation of things, including an empty tube of toothpaste, a postbox, an arm and Jeremy Bentham's desiccated body. She shows how utilitarianism was historically used to shape the subjectivities of those deemed least desirable and most disposable – the poor, the incarcerated, the orphaned and the unhoused.

What's the Use? is the final book in a trilogy that began with *The Promise of Happiness* (2010), which looks at the regulatory uses of happiness, followed by *Willful Subjects* (2014), which valorises 'wilfulness' – to have a disposition towards disobedience, or to be 'what gets in the way of what is on the way' – as a way for feminists and minority groups to assert agency. In its own way, each of her books tracks, with forensic care and attention, the peristalsis of power: what feeds it, what impedes it, what lubricates its sinuous passage through the halls of institutions and everyday life. Bodies, for Ahmed, are a locus of feminist investigation. Having an 'out of skin' experience – being at odds with the world or with the promises that mark its horizon – can be the starting point for a revolutionary consciousness. It can help us recognise that the disciplinary walls of the institution or the 'happy family' conspire to individually pathologise people, rendering their subjectivity and citizenship conditional. It can turn us into 'affect aliens' or, to invoke the phrase for which she is probably most well-known, 'feminist killjoys'.

In September and November of 2021, Ahmed and I exchanged emails about *Complaint!*, which looks at complaint as a 'feminist pedagogy', and which she completed during the COVID-19 pandemic. The book opens a vein, drawing from numerous written and oral testimonies of beleaguered individuals in the university setting who complained to Ahmed about bullying, harassment and normative structures that prevent their flourishing. Many of the concerns in *Complaint!* are prefigured in earlier works, which similarly indicted universities for protecting sexual harassers. Her new book is no less urgent, offering a 'weary hope' to wilful readers, refusers and resisters. RHODA FENG

THE WHITE REVIEW In *Living a Feminist Life* (2017) you write that 'Hope is not at the expense of struggle but animates a struggle.' The question of living a feminist life – figuring out how to create a less unequal world – can be all-consuming. How have you been able to sustain hope from project to project? Where are you drawing hope from these days?

SARA AHMED Writing gives me hope, as it is about connecting what we are doing to what came before, to who comes after. Reading is also for me a way of being 'in connection'. When I am feeling despair, political or otherwise, I tend to write or read. I often read Audre Lorde – her prose or poetry is always close to hand. For me, reading and writing are profoundly optimistic gestures. But that does not mean they are that for everyone. We take up the struggle differently. I am always struck not only by how hard people fight for more just worlds, but how there is creativity in that fight. This means that what is creative is close to what is exhausting. I draw hope from writing as I draw hope from connection, community and from political struggle.

TWR *On Being Included: Racism and Diversity in Institutional Life* (2012) was the first of your books to draw heavily on qualitative empirical research, synthesising interviews with an array of subjects. It made me think of the form of the gathering, or bringing people together to discuss a common grievance or for a shared aim, which in turn structures how they feel, act and react to the world. It has often been observed that one of the first signs of a society devolving into authoritarianism is that the right to assemble gets trampled upon. Reading your interviews with communication workers, diversity practitioners (those working on diversity initiatives in academic settings) and complainers makes me wonder how these experiences, once entered into the written record, might feed back into the real world. What was your hope for writing *On Being Included*, and do you think your goal has been realised?

SA I don't think I had a specific goal for this book. I just wanted to share what I had learnt from talking to diversity practitioners. I wanted to share their wisdom. We learn so much about institutions from those given the task of transforming them. But we also learn from the fact that they are who teach us! It is practitioners who know from first-hand experience the gap between what institutions say they do, or what they say they are committed to, and what they do. I didn't want the time that practitioners gave me – the energy – to disappear or be funnelled into academic papers no one reads. *On Being Included* was a hard book to write – the most difficult book I have had to write – in part because I did not go much further than describe the exhaustion of doing the work and the exhaustion of what the work does not do. But I am glad I put it out there, and that it can be of use to those who are trying to transform institutions, who know all about those walls.

It was extremely hard to get a publisher for *On Being Included* – I wanted a UK/European publisher given the focus. So many publishers said there was no market for it. Duke University Press, my publisher, does not tend to speak of the value of books in terms of markets. This book has a very wide and growing readership. It is being read more now than when it came out a decade ago, probably because the material has if anything acquired more relevance. The genre of the 'non-performative' has proliferated since the book came out; I am thinking here of all those organisations making statements about how Black Lives Matter whilst remaining hostile environments for Black people.

TWR In *The Promise of Happiness* you write about happiness as a moral imperative that shores up (hetero)normative visions of the family, community, state and nation. In *What's the Use?*, you showed how the *idée fixe* of utilitarianism (maximising public utility) was yoked to the oppressive imperative to be happy by educators like Jeremy Bentham. In the British colonies, Indian children were indoctrinated to serve a useful function for colonial companies and were promised that in fulfilling that function, they would be happy. Happiness, you write, instantiates 'a hopeful performative'. What do you mean by this? Is the responsibility for generating such a 'feeling-state' one that falls more heavily on the shoulders of women?

SA *The Promise of Happiness* does offer a critique of positive psychology as a way of thinking about human subjectivity. The 'hopeful performative' is my term for a kind of 'task' given to subjects to think or talk themselves into more positive or happier states of being. I am quite sure that these tasks are gendered, falling more heavily upon women. Some are made responsible not only for trying to make themselves happier but for making others

happier, too. I have been returning to some of this material in my chapter 'The Feminist Killjoy as Cultural Critic', in the forthcoming *The Feminist Killjoy Handbook*. I have been thinking of the hopeful performative as a kind of polishing (drawing on Simone de Beauvoir, as well as the academic Anne McClintock, on polishing as domestic labour). Polishing is about the creation of a shiny surface. You can create an appearance of happiness by removing what does not correspond to it. To polish is also to remove the polish, the labour, from the appearance. I had already described diversity as 'institutional polishing' in *Living a Feminist Life*. I think the happiness duty can also fall on people of colour. We have to remove so much from ourselves to provide organisations with shiny happy diversity. We can also think of imperial history as polished, how the violence of empire is removed by how it is remembered (that story of empire as a gift of modernity). What is polished has not gone away. This is why to see through happiness is to encounter what is real.

TWR Your new book, *Complaint!*, assembles a patchwork of complaints about abuses of power within universities. Elsewhere, you've mentioned that the seeds of this book were planted after you resigned from your position as Professor of Race and Cultural Studies and Director of the Centre for Feminist Research at Goldsmiths, University of London over the university's normalisation of sexual harassment. Your resignation letter attracted much attention, and you became part of a 'complaint collective', which was a kind of early iteration of this book: a place for stitching together grievances that have been dispersed through disciplinary and structural boundaries. Can you talk about the personal dimension of complaints?
SA Before I answer your question, it is worth pointing out that the timeline of *Complaint!* is messy. I decided to research complaints whilst I was in the middle of a long complaint process that involved multiple enquiries. I was supporting students who had submitted a collective complaint about sexual harassment and sexual misconduct. I realised that despite the indications that the university was going to take their complaint seriously – they held the enquiries after all – there was so much they were not going to recognise or do. We realised there was not going to be any public acknowledgement that the enquiries had even happened, let alone a discussion of a problem with the institutional culture they revealed. That silence was a wall. I decided to do the research before I resigned because I realised that if we asked people about their experience of making complaints, we would learn so much about institutions. And then, when I resigned, a 'complaint collective' did indeed take form (although I did not use that term – it came from doing the research). Not all of this collectivity was public. So many people who I had never met got in touch with me to check in and ask if I was alright and to thank me for taking a stand. So many people shared with me their own stories of what happened when they complained. The conclusion of *Complaint!* has a discussion of resignation letters, how they can become part of the work of complaint in sometimes surprising ways.

There is so much work in the complaint and that work is mostly withdrawn or hidden. That work gets me to your question! Making a complaint can feel like becoming institutionalised: you have to fill in forms and follow procedures, paths laid out by the institution. And, then, your complaint often ends up in a file. It is you, a person or a group of people, who is doing that work, who is filling that file. The harder it is to get through, the more you have to do. And the more you have to do, the heavier the file. But it is not just the file that becomes heavier. We can experience complaint as weight. People told me where or how they felt the weight of complaint; in their necks, or backs or on skin. I think of one senior researcher who made a complaint about bullying. She was so traumatised by the process that her periods stopped. That detail was in a document. That document was in a file. And that file was held by the institution. If the personal is institutional, the story of complaint can be one of alienation, of becoming alienated from one's body and being. In other words, alienation can be how the institutional is made personal. What they file, we store, often in our bodies. This is why our bodies can tell us so much about institutions.

TWR Complaints can be an expression of a 'snap', marking a kind of breaking point, as well as of grief or pain. A disabled student in a wheelchair might, for instance, complain that doorways are too narrow and therefore inaccessible. If you run into the same problem repeatedly, you can start to think that you are the problem. How is making a complaint connected with diversity work?
SA If my project began as a project on formal complaints, I realised very quickly that to keep

that focus would be to narrow it too much, to miss too much. Thinking of complaint as diversity work was a way of showing how the work of complaint exceeds the form of complaint. In *On Being Included* and *Living a Feminist Life*, I understood diversity work in two senses: the work we do when we try to transform institutions and the work we do when we do not quite inhabit the norms of institutions. These two senses often meet in a body: those who do not quite inhabit the norms of an institution are often given the task of transforming those norms.

If you have to ask for an accessible room, you are not making a complaint in any formal sense. You are asking in fact for what is necessary to do your work, you are asking to receive something to which you are entitled. But you are still often heard as complaining, as being negative, and as getting in the way of others – those who are already accommodated. One disabled student told me how she was perceived as a 'complete pain in the ass' when she asked for reasonable accommodations, for what she needed to do her work. She said to counter that perception, you have to appear 'grovelingly grateful' or even to become a 'cheerleader' for the organisation. Trying to manage perception, not to appear as a complainer, to maximise the distance between yourself and that figure, is diversity work *and* the work of complaint. So, although she did end up having to make a formal complaint to get what she needed, the work of complaint began long before that. Complaint can be about the work some have to do to enter or to be in institutions that are not built for them, as well as the work we do to make institutions more accommodating.

TWR Lodging a complaint can turn one into 'an institutional plumber', you write. There's a way in which making a complaint can dislodge other (similar) complaints that may have been stalled. You also write that in deciding to go public with your reasons for resigning, you became 'a leak'. One can trace in your work a motif of dripping, making a mess, refusing to be contained and constrained by institutional structures.
SA I first used the term 'institutional plumber' in my book *On Being Included*. It was the term that came to mind as I was listening to diversity practitioners talk about their work. Diversity practitioners are typically employed by organisations to institutionalise their commitments to diversity. And yet, they often experience the organisation as blocking their efforts. If the institution has many pipes, literal and metaphoric, systems for passing materials around (including waste), diversity practitioners come to know these systems because of how much gets stuck in them. I was rather surprised by the extent to which my research on complaint returned me to this earlier work. I was surprised in part as a complainer or complainant seems to be in a structurally different position to that of a diversity practitioner who, in the UK at least, is typically an administrator. The points of similarity seem to be around an experience of 'stuckness'. The complainer often ends up having to administer the complaint process; they have to do what they can to keep the complaint moving. And they learn about institutions from the difficulties they have getting a complaint through them.

Even if you get a complaint through the system, complaints are mostly made behind closed doors, which means people don't tend to hear about them. So, if complaints get *through*, they often don't get *out*. A complaint might be filed away. Or a complaint might end up in the 'complaint graveyard', to use an evocative image shared by one student. Perhaps filing cabinets can be graves. Or we might end up filing complaints away ourselves. I think of a woman professor who, after describing how a sexist and heterosexist comment at a meeting became a bonding moment between men, said, 'you file it under "don't go there"'. The file 'don't go there' tells us where we have been. We might file away what it hardest to handle. If so, then a file becomes a handle. Sometimes, to get the complaint out, we need to snap or to fly off the handle. And because of how many complaints have been contained (whether in cabinets, our bodies or both), to leak can be to let out more than a single complaint; it can be to let all of them out, all the complaints that have previously been filed or suppressed. Complaints can end up all over the place. We can, too. If we let something out, whether by writing a blog post like I did, or making a loud sound in a meeting, or writing a resignation letter that could land anywhere, or distributing leaflets that name harassers who have been protected by their colleagues, to reference some of the leaky actions described in my book, others can find us. This is what I mean by 'a leak as a lead'. I also describe mess as a queer map; if a complaint can leave a trail as well as be a tale, a complaint can be how we know where to go to find each other.

TWR I'm struck by how your work, here and elsewhere, makes a case for how 'queer use' can be a life raft for all the 'misfits' who try to flourish outside the boundaries of the normative order, and how 'queer vandalism' can be a strategy of survival and transformation: a means of negating propriety, refusing to use things 'properly', and finding hidden, deviant potential in materials.
SA My conclusion to *What's the Use* is on queer use – how we can use things in ways that were not intended, or for purposes for which they were not intended. I use an image of a postbox that has become a nest; *Complaint!* also returns to this image. I acknowledge that it is rather happy and hopeful. Queer use is rarely about just turning up and being able to turn a box into a nest or a room into a shelter: to queer use, to enable some to take up residence in spaces not built for them, usually requires a world-dismantling effort. *Complaint!* offers a partial description of that world-dismantling effort from the point of view of those making it.

TWR As you note in your book, the complaint has an estranging effect. Often, to complain is to become a stranger – to others and even to oneself – to call attention to your status as an outsider. How is this related to other forms of exploitation, like racial discrimination?
SA I suggest in the book that not everyone who makes a complaint becomes a complainer. Some complaints can be a form of bonding – complaining about the weather, for instance. I think of these as *happy not snappy* complaints. The question of who becomes a complainer is not unrelated to who becomes a stranger. White supremacy is an ideology of who comes first. To be not white is to be positioned as *coming after*, as a guest or a stranger who might be welcomed or not. Those who are not white, who are assumed to come after, to be not from here, are expected to be grateful for being here. That expectation of gratitude often translates into a judgment that those who are not white have no right to complain when we get here. When those who are not white make complaints within the institutions of whiteness about what happens in those institutions, we might complain about exploitation or discrimination, how we are required to do more less-valued work, or how we are paid less for the work we do, or how we do not get the same opportunities as white colleagues. We become strangers *all over again*, or we become strangers *all the more*. In other words, our complaints are treated as evidence that we are not from here or not supposed to be here.

When our complaints are used as evidence that we don't belong, doors are shut. Take an example from the book. A Muslim student of colour does not get the same number of classes or fellowships that other students get. Not getting the same classes, not getting the fellowships, meant not having enough to make do. When she makes a complaint about racial discrimination, the situation worsens. She decides to leave the programme but she needs references. When she does not get into another programme, she asks to see the references: 'She wrote that "I am good at transcribing data." Nothing at all about my research, awards, the paper I was working with her on, nor about the classes I took with her. It was a short and very weak letter.' All you need to do to close a door on someone is to write them a less-positive reference. The content of that less-positive reference matters. The reference says she is good at 'transcribing data'. Those who embody diversity often become data. We need to remember that she had to make that complaint because of doors that had already been closed, because of opportunities she did not receive as a Muslim woman of colour. But then, when you complain about how doors are closed, more doors are closed. And yet, diversity is often represented as an open door, as if there is nothing stopping us from getting in or getting through. If the closed door is not perceptible to others, it then appears as if those who stop have stopped themselves.

TWR You have likened putting *Complaint!* together as a kind of massive exhumation effort. One might also characterise it as a Wikipedia-like attempt to contribute to the shared commons of thought about complaints made in academic contexts. I'm interested in this bending of your authorial mode into more of a communal mode.
SA There is so much complexity in this bending. There are many voices in this book. The stories are shared. To become a collective, to work in a communal mode, can be itself a form of resistance. Complaint procedures, as well as social norms, often lead to – even demand – atomisation. Doors, too, can turn our offices into atoms. And our complaints seem smaller when we are kept apart. To bring complaints together is to exceed the space we have been allocated. There is, nevertheless, a problem with thinking of this book as collectively

authored. I am still the one who received these testimonies. If I heard them together, and brought them together, they are still being narrowed by coming to and through me. It is still my name on the book. If I have bent the usual model of sole authorship, I have not snapped out of it.

I am so pleased that there are two conclusions in *Complaint!*. The first is written by Leila Whitley, Tiffany Page and Alice Corble, with support from Heidi Hasbrouck, Chryssa Sdrolia and others. They were all PhD students where I worked – the inspiration of the book came from working with them on the enquiries. The students had already worked together to submit a collective complaint before I joined their collective. To submit a collective complaint is to become a complaint collective. I was lucky to become part of their collective. It was important that they got to tell the story of their complaint – and that they, at least, got to be named authors.

'Unburial' is another way of thinking about complaint collectives. When we make a complaint, we often find out about earlier complaints and about those who made them. Complaints can stir up other complaints. Complaints can stir up a history. Complaints made in the present can be how we come to know about a past that would otherwise not be known. This is how complaints can come out of the 'complaint graveyard', rather like an arm coming up from a grave, to evoke an image from the Brothers Grimm story, 'The Willful Child'. There is hope in unburial.

TWR Do you think theory has run out of steam? Does it absorb and depoliticise our energies for social transformation, or can theorising about the uses of impatience, among other things, be one of the urgent tasks facing thinkers today?

SA There are many ways to talk about 'theory'. In *Living a Feminist Life*, I questioned what counts as theory, and discussed how a very narrow body of work is identified as theory. That work refers to other work referred to as theory; theory can be a self-referential chain, pointing to itself. I was questioning theory as capital, I guess. But I was also trying to think about feminist theory differently, feminist theory as homework, to use my terms from that book, as what we are doing when we are questioning how worlds are organised. In *Complaint!* there is a critique of how theory can be used as exemption, as an attempt to exempt a person from an obligation to act in a way that is consistent with equality norms (so I can misgender you if my theory means I don't recognise 'gender identity'). But there is also an attempt to think about theory differently, how the work of trying to transform institutions, diversity work, the work of complaint, is theoretical work. To make the kinds of complaints I discuss in the book, complaints that identify abuses of power or that confront hierarchies, requires much thought and reflection as well as action.

Take the idea of 'institutional blinds'. One of my interviewees in *Complaint!* describes institutions really vividly, and I borrow from her descriptions throughout the book (even down to my uses of visual images): the doors with locks on them, the narrow corridors, the window with blinds that come down. Complaints can bring so much into view. If you have to complain that you don't have enough room, you become even more conscious of rooms. This is why I think of complaint as offering a phenomenology of institutions. With her description of 'windows with blinds that come down' in mind, we can think about how blinds are used to stop something from being seen. Violence can be shut in. A complaint can be an effort to raise the blind, to get out what has been shut in. But that can be when the blinds come down. In other words, it is not that we don't see violence because the blinds are down, but that blinds are down *because the violence is seen*.

I think some 'theories' are being used as institutional blinds; they are ways of justifying an action by trying to stop violence from being seen. This is why those who complain notice the blinds; they notice what is pulled over what they see. If the complainers became our critical theorists, there is so much more we would notice. Not only that, our theoretical work would be urgent; it would be animated by our impatience, our refusal to accept institutional fatalism, that what has come to be must be. Theory would be the shared and practical task of transforming worlds. However impatient we are, the work is slow.

TWR Any plans for a future book project that you'd care to share?

SA I am writing two handbooks for a wider audience (I hope!), *The Feminist Killjoy Handbook* and *The Complainer's Handbook*. I want both of these books to be cheaper and more accessible than my other works. It is important to me to reach people, killjoys and complainers, wherever they

are! *The Complainer's Handbook* will be a chance for me to pull the stories out from the university as a research site, and to be part of a wider conversation about how to challenge abuses of power and how to dismantle structures of inequality.

I have also begun research for a new project on common sense. I will be returning to some of the early critiques of common sense as ideology and hegemony in cultural studies, as well as offering a phenomenological exploration of the many senses of common sense. I hope to address 'common sense conservatism', and the uses of common sense to defend ideas of racial purity and binary sex. Common sense seems to matter more, the more it is deemed under threat. This is why when there is an appeal to common sense, you will quickly find evidence of its disruption. In thinking through the queer potential of these disruptions, I will return to some of my arguments in *Queer Phenomenology* (2006). In that book I talked about the significance of disorientation, how things appear out of line or become wonky. I will also develop the framework of 'complaint as a queer method', which I introduced in *Complaint!*. I had noticed, listening to different people's stories of complaint, how there is something queer about the experience. Words that are everywhere in my data are 'surreal', 'odd', 'bizarre', 'strange' and 'weird'. I am interested in how a sense of reality is shared over time, that feeling of what has always been there, and what we learn from those moments when that sense of reality is disrupted. That some of us, or that some of our actions, come to disrupt other people's sense of a shared reality matters.

R.F.,
September – November 2021

FAHAD AL-AMOUDI

POETRY

MISTRANSLATED QENĒ

 1. For my father

At my auntie's house we slaughtered a god.
In my father's hotel room we prayed to a goat.
 I can hear them bleating.

 2. For my mother

What move is left to play but the orphan's gambit;
Needing the night to sound its granular echo?

(Sacrificing the queen without a fair return.)

AMATEUR BUG CATCHER

The road to Menagesha is a short one, spinose,
I know it like braille, or the Morse code of bumps
in the belly of mum's sun-bleached jeep.

Back then, I'd flip open my Gameboy, listen
for the finicky language of traffic lights, door
locks, safe behind the veil of Amharic.

My ears are butterfly-nets; nothing sticks;
children sharpening cattle whips against the low
cloud, electric laughter, the distant rattle of church.

Walking up this road, young boys look at me
as if recognising a dead explorer. They stamp
as though trampling insects, open their hands,

like this place is a mistranslation of flower,
glistening where the tall trees cluster in pairs,
each with a fletching of leaves nocking against the sky.

I have breathed the same bullet-shattered
air, climbed the same crumbed hills,
sat at aunties' tables, ruffled by long leaves

and watched coffee beans crackle
over a naked flame, pulled a smile, small as a toothpick,
waved at the same women selling wicker baskets

but still I am a tourist, ferenghi, ārebi. Elbows bent
like palm trunks, they greet me for the first time.
I wonder what I must look like to them, mouth agape.

THE NIGHT YOU SAW MARVIN

*In 1980 Marvin Gaye turned up late to a Royal Command Performance
on Drury Lane long after the audience had left. According to promoter
Jeffrey Kruger, Marvin performed to the cleaning staff.*

The song begins in a tenor of water;
slow frets, twists, the threat of a melody
strummed by the hair of a mop and bucket.
This is your face at the end of the day's shift,
when the stage is stripped naked to a piano,
the ruin of instruments chiaroscuroed,
your arms an ecstasy of dry ice staggering
to the back of the theatre, a long carpet
studded in kernels blinking at the stage.

Up there, the light is different, dilating;
it yawns in the heat of an adolescent night,
where a homeless man looks at a twopence
through one eye, its shadow enveloping
a fossil of moon.
Can you believe it? A man enters a place like this,
seats still chattering. He is a spectral presence,
brings with him the metallurgy of night –
a drummer splashing in the buff corners of the stage,
the circle of horns catching fire in sequence.

This light finds him, pulls back the frills,
his open tux a surprised bird pushing up
knuckles of peppercorn, a bowtie limp
on his shoulders, his jacket a trumpet flare
on a sliding key, keeping him upright,
but then he sings, *mother mother,* and the columns
thin, pupil slits strain, bars tighten
around your lungs, his unsteady vibrato
weak, light-headed: a beached fish
silver against the fishmonger's knife.

Drury Lane, that old drag, short smoke break,
a head of tree leaves, and flattened braids
in the mirror of the funeral parlour – happy-
go-lucky – you lick coral red off your teeth,
as a drunkard tackles the curb

with crossed feet, and women, skirt-lipped
weave in and out the gloom like swan necks,
a slick helix of rain drained from boots
and coat hoods steaming the day's strict shivers.

Here, the body sublimes, Marvin's falsetto
chimes through the theatre, unsheathed
like construction tarp ripped from the skin,
the exposed face of a billboard gleaming.
His long runs take you home
to your mustard commode, brass, needle,
wax, where years from now, swaddled
in the same blue midnight, you will see
the shadow of his ghost surge through
your fingers, gripping the handrests
up to the ball and socket of your shoulder,
where a familiar whisper will turn the joint
loose, like a door opening somewhere far
away, the sound of the last, lone applause.

SOST GULCHA
after Gemoraw & Meron Getnet

The small fire that smiles
between three stones in winter
thinks itself a hearth,

even as it burns
a kitchen's pitted belly,
even as it dies,

the stones leavened, once
a ripened fruit, now bloated
for the flies to come.

BEDTIME
after billy woods

I put my finger to the wind and don't get it back / low light snatches me from the front step / the courtyard dervishes with my feet / *thinking of that empty house as the shadows stretched* / fists punch up through the ground / scatter milk teeth / bloom into hyenas / there are no rules in these hours / this is where magic lives / the blue in green / where time shrugs like a sieve / all the other houses yawn in their sleep / I am delirious / howl my name at the trees / wait for someone to claim it / I steal flickers from the streetlamp / play keepy-ups on the second hand of a watch / a wheeze of grass blades / *ain't no bedtime / mama* / the city sleeps damp on a blotted paper sky / droplets of hand-pressed wine / balloons on the window panes / Kirby-pink / everyone is a parapet / I am the only one awake / I move from one house to another like a hammer throw / smack drool out the dogs / throw tennis balls like a hailstorm / the barking follows / grapes wither on tongues / fruit flies rub their hands / stone eyelids / alarms rattle through the compound / I listen for an echo / my name hasn't come back yet

MUM'S JEWELLERY

She sits alone on a rocking stool,
pearls crowd her neck like evening
around a church spire, men come
breathing through the gills of open shirts
dampened by the stroke of her lip,
a bow moving up the violin's high notes,
locking in the notches of a metal watch
and sliding off with a sweet clink!

She wears a blazer with two ogling buttons,
shoulders padded in the Soviet-style,
square as an old colony
holding up the sky in right-angles.
She sees her fortune in these encounters
that hang off her like emerald earrings,
bending their silver-suited backs
to a pair of folded over knaves.

When she's got a few on one arm,
like a planet's moons, she returns home,
adorns her son with a gauze of rose
gold, their quietest parts unseen.

He asks no questions; she tells no lies,
their bodies the perfect counterweight.

THE OLD JUSTICE

My grandfather was a construction worker, a travel agent;
I knew him as a sea-captain, his wink like an eye-patch,

the gap in his teeth a keyhole I might peer into.
But all I could pick in the whistle of air was a shanty,

sweet on his breath, whiskey foaming on his upper lip,
and his blood salivating, a kind of poison he survived on.

Auntie was the dark green storm of a glass bottle.
She made herself dizzy, swatting the air like lightning,

drunk on those unspeakable nights she went below
deck with the man who set us on the voyage;

his bad eye sliding over each plank, moving low to the ground,
like a crocodile sculling in the shallows, or an island

sinking back into the ocean. When they told me he died,
I retched, thinking of his seasick corpse, the hollow flush

of a minute hand passing time at a funeral cut down by rain
and my absence, the echo of it heaving in a toilet bowl.

That night, I imagine surfing on his coffin, taking a sharp nail
to his heart and pulling up a rusted square of flesh.

In the dead air, I creep into auntie's flat, slip the quiet pulse
in the panel behind the grandfather clock where the wax nativity

slow roasts by the fire, her living room crowded with vials,
auntie, the mad concocter, weighing his deeds like a wine glass.

THE GOD OF BAD NEWS AND SOFT DRINKS

When the world was young and there were many gods;
big gods and small gods; the god of paper cuts, the god
of hailstones; none were as young as the god of coca-cola,
who did not yet know that the universe would not fit
in the golden-brown light of his bedside lamp
without tipping out a star or two. Looking at the sky
he became sugar-drunk.
He let loose a hush of pencil, dividing the night
with the mercy of a free hand, a toothless smile.

When the world was young and the gods came to visit us
as nosebleeds, in waiting rooms, nudging their idle chins
on the windowsill, I made offerings to the god of coca-cola:
a dice-throw of dead flies, crossed cutlery on paper plates,
recreated our last supper peeking out from fast food boxes.
Outside, a dog-cone of streetlight played the close night;
I answered a telephone box, naked as if struck by lightning,
and under the brass fist of clouds, the static of a dial tone,
a voice tried to steal itself back

THE INHERITORS
ARIEL SARAMANDI

ESSAY

It is a story told in every Creole family I know in Mauritius. It is often narrated during a long drive: a window rolls down and a hand gestures to stanzas upon stanzas of sugarcane, or bungalows on the coast, or valleys now privately owned. 'This used to be ours,' says a parent. 'They took it. We lost it.'

There are several common stories of the taking. The Creole child of a white man is forbidden from inheriting his property. An illiterate widow signs acres of land to corrupt notaries, who promise that her progeny will be taken care of. Families are chased out of their homes.

These are old stories, learned by rote and handed down like a relic, a warning: *Look at all we had. Look: you could lose everything too.*

With time and pain these stories often become nebulous – sometimes on purpose.

My mother's way of coping with her family history is near-absolute silence; she fears, perhaps, that poverty and stigma will return to plague her once it is spoken out loud. Details of her life are sparse and often excruciating. A lower middle-class upbringing. The shame of having bronze skin with a white surname. On my mother's side of the family, my great-grandfather was a wealthy white man, who had many mistresses; one was a woman of African descent, his maid. They had several children together and eventually married. My great-grandmother loved her husband fastidiously. They brought up their children in the big house; my grandfather and his sisters carried the white name, though, according to my mother, it would have been a kindness if my great-grandfather had given them my great-grandmother's maiden name instead. My great-grandmother would hide in another part of the house when my great-grandfather's white friends would drive up the Montagne Longue mountain to see him.

My mother took me to Montagne Longue only once, when I was around five years old. I remember that she was with her eldest brother, and that we were in the region to visit a friend. My uncle probably decided we should look at 'our' land again, though there was no former family home to visit, no graves. It was late afternoon, and we walked through golden, parched grass which reached up to my knees. The crest of the mountain surrounded us. My uncle pointed to the cascading hills below, covered in pineapple plantations. 'All of this was ours. Covered in pineapple like it was back in the day, but also in vanilla and cane.'

These lavish tracts of land were now lost, but my mother wouldn't tell me exactly how. Over the years, and after putting many impertinent questions to family members, I've gathered fragments of a story of dispossession: an eccentric old man, with many eminent French friends, who was estranged from his kin and society once he'd decided that his Black son would carry his name; his land taken from him by his white family and business associates, while other parts of the land were lost to debt. There's a family tree that my uncle was able to recover: it was drawn by my great-grandfather's white family and their descendants. Some of the branches were drawn to look like fingers; at my great-grandfather's name there's an amputation, a cut to mark the place where whiteness ends.

The documents that would tell the story of our inheritance are also lost, according to my mother. When my grandfather died my mother took care of the funeral and the household expenses; my grandmother thoroughly cleaned the house and disposed of old papers that she thought weren't of any value. My mother was too wrecked by grief to take much notice of what she was cleaning, but she suspects now that this is when the papers disappeared – parchments inscribed with plans and letters in

her grandfather's hand that she remembers seeing as a child. The papers were sold or thrown away; possibly used as scrap paper to envelop *gato pima* sold by the road.

Until I heard of Danielle Tancrel's fight to reclaim her land I thought that the stories of Creole dispossession were mundane, irrevocable facts of life. I met her through Jean-Clément Cangy, a family friend whose work as a journalist, researcher and writer has produced invaluable material on Creole culture and history. Jean-Clement and Danielle wrote the book *Spoliation des terres, Crime contre les droits humains fondamentaux* (Spoliation of land and crimes against fundamental human rights) in 2019, which provides an overview of cases of land dispossession as well as their historical context, tracing the changes in land ownership laws throughout the centuries.

Danielle is a very different woman to my mother. She has no interest in ossified memory.

She lives a few minutes away from the small village of St Julien, in the district of Flacq. Her house is surrounded by sugarcane fields. When I walk into her living room, I see her ancestry laid out in hundreds of papers classified into boxes. These documents sketch the initial story of her family.

'My grandfather and father worked for the sugar company. Their factory is just there,' Danielle says, pointing to thick smoke rising about three miles away. The company is one of the largest sugar producers in Mauritius.

'My father was a mechanic. He was also a handyman for the white management, he organised their grand dinners in their bungalows. One day, while he was working, one of the white men asked his name. Upon learning it he was shocked and said, "the Tancrels have plenty of land right here!" My father then spoke to his boss. His boss said, "I can't help you. You have to seek help from higher up." When my father came home that night and told us what he'd heard, we had no idea what to do next.'

'My brother went to the archives to find out if all this was true sometime in 2006. He found our family name on page 666 of the civil status records for 1795–1815. I told him it was the devil's number. Maybe that's why my family suffered so much. My grandfather was raised only by his mother. He never talked about his childhood. He was illiterate. My family was very poor. My mother would cook the vine leaves that grew in the garden for us to eat almost every day. I visited the archives too, and soon grew obsessed. I wanted to know the truth about my family. I spent all my weekends there, my holidays from work. I photocopied every document with the Tancrel name on it,' she says, handing me another pile of documents to look at. We go through them one by one, interpreting the thin cursive, deciphering eighteenth-century French. After an hour she brings out cookies and juice for me. She takes silent note of my penchant for the chocolate ones and serves me some more.

I marvel at the fact that she's been able to trace her family back through eight generations. 'It was really difficult. When I asked for my great-grandfather's birth certificate at the Civil Status Office, they said they didn't have it. My childhood friend worked at the National Archives. She rang them up and pestered them. They eventually gave it to me. In another office, they tried to prevent me from accessing notarial documents. When they understood that I was just looking for my ancestors, they let me in. The staff told me that they'd caught lawyers and notaries ripping up papers here before.'

Danielle was able to trace a deed granting 86 arpents (the equivalent of approximately one acre) to Antoine Tancrel, her direct ancestor, in 1783. She examined the map detailing the area: the land, covered in virgin forest and in cane, is claimed by the sugar company. She wasn't sure what she could do.

But then came the Truth and Justice Commission of Mauritius. Launched in 2009, it was the first truth commission in the world to independently investigate the legacy of slavery and indenture. In a six-volume report, it offered a revisionist account of the island's history, detailed the racism and economic oppression faced by descendants of slaves, and proposed recommendations for reparations. The volumes are strewn with hundreds of stories of lost land; the second volume is entirely devoted to land reform and cases of dispossession. One tale in particular is legion: 'the sugar company stole it.'

The Kreol word for sugar company is *tablisman*. It is derived from the French *établissement agricole*, or agricultural establishment. French colonists were granted acres of land to grow variegated crops in the eighteenth century; after the British took over Mauritius in 1810, land was used almost exclusively to grow sugarcane, and sugar companies emerged in their hundreds. A typical establishment would consist of a colonial home; buildings used to house enslaved men and women, then later freedmen and indentured labourers; a sugar factory not too far away; a chapel, and then a Hindu temple, all surrounded by fields of cane. With time, these sugar companies consolidated and turned into conglomerates in the twentieth and twenty-first century. They now dominate the private sector.

Four-hundred or so official claims were made to the Commission. Danielle was among the first to present her case. The Commission advised her to contact a land surveyor, who studied her dossier and drew up a report in July 2011. The surveyor's report described how the land isn't found in the company's title deeds, their sugar estate records or in their mortgage files. The surveyor stated that the land is covered in sugarcane and is occupied by the company 'in utter bad faith'. The Commission then summoned the company's Chief Executive Officer in September 2011. He couldn't produce any evidence supporting the company's claim to the land, except to say that it had been under 'continuous and uninterrupted occupation' by them since 1938. The Commission told Danielle that she should go to court with her case, as it was clear that she'd been dispossessed.

'The first time I spoke to the CEO in 2011, he told me that he would not negotiate with my family, and he awaited the report of the Commission. Then he died a year after the Commission gave its verdict. The following year, I thought I would try again. I gathered up my strength and rang one of the company directors. He answered in a harsh voice. I said, "Please don't intimidate me. It's taken all my courage to talk to you." I explained my case to him and sent the files. He said, "I'd like to know what the Court of Justice thinks of this." I then sent the company a formal legal notice asking them for my land back. They said the claim was "baseless and unjustified". They can pay the best lawyers and keep deferring the case until my money runs out. And I have no money to continue the legal fight.'

In the days that follow our meeting I send Danielle several emails. The Truth and Justice Commission outlines her case in the report, and when I read through it I find a possible error. Their verdict states that 'it seems to be a typical case of dispossession by sugar estates, of land belonging to a French *colon*, who had children with a woman slave.' The Commission

suggests that the dispossession happened around 1850, but slavery was abolished in 1835. Their timeline of events doesn't make sense.

'My grandfather was illiterate. That's how our land was stolen,' Danielle says in an email to me. She sees her family's poverty and illiteracy as the cause, not the consequence, of the dispossession. It doesn't make much sense to me, that somewhere along the way her family became poor and then lost all the land they owned. The land would have kept them rich. If they had serious debts, they would have started by selling their land in order to recover some financial stability. There wouldn't be large parcels of land left – certainly not one of 86 arpents so close to the family estate.

I want to understand what happened. I ask too many questions. She tells me that she feels embarrassed, that I am being intrusive, that she can't go through the pain of the investigation again. She is exhausted. I apologise, feel stupid and clumsy. In my attempts to elucidate the mystery of her dispossession I've barged through her life. Hers is a public case of great historical and legal importance; public, and still so raw. She graciously sends me more information, though, and examines my hypotheses on her stolen land even as she believes that we should be concentrating more on the case as it stands at present: no matter how her land was stolen, she has proof that it was indeed stolen, and that's all she needs in court.

I attempt to trace her ancestry myself and establish my own timeline. I visit the National Archives. On my way there, I drive past districts, towns and villages that have been almost entirely rebranded by sugar conglomerates which are mostly white-owned and white-run. 'The government only manages 10% of the country's land, and the private sector owns the rest. Ten families cultivating cane on about 100,000 arpents,' writes Jean-Claude de L'Estrac in his 2020 book *Terres: Possession et Dépossession* (Lands: Possession and Disposession). Ten white families, and whites make up less than one per cent of the population.

These newly rebranded areas are often part of 'smart city' schemes: I pass by Mon Trésor and Moka and their newly-floral logos. Sugar is worth next to nothing now, and all that land has to be monetised differently. The most lucrative way seems to be real estate. Some of these cities hope to draw upper-middle-class Mauritians away from their dying locales and into new urban areas, which promise cutting-edge infrastructure and sustainable, nature-centric lifestyles. There are lots of shopping facilities, too: my drive to the archives takes me past Bagatelle Mall of Mauritius, the country's premier shopping mall built with a colonial aesthetic. The chimney of an old sugar mill stands in its centre, an on-the-nose metaphor for our island's history.

The National Archives building lies in the industrial zone of Coromandel, a town at the edge of the capital of Port Louis. The building is decrepit. Three years ago I went through 300-year-old documents kept in a cardboard box. The papers were speckled with dead moths. Cellophane had been used to stick pieces of paper together, and the adhesive had eaten them like acid. This time around my work is easier. Many people come here to trace their ancestry, and so the staff have plasticised and photocopied essential, in-demand material. I can't access the notarial records, though: they are out of bounds, and I'd need an affidavit from a family member to consult them.

I wonder just how much more I'd be able to uncover if our archives hadn't been pillaged. In the 1820s, about a decade after the British took over the island, the chief archivist took 17 suitcases filled with documents and registers to London and they were never seen here again. This is just

one well-known story. The truth of Danielle's dispossession could be found on the island, in the inaccessible private archives owned by individuals or sugar estates. The truth could be found in archives abroad. The truth could also have been destroyed.

 I go through civil status and district registers, scrutinising records bearing Antoine Tancrel's coarse, heavy signature. I use the family tree Danielle gave me and add more branches, defining each branch as best as I can. At home I go through numerous online genealogies and ancestry testing sites, cross-checking the data. I talk to historians, show them what I've collected, gather their opinions. White histories here are so detailed, their ascendancies so easily traceable, but at some point in the Tancrel line there comes a gap. A gap to mark the place whiteness ends. A gap that explains how the descendants of one of the island's wealthiest white families grew up in poverty in Mauritius. In the end, I don't know if the timeline I establish for the family is a close historical approximation or fiction. I wonder if it is brash audacity to construct a narrative out of fragments.

*

A carpenter in Brittany hears that there's a fortune to be made in one of France's colonies. He is 19 years old and unmarried, thinks there's everything to gain, joins packs of men from the region who are eager to leave their dismal country and their current prospects behind. After months prowling the African coast, his ship docks in Mauritius in 1748. He looks at the indigo mountains, the flurry of foliage, the thriving town of Port Louis and its grandiose, Brittany-inspired colonial mansions, the port that bears the beloved emperor's name.

 Antoine Tancrel is given 312 arpents of land by the French administration upon arrival and plenty of enslaved people, the lot of the average colonist. And he is happy with his lot, had never dreamed of owning so much land before, swathes of forest by a river, framed by rugged hills in the distance, a place named Camp de Masque in the district of Flacq. He won't even have to work the land himself. He thinks he can make a home here, ascend, establish a legacy. He sets out to make a name for himself, and it starts with the basics – learning to read and write, finding a wife. He secures property in the capital, involves himself in trade, ensconces himself in society. His days as a carpenter are over.

 He marries, eventually, to a Mauritian girl of French descent named Marguerite Talec. He's 37 and she's 15. She becomes pregnant at 16; they name their firstborn Louis. They name their second son Benjamin, a name which traditionally denotes the youngest member of the family; perhaps they believe that after five years of trying he will be their last. They then find a trail of names for the eight children that follow over the course of three decades, ending with Baptiste, born to Marguerite at the age of 46. Their children marry into slaveholding families of good repute.

 By 1827 Antoine is dead and Louis is married with 12 children. The Tancrel family own land the size of Central Park. Their estate is actively managed by Louis, Benjamin and Baptiste and some of their brothers-in-law. Sugar is the colony's new king, and the brothers have their slaves build two sugar factories. But not everything prospers in the tropics; Louis buries his wife in 1830, then witnesses the deaths of many of his children in close succession.

 Perhaps Louis envies the Michel family, who live in the same district. They would have seen each other at balls and at church. The Michels are

white, prosperous and have copious children – children who survive. The names of the Michel progeniture are meticulously registered at the civil status office. There are so many Michels around that Louis can barely keep track. He knows, of course, about the scandalous, eccentric Michel: the man had children with an enslaved woman; he freed those children, then gave them his surname! Unforgiveable. Bastard children with bastardised names, something like Angel and Ortencia.

Still, Louis hopes that his surviving children will marry well; that his youngest son, especially, will consolidate the Tancrel reputation. But Jules has no interest in the old ways of living and loving. Almost all the marriages he has attended were made for money, connections, whiteness – and decent matches aren't easy to find. He doesn't want to be like his sister Héloïse, who married her distant cousin, a man 30 years older than her and a *widower, en plus*. Jules doesn't want to marry any of his cousins. He was 15 when slavery was abolished in Mauritius and feels like he could be the harbinger of a new generation. He's in his early twenties now and he's furiously in love with Ortencia Michel.

Louis can't fathom where they met: she wouldn't have been invited to any of the balls; she would have been at the very back of the church at mass. He is livid at their relationship, then desperate. Why won't he just keep her as a mistress, set her up in a lavishly-furnished house in Port Louis, keep his love at an agreeable distance from the family estate? Why must he marry her? He tells Jules that as his son he has the weight of his ancestors and all their achievements on his shoulders. That the Tancrel line won't survive for much longer if Jules doesn't marry into another white family. That he will destroy his family, in fact.

Jules and Ortencia get married anyway, buoyed by the freedom of a new age, brave enough to withstand the estrangement that their marriage produces within Jules's family. His in-laws love him though, thankfully. They live in Trou d'Eau Douce, a village by the sea. Jules grows close to Ortencia's brother Angel; when Ortencia becomes pregnant, the couple decide to name their child after Angel if the baby's a boy.

Louis doesn't live to see his only grandchild. He dies a few months before Angeli is born. Though his marriage may have quite literally killed his father, Jules hopes that the other Tancrels will come to accept him and his new family. His sister Josephine still loves him, for one.

In time, Jules and Josephine become the only remaining heirs of their father. They all move to Trou d'Eau Douce, well away from the hills and forests, away from the Tancrel family estate in Camp de Masque. They still hear rumours, though: it is whispered that the sons and grandsons of Benjamin and Baptiste are deeply unhappy with Jules. Rumours that Jules's extended family is finding the best way to punish him.

Jules and Josephine head to Port Louis, obtain a legal attestation claiming that they are sole heirs of Louis Tancrel. They cling to this document and its copies, believe that this will protect them and what they own: their share of the land in Camp de Masque and around the district of Flacq, the properties in Louis's name in the capital.

But the law won't save them. In the night, Jules and Josephine hear horses and the laughter of men. The laughter sharpens as it clusters around their home, a wooden mansion in the Brittany style. The men laugh as they torch the place. They beat Angeli when he tries to fight them. In their joy they throw Josephine to the ground as she tries to reason with her cousins and uncles, and she dies from the blow. The Tancrels' Creole neighbours alert the police, but the Englishmen at the station say they won't interfere.

Jules, Ortencia and Angeli escape from the ruins of their home and move in with Ortencia's brother and his family. In time, as Angeli grows up, he falls in love with Angel's daughter Eugenie. He works as a blacksmith, like many free men of colour, but struggles to feed his family.

Angeli's son, Wilfrid, turns to the sea. He doesn't have to take his boat far out into the lagoon to catch fish, and he believes other fishermen when they say that the produce in this region is the best in the country, that maybe it's because of the blend of freshwater and saltwater. From these men he hears scraps of the goings on about town, hears the news of white men working for sugar estates and helming large businesses in the capital, recognises some of the surnames as those of his cousins. He learns that the Tancrels' ancestral property in Camp de Masque is falling into ruin: there are so many other homes elsewhere, closer to the capital, to society. But there's no going back there, he thinks. He doesn't want any of it. He's tired of his father's stories of French-style mansions and clothes imported from Europe, tired of stories of *how we lived* and *what we had*. His father's all worn now, his body beaten like the metal he hammers, all he has is the comfort of memory. He barely even registers Wilfrid's presence at home, and so Wilfrid moves away.

Wilfrid doesn't tell his wife anything about the weight of history that he bears. There's no time for such talk, anyway: life is difficult, Wilfrid's health is failing him, and when he dies she's left to take care of their only son, Benjamin. She doesn't know that Angeli is still alive, figures that even if he isn't dead he wouldn't be able to take care of his grandson, a child with eyes the colour of the lagoon.

Meanwhile, there's barely a trace left of the Tancrel estate in Camp de Masque. The sugar factories that sprang up in the region have consolidated into a company, and cane is grown on every inch of available land. Stems of cane shoot up by the neglected estate. The managers of the sugar company see that cane is encroaching upon the land and do nothing to stop it. With time, they claim the land as their own.

Benjamin grows up. He hears that there are jobs at the sugar company in Flacq, thinks his prospects are better there than in Trou d'Eau Douce. He's little more than a child but his body is strong.

He'll work at the factory for the rest of his life. Every day he walks across acres of sugarcane without knowing that they are his inheritance. His son would have died without that knowledge, too, if it hadn't been for a white manager who asked him for his name.

*

'One drop of black blood is enough,' Danielle tells me. I am at her house once again, going through her documents one last time. I nod as she speaks, looking at her hands, whiter than mine. Her eyes are the colour of river water. She shows me pictures of her family. 'Every sibling turned out different,' she says. I reply that the same variations are found in my family, too. Creoles are primarily descended from enslaved and free Africans and Malagasy people. Rosabelle Boswell wrote in *Le Malaise Créole: Ethnic Identity in Mauritius* (2006) that Creoles have experienced 'both fragmentation and hybridisation, such that three hundred years later, Creoles are a people of mixed African, Indian, Chinese and European heritage.' We identify and are identified as Creole, and represent about 30 per cent of the Mauritian population.

I think about who we are and where we've come from. Upon abolition, the 66,613 enslaved people on the island were made to work

as apprentices. 9,000 or so of them purchased their freedom by 1839, and many bought small plots of land: some had deeds of sale, some had verbal contracts. Most chose to settle as far away as possible from the estates in which they'd been tortured and held captive. Assiduous, unrelenting racism ensured that enslaved people and their descendants had to fight to remain self-sufficient, fight to be employed, fight to keep ownership of their land. Many ended up leaving the island for better lives elsewhere.

I think about the kinds of machinations involved to prevent Danielle from claiming her land. The confidence of the sugar companies, who know they can just pay lawyers to defer the case until Danielle's money runs out for good. The 86 arpents that she claims are worth millions, but I suspect this is still just a sliver of what she is owed.

After many false starts by the government over the last decade, parliament passed a bill late in August 2020 which would establish a Land Division of the Supreme Court. This Division promised to facilitate 'the just, expeditious and accessible resolution to land disputes', in their own words, but it's over a year on now and nothing had been done. The Truth and Justice Commission's recommendations have hardly been implemented either.

'If I win, I can lift my family out of poverty,' Danielle says. 'Sometimes I imagine how different the country would have looked if Creoles hadn't had their land stolen. If they'd been able to prosper in business. If they hadn't needed to emigrate *en masse* for a better life.'

When I leave her house I visit the St Julien cemetery. Danielle has been able to identify a few Tancrel tombs, all of them from before the gap, before the mixed marriage. She's searched for Jules Tancrel's tomb for years and hasn't found him yet.

Some men employed by the parish sit on tombstones and smoke. They tell me that all the eighteenth-century graves are at the periphery of the cemetery, by the edge of a ravine. Some have fallen off the edge into the forest below.

I spend hours trying to decipher names and dates on black slabs, some covered by moss, others smashed in pieces. Few are legible. A young gravedigger tries to help me by brushing some slabs. He rubs others with soil, hoping that the earth will transform random dents into identities. I only find one of Antoine Tancrel's grandchildren here, Héloïse, buried with her husband. Her vault is one of the largest in the parish. A branch has pierced through the stone; it adorns the marble plaque bearing her name. As I walk back to the entrance I see white smoke churn from the mastodonic sugar factory nearby. Briefly, I wish that I could summon the dead to speak the truth from the ground.

INTERVIEW MONIRA AL QADIRI

A row of pearlescent objects float along a purple wall. Melon-sized and covered in tiny iridescent teeth, they evoke treasure, alien genitals, toys. Collectively titled *Spectrum* (2016), the sculptures are in fact 3D replicas of drill bits used by the oil industry to cut holes into the earth's crust. These bits are made from the hardest substance there is, synthetic diamond, designed to crush through rock and soil as they rotate.

The history and future of crude oil – that naturally-occurring fuel, formed from the remains of dead organisms – lies at the centre of Monira Al Qadiri's practice. Born to Kuwaiti parents in Senegal, Al Qadiri returned to the emirate as a child in the 1980s. A small, desert nation encircled by Iraq and Saudi Arabia, but with long coastlines along the Persian Gulf, Kuwait was once at the centre of the pearl-diving industry. The 1950s oil boom transformed the country almost entirely, the old city demolished to make way for the new postmodern skyline. Al Qadiri's practice tries to make sense of this landscape transformed by oil – a substance at once lavish, volatile, destructive and occult. In the sculpture *Deep Float* (2017), she explores the mythologies that draw bathers to oil spas in Azerbaijan; in *Chimera* (2021), the drill bit appears again, this time as a giant five-metre sculpture coated in an oil-like rainbow car paint.

The role of sorrow in Kuwaiti culture is also threaded through Al Qadiri's film and performance works. In the early video *Wa Waila (Oh Torment)* (2008) she appears in elaborate drag, with a big curly beard, lip-syncing to a famous Kuwaiti lament – at once an elegy to the aesthetic of sadness and a wry commentary on gender as performance. *Feeling Dubbing* (2017), performed at the Villa Empain in Brussels, animates her research into the Arabic-dubbed cartoons she watched as a child, and the turbulent life stories of the voice actors.

Kuwaiti music is part of Al Qadiri's family history, too. Her grandfather, Issa, worked as a singer on pearl-diving boats in the early-to-mid twentieth century. The pearlescent coating visible on many of her sculptures evokes the history of the industry to which he belonged, a vanished culture that has since been romanticised in the Gulf imagination. In the short film *Diver* (2018), synchronised swimmers dance in oil-dark water to an old pearl-diving song, dressed in goggles and glittering suits. Accompanying the swimmers, the drone of the music is a reminder of a history now beyond reach: often illiterate, enslaved or working as indentured labourers, the pearl-divers of the past left behind few records.

I spoke to Al Qadiri as she prepared to participate in the 59th Venice Biennale. She was warm and articulate, giggling infectiously as she spoke, traversing subjects from robot jockeys in camel racing to the visions of the colour purple and drills cutting into the night sky. IZABELLA SCOTT

THE WHITE REVIEW You've worked with drill heads in so many of your works – in sculptures like *OR-BIT* (2016–18), where a row of drill heads levitate quietly, coated in orange, purple or lime. Or the large outdoor drill-head sculptures, such as *Alien Technology* (2021). When did you begin making them?

MONIRA AL QADIRI I grew up in Kuwait, but then spent a decade living in Japan, and returned to Kuwait in 2010. After being away for so long, I'd absorbed lots of ideas and rituals from Japan, one of which was the cult of ancestor worship. Back in Kuwait I started thinking about my ancestors, my inheritance – in particular, my grandfather, Issa Al Qadiri, who worked on pearl-diving boats until the 1960s. I never met him, because he died before I was born, but the stories relayed to me often had a magical character. His life was a kind of fiction to me. It was also separated from mine by the rupture between the time before oil and the time after it. Two generations ago, life in Kuwait was unimaginably different, and the arrival of the oil industry in the 1950s changed the landscape, the rituals, the cities and even our bodies. As I began to think about oil and my relationship to my grandfather, I began looking at pearls. I asked myself: why had they been so important to past epochs? A pearl is the result of an infection inside a mollusk. The oyster forms a pearl sac around the infection and covers it with calcium; when human beings discover these lustrous balls, they find them beautiful, they love to wear them. To try and understand what makes a pearl so desirable, so seductive, I started examining the colours. The surface is magical because it's constantly changing: it tricks the eye, which means you can't really capture it, so you have to look more, look again. Oil, too, has the same rainbow magic. I decided to begin making a connection between oil and pearls, connecting the histories which define Kuwait through colour, with pearl on the lighter side and oil on the darker side of the same spectrum.

I first came across pictures of the drill heads, almost by accident. I realised that, even though 90 per cent of Kuwait's economy is based on oil and excavation, the inner mechanics of the industry are almost totally oblique. I began researching the bits, and I had a very clear sense of what I wanted to create: sculpture of these heads, coated in pearl-like sheens.

TWR Was there a political project behind making these drill heads seductive, sparkly? What did you hope this visibility would do in terms of the conversation around oil?

MAQ I wanted to create a critical space around oil. There's an optimism around oil because of the wealth it's delivered to the region. In Kuwait, critique is almost taboo. In 2013, I gave a lecture at a university about the drill head sculptures I was planning, and the content of what I spoke about actually got distorted in the reporting afterwards. In a news item on the lecture, it was said that I 'talked about my favourite colours and art history'. To my surprise, critical commentary on the industry was not seen as favourable at the time.

TWR Where do you think the fear of critique comes from? Is it to do with a concern about revealing the gap between the fantasy of a state forever sustained by oil and the reality of the potential cost of dependence on a volatile substance?

MAQ I think there is a mythical aspect to oil in the Gulf, in part because of the sheer wealth it's brought to the region. It's considered quasi-divine. In Kuwait, people say: 'God gave oil to us, we're a blessed country', and they don't take it further. Geologists can tell us that oil is formed from the remains of ancient organisms that died hundreds of millions of years ago – but in Kuwait, it's associated with divine intervention.

TWR The fact that oil is so ancient, to the point of being mythic, is something you approach in the installation *Prehistoria* (2021). You present nine aluminium panels, which reimagine the drill bits as fossils. Are you going back in time, or conjuring a future where the drill bits are forgotten, fossilised, obsolete?

MAQ I'm always trying preemptively to end the era of oil. This means I set the work in an imagined future – as if I'm an archaeologist, working 100 years from now, uncovering a glossy crown-like object in the desert. I don't know what it is. Did people wear it, I wonder? Is it a ritualistic object, an artefact? Or a fossil of some creature that we don't know of? I play with a sense of time travel in my work as a way to try and imagine life after oil. Today we burn this prehistoric substance every second. At some point in the future the oil infrastructure will be obsolete. It's inevitable: oil will run out or become worthless. I often wonder

what the remains of this culture that we built around oil will look like to somebody in the future. In *Prehistoria*, the 'oil world' appears as a cryptic ancient reality, full of odd machines and fantasies that nobody can understand.

TWR Another work, playing with time, is the sculpture *Wonder* (2016–18), in which a pearl has been carved into the shape of a drill head and exhibited in a small aquarium. In turning a pearl into a drill head, you neatly overlay the histories of pearl diving and oil. How do these histories come together in Kuwait? How is the pearl-diving history told?
MAQ There's this watered down, sanitised version of pearl-diving history that is shown in museums and in public art displays around the Gulf region. It's very distorted, and that was the idea around *Wonder*: I wanted to distort, rather than transform, a pearl into a drill. Oil wealth has distorted, and to some extent erased, this history. The version that remains has been romanticised, where pearl-diving was part of a fairytale past – but the reality was poverty. When my grandfather was a singer on a pearl-diving boat, teams of men would go on six-month expeditions looking for pearls. Many would get sick, go mad or drown, diving around 25 metres to the oyster beds, over and over each day. It was exhausting, perilous work, for very little income. My grandfather's role as a singer on the boat was to keep morale high, and to remind the men of home. At first, I had a romantic vision about my singing grandfather, but when I listened to recordings of singers from the same era – there are some from the 1950s – I realised these songs were labour songs. They are melancholic and very physical. The divers are all participating in the singing, using pots and pans in the boat to make instrumental noises. There's a lot of heaving and ho-ing, making guttural noises, screaming. That part is completely gone from the cutesy version of this music, which is often played on the radio. The cleaning up of this history comes out of a desire, on a national level, to erase the hardship of that time.

TWR The pearl-diving industry relied on indentured workers and enslaved Africans, alongside local divers. That part of the history is erased too. The conditions were intense: I read that divers went below the surface perhaps 30 to 40 times a day. Such a tiny fraction of oysters contain pearls – only one in ten thousand. Did your family ever hear your grandfather sing?
MAQ I'm told he would never sing at home; that he was a harsh, difficult man. He'd return home after six months at sea and tell no stories. He'd just sit there and zone out. I have no idea what he went through on those trips. But I found a book by an Australian explorer called Alan Villiers, titled *Sons of Sinbad* (1940), who boarded a Kuwaiti pearl diving-boat in Yemen in 1938. My dad thinks that this may have been a boat that my grandfather was on. Villiers spent three months on a boat, and in his travelogue he complains so much about the singer – he writes that the voice sounded like a 'squadron of bombing aeroplanes'! That made me laugh. He can't understand why the divers love the singing. I suppose the screaming and growling must have sounded like heavy metal to someone who'd only heard, say, classical music. Sadly the only written documents about this history are by European explorers who did studies in the 1930s and 40s. Many of the boatmen, my grandfather included, were illiterate.

TWR This is something so many archivists contend with – that the record of a certain history, like this one, is authored from the outside and through a colonial lens. Your large, silvery screen prints, *Father of Pearl* (2014), are based on a photograph of your grandfather. Where did you come across it?
MAQ It's the only surviving photograph of my grandfather. He's wearing sunglasses and he looks remote, inaccessible. The silkscreen prints are pearlescent, printed in whites and silvers, and you have to move with the light to see my grandfather's image. It's a disappearing-reappearing portrait, because I can't capture him. The world he lived in, before the oil boom, has vanished. There's a bigger philosophical conundrum in there too, because history will always be on some level oblique. We can read, guess, study documents – but there's a gap.

TWR The academic Saidiya Hartman uses the term 'critical fabulation' to describe the process of gathering as much as you can as a historian – sifting archives, reading all the source material – but then at some point, acknowledging the 'gap' you mention and stepping into fiction. I think in your work you do the same thing: you move from research to fabulation. I'm thinking of your film *Diver* (2018) in particular.

MAQ It's true that I'm creating fictions out of history, and that film is a good example. Pearl-divers, these vanished men from my grandfather's boat, are represented in the film as female synchronised swimmers. They are wearing iridescent body suits and swimming in the middle of the ocean at night. The water looks black and dark as if they're swimming in oil. The swimming is choreographed to an early recording of pearl-diving songs. On some level, the film was a metaphor: there is an artificiality to any kind of reconstruction.

TWR The healing qualities of oil are something you think about in *Deep Float* (2017), a sculpture of a bathtub filled with oil that draws on the history of crude oil spas in Azerbaijan, which were very popular during the Soviet era. People would flock to bathe in oil, which was reputed to have all kinds of healing properties for things like eczema and joint pain. Have you ever visited one of these spas?
MAQ Never – but I became fascinated by this parallel history of oil. The substance has been around forever, and it had many uses before the modern fuel and petrochemical industry took hold. I read that it was used to treat cuts and wounds, especially on camels. Later I found out about the spas in Naftalan in Azerbaijan where people, to this day, bathe in oil, and believe it will cure all sort of ailments. Crude oil is toxic, it can kill bacteria – it's an old sterilisation method. Perhaps that's how it developed into a spa practice. Recently, the health authorities in Naftalan limited the time bathers are allowed to stay in the oil baths, because it's so toxic, but the awesome mythology around oil remains. It's still believed to increase your fertility, to cure skin diseases.

TWR Animals often feature in your work. I'm thinking of the snails that appear in *Empire Dye* (2018), the octopuses in *Divine Memory* (2019) and the camels in the short video *Travel Prayer* (2014). That last work is a slowed-down video of a camel race which you have tinted pink. There are SUVs in the background, following the race from the sidelines. And if you look closely, it becomes clear that there are strange objects riding the camels. They look like monkeys, or tiny people. They have caps on and arms that spin and whip the camel. Can you tell me about these 'robot jockeys', as they are called?
MAQ I saw this camel race on TV when I was flicking channels. I couldn't believe what I was seeing, and I started filming the screen. I'd never seen robo-jockeys before. When I asked my father, he explained that this is how camel racing was done now in Kuwait. There was a law passed in 2002 that banned human jockeys – a move against what had essentially become child slavery, since very small children were used to ride camels,

boys sold into servitude. The robot jockey was developed after this ban. It's very rudimentary: a mechanical drill, of all things, with a whip that can be remote controlled – which is what the people in the SUVs are doing as they drive next to the race. When I saw this on TV, before I knew the context, I felt this overwhelming sense of tragedy. In the video, I overlay the footage with a traditional travel prayer 'Dua'a Al Safar'. I imagine the prayer was helpful to people travelling in the desert. These days it gets played on planes in the Gulf before they take off. At one point, it says: 'save us from this depressive scenery.' For me, the video is an allegory about our tragic race to the future. Where are we headed?

TWR As much as we associate oil with plastics, with the unnatural, it's formed out of marine animals – it's another quasi-animal substance in your work. Yet it also kills. In its current form it signals ecocide. Are there apocalyptic themes in your work?
MAQ They are definitely there. In my snail work, *Empire Dye*, I created a sculpture of a murex seashell coated in violet acrylic. The snails that live in these shells produce a violet dye, known as 'imperial dye'. Its use dates back to the Phoenician era; the purple was valued because it was difficult and expensive to extract. Purple comes up a lot in my work. I watched the Hollywood movie *Deepwater Horizon* (2016) recently, which is about an oil rig explosion. One of the characters is spooked that his colleague is wearing a purple tie, because on oil rigs purple has an ominous meaning. On the machinery, purple comes after red as the colour for maximum danger. Purple basically means the rig is about to explode. It's the colour of destruction and death. Since purple dye was popular among the aristocracy and used in the construction of empire, I wanted *Empire Dye* to also signal 'empire *die*': the death of the oil empire.

TWR You're participating in this year's Venice Biennale, as part of the International Exhibition, *The Milk of Dreams* (April–November 2022), curated by Cecilia Alemani. What will you be showing?
MAQ The work I'm showing is the product of a dream – which fits with the theme of the exhibition quite directly. Dreams are often part of the process of my work. Take the row of levitating drill heads in *OR-BIT*. That image came to me in a dream, after I'd been painting drill heads for another work. When I spray paint the drills, I turn them around on a dolly to make sure the paint is evenly distributed. As I spun the work, it came to life in my mind; the image lingered. That night, I had a vision of a drill cutting into the sky rather than the earth. So I went about trying to create this image. It's in dreams that images can coalesce, come together.

TWR One of your large drill sculptures is called *Chimera*. The title got me thinking about gender in your work. In the West, the word 'chimera' was used in the eighteenth century to describe people who were intersex. It was a kind of euphemism – and not necessarily a very nice one, coming out of the emerging discipline of sexology. When I first saw your drill bits, particularly the smaller ones, I thought they were kinky and queer – that they reclaimed the 'chimera' in some way, and that they were suggestive of sex toys and prosthesis and all the many ways there are to think of sex outside of a normative imagination. What does the chimera mean to you?
MAQ I was thinking primarily of the Greek mythological creature, which is a collection of different parts: part lion, part goat, part snake. I considered the first large drill sculpture, which I made in 2014, to be a self-portrait: a vision of myself as a post-oil mutant. I think of myself as a mutant thing – because I grew up in so many places, in Senegal, in Kuwait, in Japan. And because I've never been straightforwardly femme. The title of the work actually came from the drill head itself, which was called 'The Kymera'. The drills often have these Hollywood names to make them more attractive to buyers. This one just happened to be called the Chimera, which I thought was beautiful and apt. Like you, I've always seen the drills as extremely phallic. I spent my formative years in Kuwait, and in a society, and even a family, that thinks of male figures as heroic. I've aspired to masculinity at various moments, and these sculptures are, in part, about that expression of masculinity.
TWR Perhaps the drills enact a kind of drag. There's something phallic to them, but then the iridescent sheen is a kind of campy layer that turns them into something else, as they are warped from something destructive into something baroque. The novelist Shola von Reinhold writes about iridescence in their novel *LOTE* (2020).

'Iridescence... is inherently Queer and always has been, well before rainbow flags', one of Reinhold's characters declares. For Reinhold, iridescence – particularly Black iridescence – represents a kind of excess that is a resistance to whiteness and even masculinity, both of which are afraid of decadence. There is a kind of rebellious excess to some of your early performance work, such as the music video you made, *Wa Waila (Oh Torment)* (2008). Could you tell me about that work?

MAQ Yes, my cross-dressing work. So much of Arab culture is about appreciating sadness as a beautiful thing and singing sad songs to make yourself feel better. One summer in Kuwait, I decided to make a music video to a folk song in which I acted out the role of the male singer. I wanted to explore performing as the tragic male hero. When I screened the work at the Gulf Film Festival in Dubai, everybody laughed. I thought the work might get me into trouble, but instead I discovered that humour is a powerful weapon to bypass censorship.

TWR Is there a comedic tradition in Kuwait in which there is room for gender performance?
MAQ A law was introduced in Kuwait in 2007 – which, incidentally, was repealed just the other day, in February 2022 – which made it a crime to 'imitate' the opposite sex. It came as a shock because drag is embedded into Kuwaiti culture. There was a very famous actor called Abdul Aziz Al-Nimsh who played a female character on stage in Kuwait's theatre scene, and later on television, from the 1940s up until his death in 2002. He was said to sit around with old ladies and pick up how they talked, so he could become them on stage. Everybody loved him. He was a national hero. He was also a kind of archivist, storing oral histories in his repertoire. Cross-dressing only became a problem in the eyes of the state in the 2000s. It's a common misconception that some of the anti-liberal views around gender that appear in the Gulf are very old, when in fact they are very modern inventions. My mum told me that when she was a young girl in Kuwait in the 1950s, there was a gay couple who lived next door. It was more fluid.

TWR You've talked about time travel in your work, and how the oil boom transformed Kuwaiti society in the 1950s and 60s. The architecture from that era is so utopian and hopeful: space-age buildings, a vision for a new society, new ways of living. You lived through a very different era, perhaps most significantly the 1990 Iraqi invasion carried out by Saddam Hussein. As you mentioned, you've lived in many other places – Senegal, Japan and now Germany. In what way does Kuwait form a backdrop to your work?
MAQ I'm shaped by my childhood in Kuwait. I was seven when the invasion happened. It was

a year of war, but for me, it felt like ten years. A nihilism set in after the war. I think there was a sense that the war was a kind of punishment – because we had been too ambitious, too happy, too rich. I have a very dark vision of Kuwait's future. It remains entirely dependent on oil; there is no Plan B. All of Kuwait's visions of the future are in the past. Everything that is big and glitzy and ambitious was built in the 1970s. Now these buildings are all dusty and broken down. Kuwait City is a very melancholic place, a city of past glories. I think of Kuwait as a temporary project that could collapse at any given moment. It's a Babylon.

TWR Your mum, Thuraya Al-Baqsami, is a painter and printmaker. She began making work in Kuwait in the 1960s, and she's a celebrated artist today. She must have been a huge influence on your life.
MAQ I grew up in her studio, in her world of colours and paints. She's the reason I became an artist. My sister and I spent so much time in her studio that it became our fantasy land. During the war, she would allow us to use her special papers and paints and materials, which she would never usually allow, to keep us preoccupied. But life changed. My mum made a lot of work in that period, and she remains extremely active today. She is over 70 and so energetic. My parents' story is very interesting. They both grew up Kuwait in the sixties and seventies, which were liberal decades. Everybody was partying and wearing miniskirts and had their hair out. It was a completely different reality – when I see pictures, I can't believe it's the same country. My dad had communist leanings, and in the 1970s, they moved to Moscow together to study there. Of course, my dad's dream collapsed after he arrived. The propaganda he'd consumed in Kuwait gave way to the reality of the situation in Russia: breadlines, poverty. And yet they stayed for a few years. For my mum, it was amazing to study in Moscow. The arts education was a thousand times better than anything that existed in the Arab world at the time. What I find interesting is that, while living in the USSR, my parents missed the conservative turn that happened across the Middle East, following the Iranian Revolution in 1979 to the northeast of Kuwait, and the Sunni Awakening, as it's called, to the south in Saudi Arabia. My parents returned to Kuwait in 1984 to find all their friends and neighbours had become extremely conservative. They, meanwhile, were still living with a seventies mindset, and they soon found themselves to be outsiders. I'm glad my parents missed the conservative turn, because otherwise my sister and I wouldn't have grown up in the extremely liberal atmosphere they created.

But in turn, that liberal atmosphere made us strangers in our own country. People would treat us like outlaws. They called us 'the crazy family'. We had a completely different upbringing to everybody else around us. We felt like aliens.

I.S.,
March 2022

WORKS

PLATES

I–II	*Amorphous Solid Ghost* (detail), 2017
III–IV	*OR-BIT 1-6*, 2016–18
V–VI	*Divine Memory*, 2019
VII–VIII	*Travel Prayer*, 2014
IX	*Muhawwil / Transformer*, 2014
X–XI	*Feeling Dubbing*, 2017
XII	*Wonder*, 2018
XIII	*Holy Quarter*, 2020

III

IV

VI

VII

Oh Lord, please facilitate our travel

IX

x

IX

XII

XIII

THE DREAM LABORATORY
OF NICOLAE VASCHIDE

MIRCEA CĂRTĂRESCU
tr. SEAN COTTER

FICTION

Florabela lived alone in a studio, on the second floor of a small, very old apartment block. Her mother had lived there, and her grandmother, because it was the apartment where, when he returned from Paris and settled in the Romanian capital, Nicolae Vaschide had moved his laboratory. One full wall, covered with old photographs, in rectangular and oval frames, was dedicated to him, or better said, because there were always little candles lit before them, it formed an altar to the master of dreams. On the floor in front of this evocative wall were silver candlesticks, vases with dried-out flowers, tall heaps of yellowed books, ready to topple over whenever a tram passed under the windows. The photos, which Irina and I studied for a long time before we sat down, showed the dream researcher always in the company of a girl with ribbons in her hair, she was either in his arms or on his knees, or when they were both standing, they held hands, and here you were amazed by the difference in their heights: the man seemed endlessly tall, with his head bent slightly to avoid the ceiling, while his daughter lifted her face barely above his knees and held her hand as high as she could to grasp his acromegalic hands. An atmosphere out of Poe, strange and melancholy, floated in each of the photographs: a sepia world, a terrarium of frozen creatures, smiling toward you crookedly from the midst of their loneliness.

Florabela's great-grandfather, Ortansa's grandfather and Alesia's father, had actually been unusually tall. But beyond the fact that, when he strolled down Calea Victoriei, or in Paris on Rue Saint-Denis, where for many years he kept his dream-making workshop in an upstairs chamber, among those rented to the hundreds of whores who held the walls up outside, in whose company he rose above everyone by a head, he gave the impression of a constant, vertical lift, of flying through himself, as though through his ogival, gothic, tubular bones, first to his pelvic girdle, to acquire a burst of energy, and then to reach, like elevators in a tall building, the shoulders, clavicle and shoulder blades, and in the end to stop in the cupola of his cranium, a sizzling champagne flowed, whose bubbles ascended higher and higher, threatening to lift the oneiric scholar a few centimetres above the sidewalk where he stepped. He was not just tall: he ascended, moment by moment, through his own body, until, like a steeple, he completed his vertical form. He looked the same in every picture: dark-faced, with knit eyebrows above the brilliant and unusually sad eyes of those destined to die of phthisis, a high forehead, strong contours at the temples, a straight nose and attractive, sensual lips, perhaps out of place in the overall austerity of his face. The line of women that descended from him, each one twice as wonderful as her mother, inherited the feminine mouth of the master of dreams.

He was born, according to Florabela and confirmed in my subsequent, desultory investigations (I wasted a few afternoons in the National Library looking for his famous book, *Sleep and Dreams*, published in 1911, from whose preface I gathered a few uncertain and disputable dates), in Buzău in 1874, during a windstorm that crowned one of the harshest winters anyone had known; a white, luminous winter had for a time entirely erased the miserable city, one

about which you can only say that you have nothing to say about it. A few houses, a few storerooms, a few empty lots – and above, a hopeless yellow sky. The child took a long time to start talking, such that his father, the cheesemonger State Vaschide, had no greater ambitions than to tie an apron on him when he grew up and keep him as a shop boy, destined to spend his life fetching hunks of telemea from the barrel and slicing them, thinner or thicker as the client desired. All the more so because, at the age of four, once Nicu began to repeat a few words, his family would have preferred that he had stayed completely mute. The child spoke a mixed-up gibberish and said different things than his older brothers and sisters, as though the world he saw was not the same as theirs. His mother, Eufrosina, for example, was told that the night before, she had woven a sweater 'out of pig guts'. His sister, Fevronia, had given birth to a second sun, that rose from her womb into the sky 'like a balloon filled with helium from the fair'. State himself was said to have sliced up a large piece of cheese while it cried, imploring him to not kill it, and it bled onto his apron and over the floor, making an enormous lake that flooded the city. And there were more and more crazy things, until, too embarrassed to send him to school, his parents hid him in their house on Strada Carol, until Nicu was ten. Constantly wet with whey up to his elbows, he helped out in the store, under the storey where they lived. But soon, while State and Eufrosina continued to hear, every morning, in spite of Nicu losing many arguments and battles, news of their nocturnal adventures (they were said to have grown wings made of pearl and risen, like a pair of fat sparrows, to the roof of the house, where they sat between two plaster angels, gossiping and laughing with them and watching the empty street, or Nicu said they grabbed him and kneaded him and patted him like dough, giving him four hands and four feet and eyes at the ends of two snail stalks, or he said they stood together behind the stall with barrels of cheese, and they laughed and all their teeth were made of gold, and their oldest son, Honoriu, had his silhouette on a butcher's poster hanging from the wall, divided into numbered areas, smiling with all his gold teeth), customers began to notice something else: Nicu knew how to write, with the chemical pencil he kept behind his ear, and he could read the newspapers he used to wrap the cheese, better than any other child his age, he was unusually smart and knew a lot of things. He had begun to collect the almanacs printed on the backs of calendars, and books of adventure stories... The child devoured everything in print. One day, his father pulled him out of the outhouse at the end of the yard, after Nicu had forgotten to come back. He was holding a book without a cover, whose yellowed pages were nothing but tables of logarithms; State was so shocked, he crossed himself and forgot to take off his belt. 'Nicu, do you understand these numbers?' he asked, holding the child delicately by the ear. 'No, but I like to read them.' 'Where did you find it?' 'In the field...' In an empty lot beside the city trash pit, he found pieces of books, licentious pamphlets, pages torn out of treatises on zoology or architecture. He brought them all back to the room he shared with his brothers and put them

in his crate, the only space that was completely and exclusively his. He read by candlelight long past midnight, and the orthogonal projections of the buildings, the anatomy of the buccal parts of insects, the giant breasts of women tossing their hair back and moaning in pleasure, the lines of enigmatic signs in books on symbolic logic, the scenes from stories and novels without a beginning or without pages in the middle that got mixed up in his mind, like a chernozem made of thousands of dissimilar fibres – this heteroclite humus, once he closed his eyes, fed his nocturnal visions, which when he awoke, amazed, enchanted, or shaken the next day, he recounted to his parents and whomever wanted, or didn't want, to hear.

In the end, they put him directly into the fourth grade, after the teachers, seeing his test scores, crossed themselves like they were in church. It was true, the child didn't know any of the things kids his age were taught at school. But he read and wrote without mistakes and could talk for hours on end – he, once a mute – about anything you could think of. In the sixth and seventh grades, his classmates (simple, scatterbrained kids, their coats worn through at the elbows) found themselves presented with large sheets of paper, torn from a notebook, a little wet, a little dirty, a little stinking of mould, but covered with panels of drawings. They were cartoons, in which one and the same person went on infinite adventures, from the Stone Age to the near future, the bottom of the ocean to the Amazon jungle, fighting snakes and giant spiders, brontosauruses, pirates, and mad scientists. They were all imagined, drawn, coloured and decorated with balloons full of words coming out of the characters' mouths by this same Nicu Vaschide, the tall loner in the back of the room. For months, the children had no greater joy than passing the coloured pages around. They regarded the author with a kind of sacred horror, meant to isolate him even more, to make his dark halo gleam even brighter. After he stopped producing his illustrated stories, a new surprise came from the silent boy, who usually didn't bother with children's games and constantly changing friendships. It was a newspaper, a real newspaper, entirely written by Nicu, a newspaper about them, their classroom, their everyday life, but which, although it made nothing up, saw things differently, like under a powerful magnifying glass, such that the children were amazed by the fondness and resignation and melancholy and laughter and sadness that, now they realised, had always accompanied, like the shadows of clouds over the city, their day-to-day and hour-to-hour activities. The newspaper, a single copy of which appeared each day, was read by all, in a specified order arrived at after many punches and pullings of hair. The paper appeared like clockwork until the end of eighth grade. Many girls, full of admiration for their special classmate, tried to win his affection, but he rejected them, the way that he seemed to reject, elastically, like a magnet with like poles, everything around him. But the really exciting moment came in physics class, when he was called to the board, alongside many others, to work on optics: reflection, refraction, angles of incidence, the spoon that looks broken in a cup of tea…

The young, green-eyed, and very intelligent teacher, who not long afterward would disappear from the school, asked Nicu how an image forms in the eye. Nicu, to the children's amazement, but surely also to the teacher's, asked in turn, 'With regard to optics or anatomy?' 'Both,' the teacher shot back, amused. And Nicu began to explain sight: the structure of the ocular globe, the iris, pupil, and retina, the inverted image received by rods and cones and transformed into electrical impulses, the nerves and optic chiasm, thalamic projections and then the visual centres of the occipital lobes. He added everything he knew about light rays, about the way the soft, crystalline lens focused them and projected them onto the retina, even about the blind spot that we all have and all ignore – but how many metaphysical, emotional, mystical and karmic blind spots doesn't our fantastical body of flesh and thought contain? – in the area named *macula lutea*... He spoke in detail, as though reading from a book, for more than half an hour, during which time not a breath was heard from the rows of students. No teacher had ever spoken to the children this way. When Nicu fell quiet, the young man at the desk remained still for a while, he started to say something then changed his mind, he looked out the window, where his green eyes were intensified by the green of the mulberry leaves beating against the glass, and then he picked the register up and walked out, without a word.

From that moment, Vaschide became a school legend, as he would later be at Sfântul Sava High School in the centre of Bucharest, his parents' new place of residence. Unexpectedly, one of Eufrosina's uncles had died, leaving her, as his sole living heir, a pair of houses of a noble and generous ugliness (neoclassical constructions, yellow like dead teeth) in a Bucharest neighbourhood packed with these kinds of merchant-style houses, with coloured glass in their transoms and courtyards with statues or fountains in the centre. The young man was enthusiastically admitted to the most storied high school of the age, on the basis of his maximal grades in every subject (with only the gym score acquired dishonestly, in exchange for a wheel of cheese each trimester) he had taken at his school in Buzău. At Sfântul Sava, Vaschide revealed his full self, spread out like a peacock's tail, the plethora of loneliness and oddness that would accompany him always, until his sad disappearance in 1907.

Grandmother Alesia, who became a nun three years after giving birth to Ortansa – conceived with an unknown man or with none, through who knows what parthenogenesis, the same way Ortansa gave birth to Florabela – told the story many times, when her granddaughter visited the hermitage: her grandfather had been, as an adolescent, one of the most famous Bucharest eccentrics, alongside Chimiță, Sânge-Rece, Bărbucică, or the onanist Ibric, but different from them, because his extravagance had to do more with the decadence and dandyism then flowering in the West than with Bucharest's apocalyptic slum life, and it anticipated the affected bizarreries of the Surrealists. Like Baudelaire,. who had died murmuring '*nom, crénom*' more than two decades before, the young Vaschide often appeared, at school and in public, with his eyebrows shaved and

replaced by green or blue stripes of paint. Once he caused the dignified ladies on Calea Victoriei to faint, when he strolled down the street with a pointed rod inserted through both cheeks and emerald lizards dangling from the ends. He shaved his head and decorated it with tattoos that precisely delimited the meandering sutures of his cranial bones, each numbered and carefully shaded: the frontal bone, the ethmoid, sphenoid, parietal, temporal, and the occipital. The bones at the base of the cranium were only suggested, through ingenious foreshortenings. Later, when his mind had reabsorbed the adolescent dream and Vaschide became an honourable scholar, his hair grown out over his cranial tattoos like a jungle covering the ancient temples of a vanished civilisation, he claimed that he had had his skull tattooed while imprisoned at Văcărești, where a master of the art (a counterfeiter steeped in evil) had followed an anatomical diagram torn from a book on osteology. What no one saw and what no one yet knew, because Vaschide had descended deep into a schizophrenic solitude, more so even than at elementary school, was that the skull tattoo extended down his spine, each vertebra was masterfully drawn and numbered with arrows that pointed to the spinal ridges. In a kind of flourish, the five lumbar vertebrae, drawn on the dry skin of the small of the young man's back, at age 17, were coloured in: the ring-shaped bones, with their prongs and spongy cores, were, from top to bottom: dirty-pink, dark blue, scarlet, ochre-orange, and luminous yellow. Vaschide never knew why the convict had overstepped both his instructions and the anatomical diagram. Vaschide had simply discovered the coloured vertebrae at home, after the torture of the tattooing was over, sitting with his back to one mirror, hanging on the wardrobe door, while looking at himself in another, that he held in his hand. But this combination of colours threw him into an ecstatic pleasure, as though he saw this aura radiating from his body like a rainbow in five magic hues. 'It's fine,' he said to himself, as though he suddenly understood it must be this way; then, he leaned his head backwards until, like a swimmer, his cranium entered the waters of the mirror up to his ears, then his entire face, keeping his eyes wide open, with his feminine lips and his chin, until Vaschide melted (for a minute, that to him seemed like centuries on end) into the empire of dreams.

 His thoughts, until then unsettled and cold like crystal vials, now burst open, the way a lily bud bursts, arching and turning in a brilliant efflorescence: they were the floral tableau of Dutch masters, they were the plethora of blue and metallic green of a peacock's tail, they were the dry lace of frost, they were the vulva's anatomy of skins and cat mouths, they were the feathery and vesicant black explosion of unhappiness in love. They were all the landscapes of the world, they were the flutter of light over every gulf, they were the quiet cruelty of all beasts with striped fur, they were a wedding dress sewn out of all cities, they were an enormous underground basin filled with every tear ever shed. There was the inside-out human, the human glove with its internal organs displayed, the human Christmas tree with its ornaments of lymphatic ganglions,

intestines, glands, and bones, with the tinsel of veins and arteries, while within, the constellations, sun, and moon burned with all their might. Vaschide's skull no longer belonged to the cosmos. It was suddenly full, like the chalice of the Holy Grail, with the hyaline hashish of dreams. When he pulled his head, still full of hallucinatory gelatine, back out of the mirror, the young man truly comprehended the path to the interior, like a mining tunnel that extracts astounding crystal mine-flowers from the dark. He scorned the superficial extravagances of his life up to then. He let his hair grow over the tattoo, he dressed in clothes befitting a studious young man, and he forgot, until the autumn of that year, his old mannerisms, which many had connected to hebephrenia.

You can't sow the world with dreams, because the world itself was a dream. The end of the century, however, in the most modern clinics in Vienna and Paris (even though none of them had managed to completely leave Gall, Lombroso or Mesmer behind), brought a resurrection in the investigation of the human mind. The Romantics had discovered, a half-century before, the lost realm of dreams and childhood. Achim and Bettina von Arnim, Jean Paul, Hoffmann, Chamisso, Nerval... Poe... They often wrote too affectedly and poorly, but they knew how to capture, like a flame rising from wet wood, the grand light of dreams. Freed from parable, taxonomy and explication. Heterotopic and paralysing. In their footsteps, Nietzsche, Kierkegaard and Dostoyevsky dug deeper, against the grain of the inept progressivism of their age, to unveil the abyss of the mind, unsoundable like karst complexes: the shame, embarrassment, hopelessness, animal fear, hate, cupidity and evil that lie within us, the perverted will that deforms the crystal palace of thought. Poets passed the baton of the search for the deep ego to philosophers, who in turn handed it over to clinicians. Charcot and Freud were the new prophets, and the young scholar Nicolae Vaschide entered, bit by bit, reading books that cited other books, into the depths of psychology and the study of human life's more enigmatic aspects: sleep and dreams. He studied philosophy and literature for a few years in Bucharest. During this time, he grew closer to the hallucinatory city, doubtlessly the saddest in the world, that sea of bizarre roofs and chipped plaster figures, of blind walls and skylights; and with money from the cheese shop at home, where his parents couldn't contain their pride at having a university student, he rented and later purchased the studio where we now sat with Florabela, listening to her stories. From that moment, his world became the desolate space of Sfântul Gheorghe, the end of the line where the trams turned around a church that quaked with every carful of passengers, making the halos of the saints painted on the pronaos audibly vibrate, like large, prismatic soap bubbles. In the evening, when the air turned dusty-red, when passing people's shadows looked like shades from the inferno, the young man walked by himself, for hours on end, to the Colței Tower and back, toward the Cantacuzino Hospital, not infrequently crossing the old city, the centre of the rose of chipped plaster, a tangle of streets and houses that emptied out completely at the hour of vespers. Then he went

home and began his workday, which for him was the night. Soon, he left philological concerns behind, including the study of philosophy, to take dreams as his only object of inquiry.

If dreams had never been, we would never have known we have a soul. The concrete, tangible, real world would have been all there was, the only dream permitted to us, and because it was the only one, it would have been incapable of recognising itself as a dream. We doubt the world because we dream. We perceive it as it is – a sinister prison for minds – only because, when we close our eyes at night, we always wake up on the other side of our eyelids. It is like the way travelling opens your eyes and mind, it is like a bird's high flight where it sees far off realms. Your village is not the only one in the world and not the navel of the world. Dreams are maps, where the widespread territories of our interior lives appear. They are worlds with one more dimension than the diurnal, and many more than our brains, which cross new landscapes without being able to understand them. Even from his seat at the university, where he studied Schopenhauer and Nietzsche and read Nerval, Barbey d'Aurevilly and Baudelaire, Nicolae Vaschide understood the mechanism of dreams in all its shining detail, the way Tesla visualised his alternating current motors piece by piece, in the air in front of his eyes.

Night by night, we fall asleep and dream. We sink into our visions' cistern of melted gold. Like pearl divers, we cannot stay in these places for a long time: the need to breathe and the pressure on our tympana force us, periodically, to the surface. Four times a night we descend into the deep waters of our mind, we stay there a time and then, almost suffocating, we work our way to the surface. In the morning we open our hand to reveal, glimmering among the lines of our palm, the frosty pearls for which we put our lives in danger: small fragments of our interior caliphate. Although we go there every night, most of the time we come back empty-handed. We are left amazed and unhappy, because we *know* we descended, we *remember* how our knife opened the oyster valves, but the pearls were scattered along the way, as though they had been nothing but unusually dense clouds, or abyssal fish who exploded from their own interior pressure.

Among the pearls we manage to keep, the so-called dreams (as though we said, holding out one fish scale: here is a fish, and pointing to a hyoid bone: here is a man), not all are of the same quality: the texture and colour, the size and softness to the touch vary so much – and our state of enchantment and magic is so different – that even in times when dreams were accessories for parables and stories, and set in long tables beside unambiguous explications ('if you dream of urinating eastward, you will become king'), they carefully taxonomised the night into so many oneiric insect collections. For Calcidius (whom Vaschide read via an edition of that man's *Timaeus* translation containing more footnotes than text), a philosopher in the fourth century after Christ, there are three types of dreams. The first come from our two souls: one inferior, sublunar, and one

above the moon. Our ordinary soul produces *somnium* or *phantasma*, dreams produced by exterior impressions or the amnesiac remains of previous days. These are insignificant, only a distant rumour of the world filtered through the walls of our closed eyelids. The superior soul produces enigmatic dreams, mazes where the mind loses its way: *visum, oneiros*. These also do not have lofty meanings, they are only bloodthirsty sphinxes. The second category of dreams contains those sent by angels or demons: *admonitio* or *chrematismos*. These are dreams that obsess you, revelations promised but not yet concretised, like a word on the tip of your tongue. Few people have these dreams, but those who have experienced them cannot forget them: you meet beings dear to you, who died long ago, or you encounter frightening spiders who scour the underground of your mind and wrap you in silk. Ecstasy and nightmare, sometimes combined in dreams of agonic coupling, in which sexes search for and endlessly penetrate each other, releasing vice's aura of amoral pleasure, they are the punishments/recompense we receive with our lips swollen in pleasure or with teeth unveiled in scream, from the angels of intersynaptic space. This second type of dream also doesn't reveal anything about you, about your true avatar.

Revelation, the kind you receive only a few times in your life, the essential dream, truer than reality and the only tunnel that opens in the walls of time, a tunnel through which you might escape, is only conveyed by the third type of dream, the supreme dream, the dream of escape. It comes from another dimension, and it bears the name *orama*. It is the clear, unambiguous dream, because the enigma, converted into a hyper-enigma, reveals the soul with hallucinatory clarity, without shadow, like a crystal pyramid in the centre of our mind. Orama is the escape plan you receive in your cell, through taps on a wall dozens of metres above the sea. Clear in front of you, if still strange and unusable, like a typewritten page for an illiterate person, like lines of equations for a lay person. You see everything clearly, every letter with its serifs, each number with its absurdity, but *what* is written there? And how does what is written there connect to your fate? You receive vital instructions in an unknown language or in a code imperceptible to your senses, but you know that there is the code and there the response, and you strive to decrypt them. Orama is the whispering voice, without vocal cords or phonic trajectory, that calls you by name in the middle of the night. It is what you whisper to yourself, you, who know much more, who know in fact everything, to yourself, who does not know he knows. Vaschide left the University of Bucharest without taking his degree, to begin a safari that would last his entire life: hunting the supreme dream, *orama*.

In order to experience it lucidly, to manipulate your own mind and, more importantly, to escape the fantastical adventure safe and sound, you had to live in a city of dreams. Bucharest, with its rending ruins, pediments, chipped statues and streetlights with broken glass, could not take you any further than *chrematismos*. In one of the last days he spent at the University of Bucharest, Vaschide had the chance to meet his idol, Alfred Binet, whose treatise on applied psychology

he had read, with great emotion, from cover to cover. Binet was giving an elegant speech in the lecture hall of the Letters and Philosophy Department, on the very new school of human intelligence measurement, both normal and pathological, that carried his name, along with Simon's, his collaborator. At the end of his talk, Binet – who looked like he was cut out of the photos of scholars of the age, all sideburns, waxed moustaches, and a lorgnette, now glinting in one lens, now the other – invited volunteers to take his test. Vaschide raised his hand first, then spent a half hour in strenuous effort, alongside 15 other students, on a strange form, one that seemed more like a collection of cryptographic codes than an intelligence test. Once they finished, the celebrated scholar himself collected the papers and retreated into a small side room. He returned after a few minutes, so pale that the decorative hairstyle of his lips and cheeks shone even brighter in its hazel curls. 'Qui est Monsieur Nicolas Vaschide?' he asked in a trembling voice. 'C'est moi,' the young man stood, surprised. 'Venez.' Face to face, at the little table in the side room, Binet revealed, looking him in the eyes, that he had seen in his completely unusual answers the signs of an oneiromancer. One of exceptional talent. While the scholar perorated in exclamations and superlatives, showing him in various places on the questionnaire how the young man had exploded the usual expectations for a normal intelligence, breaking through the parameters toward something no longer connected to understanding or to rationality, but to a kind of levitation of the mind above itself, Vaschide could already see Paris, the only place on earth where you could reach orama. And truly, Binet, enthusiastically grabbing the student by both his hands, explained that he would award him a Hillel grant, to work with him in Paris for two years at the Physiological Psychology Laboratory within the École des Hautes Études in the Sorbonne. In the very next summer, 1895, Vaschide moved to Rue Saint-Denis. Wandering the long Parisian boulevards, between rows of haunting five-storey buildings shadowed by gigantic, pale plane trees, he experienced a completely different kind of loneliness in those sunny days than he had been accustomed to feel. He was so alone that his body did not cast a shadow. He only visited Binet – once every few days, and for never less than six or seven hours. They wrote together, in a kind of communion of ideas, a few papers so strange that they were never presented to the scientific community: 'La logique morbide', 'Les hallucinations télépathiques', and above all the terrible, 'Essai sur la psycho-physiologie des monstres humains'. Binet introduced him, that autumn (after having expounded, in front of a grave jury with masked faces, on the young Romanian's great talent for dreaming), to the obscure fraternity of Oneiromancers, only a few years old, which included important people from various domains who wished to become explorers in the realm of dreams. The model for the society was the famous group of poets, the Hydropathes, founded a decade earlier, whose members had included Jules Laforgue, Charles Cros, Rollinat, and other Symbolist funambulists.

The young scholar's trial by fire was the same as for every initiate: under

the foundations of the Sorbonne, there was a compartment occupied almost entirely by a single basin of tepid water. The one being tested must sleep inside the basin, standing up, with his feet against the cistern's bottom and only his head, from the nostrils up, above the water. Around him, floating on the placid surface, five oneiromancers would lay their bodies like daisy petals, their heads as close as possible to the head of the central dreamer. They would all be naked and all asleep, drifting slightly on top of the rocking, liquid masses in the deep darkness. The next morning, all six of them would write down their dreams from the preceding night. The candidate was admitted if at least half of their dreams were the same: their commonality signalled the dreamer's talent and his power to transmit his oneiric experience. Nicolae, who to those foreigners was known as Nicolas, agreed to be the centre and stalk of this aquatic flower. Of course, he found it hard to fall asleep standing up, aided only by his total sensory deprivation. The five, who entered the chamber one by one, in the dark, did not know each other. Soon, perhaps as a result of long experience, they all fell asleep. There was, at first, only the sound of their breathing, filtered through the beards and moustaches found on all the personages of that time; eventually not even that sound was heard. Vaschide visualised his brain, as though the rest of his body had dissolved into the water, and around him he saw five other brains, open like lotus petals in the middle of the pool. He closed his eyes and fell asleep; thus, he did not see the bands of golden light, timid and retractable like the horns of a snail, that extended from his mind toward the surrounding minds, shining in the night like the tips of a crown. No one saw them, in fact, because the domed chamber had been hermetically sealed from outside.

The next morning, all the oneiromancers, upon separate questioning, recounted the same dream. Vaschide became the preeminent member of the group, which included about 200 hundred men from all levels of society. As a result of the deep-rooted chauvinism of that time, women, considered to be hybrids of children and adults, were not admitted. This was a shame, because the Romanian scholar believed more in the feminine soul of oneiric states and wanted to experiment with women, as many women and as many kinds of women as possible. His catastrophic fall from grace in the oneiromancer group and his return to Bucharest came, more than anything, as a result of this hubris.

And more than anything because of Chloe. With her first words of introduction to those she did not know, Florabela never forgot to allude to the French blood that ran in her veins. The more familiar she became with someone, the more that person was given the honour of details about her great-grandmother, Chloe, about her fiery red locks like Botticelli's Venus, about the constellations of freckles that covered every little part of her body, about her fabulous appetite for food, about her affair with a marquis and her tragic death, a precursor of Isadora Duncan's: at an aeronautical festival, her mane of hair became tangled in the wicker basket of a hot-air balloon, which picked her up and bore her through the clouds, watched by the spectators' terrified eyes, without the navigator having

the slightest idea what ballast he was carrying. The balloon rose into the stratosphere, and on landing, Chloe's body shattered into translucid, frost-covered splinters like an enormous, frozen doll.

But at the time that Nicolae was pursuing his experiments in his Parisian cell, the red-haired woman was only one of the hundreds of prostitutes who held up the walls in the area around the Saint-Denis gate, girls of every nation, colour, and specialisation, from nymphs of antic marble to hideous dwarfs, from (sometimes literally) impenetrable Chinese and Javanese women to grotesquely painted old ladies, the skin around their throats hanging like a turkey's caruncles, from fake women of double utility to angelic teenagers, with short skirts and ribbons in their hair a loving mother brushed. Through the churning crowd of perfumes, bared breasts, and sombre men feeling up the goods before purchase by the urine-like light of the street lamps, the dream researcher passed in search of the perfect prey, a sexual but also psychic prey, because (an amazing, counter-intuitive, and in any case scandalous fact) each whore, even the most infested and downtrodden, who never opened her mouth without screaming obscenities, and who accepted seven or eight men's liquids, night after night, all her orifices reddened and tumescent from use and abuse, possessed beneath her skull a brain indistinguishable from Volta's, or those of Flammarion, Immanuel Kant, or Leibniz, and through it she had access to logical space, to the crystal sphere of fixed stars, to the knowledge of good and evil only possessed by the archangels. Up from their flesh chafed by males and females, full of bruises and excoriations, up from their green cadavers, in the unhealthy light of gas lamps, up from the hell of their urogenital space, a thin stem ascended through the vertebral tube, to open under the cupola of their cranium, as the purest, most diaphanous, most virginal and most fragile dandelion globe: the mystic circle of the mind. Vaschide did not find the minds of thinkers, mathematicians, or scholars interesting; he preferred rather those of ruined women, of the daughters of pleasure, because diamonds are best revealed when placed against black felt, and paradise is lit by the flames of hell.

Every night, he chose a woman; every night, together with her, he sampled a new form of pleasure. Although the possibilities of mating our bodies seem stereotypical and meagre, pleasure jets in a thousand different ways through the mind's inexhaustible thirst for bliss. Sex between the thighs, sex between the buttocks and in the warm, damp mouth, its tongue more erotic than labia, are only the readily cartographed foundation of the edifice of carnal love. But the centre of pleasure is in the brain, and this is where the dark and burning mole maze begins, as Irina revealed to me through the stories she would whisper in my ear, raspy and gasping, while our hands touched our obscene and delicate sexes, sometimes our own, sometimes the other's; and as revealed to Vaschide, 80 years earlier, by the hundreds of women who passed through his bed during his Parisian sojourn. He learned that there is an intelligence of the sex, just as amazing as that of the brain; that just as the brain overflows with desire, sex

radiates divine wisdom. The most desired and sought-after street women were not the great beauties, many of whom were frigid, but the scholars of pleasure, the thinkers of passion, the poets of bliss. More than any of them, Chloe had an irreducible and miraculous genius for sexual mating. She didn't do anything special, different, or perverse: she was more well-behaved and timid in bed, like a warm, good wife. So why were the men worn out at dawn, why did they need the rest of the day to recover? Why did they look for her, with glassy eyes, every night thereafter? Why did one sonnet leave you cold, while another, written by a great poet, following the same rules of prosody and also using words, shake you to your depths?

Vaschide regarded sex as a portal leading to the true palace that was the brain, as though the vaginal tunnel, like all others, led to the depths within this crystal palace. His night, with an unknown woman lying in bed with him, only began after the wrestling and penetration had ended, when quiet fell over the room, barely disturbed by the restless noises from the streets. Then the two animals who had wildly and tenderly melded together closed their eyes, and at almost the same time, they lost the world. For two years, Vaschide fell asleep holding hands with a strange woman, weaving his fingers with hers as though she were a sweetheart fiancée he had known since childhood.

He slept and dreamt. He dreamed their dreams – as though he had rolled a banknote into a tube and snorted lines of cocaine – each one a different hue, consistency, and texture, like the 30 coloured pencils in a child's kit. The dreams Kyrgyz, Hottentot, Uruguayan, and Arab women dreamt. The dreams of lesbians and of brilliant students who practiced prostitution for pleasure and perversity. The dreams of cabaret singers, of gypsy beggars, of 15-year-olds and of grey-haired women, who embraced more sweetly than nubile girls. Each woman constituted in her daily life her own climate, a world as ripe and juicy as a fig, with her sisters and lovers and children and parents and money and things. But each was herself only in her dreams. There, no man reached, there they lived alone with their deep privacy, the pleasure of those who, in lazy afternoons, naked and sprawled across their beds, gave themselves, alone and with eyes closed, pleasure. Nicolae let himself be enveloped, night after night, in the golden plaits of their visions, in a golden web of spider thread, connected to their captive mind, connected to their insatiable mind. In this way, he created, among the brains with which he came into contact, an underground city, an ant or termite hill with spherical chambers linked through long, airy tunnels. In the centre was his skull, as the master of dreams, around which ran hundreds of dreaming crania. He wandered through his great castle for nights on end, reaching distant spheres, like caves filled with precious stones; he visited them one by one, each frightening bordello and each ecstatic torture chamber. He explored, like a wine taster, the *somnium* dream as well as the *phantasma*, *visum*, and *oneiros*, but he spent the longest time in those sent by evil angels and benign demons: *admonitio* and *chrematismos*. The creature, tall and strange, wrapped in his robe,

glided like the ancient king Tlá through the subterranean labyrinth of his nocturnal life. He opened doors that all gave onto circular rooms, he ascended and descended stairs in gigantic, marble dungeons, he enjoyed all the goods of his oneiric temple. Only one of the rooms was he not permitted to enter, because he knew that there, closed inside a cask with steel staves and bound in chains as thick as his hand, a frightening monster awaited him. Because there is no castle without a forbidden room, there where dwells the most unbearable object in the cosmos: the truth.

For two years, Vaschide experimented happily, in his cell, with sexual pleasures and dreams, so closely related as they were. But until he met Chloe, he could fulfill neither his experiments nor his destiny. Many times he cursed the day (November 19) when he met her, but more often he gave thanks to heaven, because through her he reached the supreme dream, *orama*. The woman seemed at first ordinary to him, like all the others, aside from her special, red-haired smell, which surprised him and made him prefer her over all the other whores holding up the wall. Chloe was as massive as a brass statue, as her daughter and granddaughter and great-granddaughter would also be. When she laid down on the bed, the boards under the mattress moaned, and the tall and melancholic man felt his power ebb away. He laid next to her and embraced her like all the others, but his sex remained as soft and small as a worm, and no mental effort, no wild image, no touch from his hand or the woman's was able to wake it. He kept to kissing her, wrapped in the wire locks of the first woman to ever leave him powerless, and thus, with their lips combined and their long eyelashes interlaced, they both fell asleep, she melting into his chest, he lowering his head, far behind him, into the mirror of dreams.

In her dream, which became his during the year they slept every night beside each other, they held hands and walked across an enormous, circular room, vaster than outer space, more encompassing than the mind. The room had a dome above, at a dizzying height, and their bare feet (they were completely naked) padded, barely audible, against translucent stone tiles. Behind them, outlined in chalk, their glowing footprints were slowly reabsorbed into the squares of two colours, like a chessboard. In the gigantic space of the hall there were people scattered about, small as a population of mirmicoides, people of every type, women and men, old and young, who, as still as statues, all faced the same direction. It was the same direction they were moving, toward the hall's sacred centre. Yet as the embracing couple passed them, people regarded the pair with an enigmatic expression, a shadowy smile, as though the revelation waiting for them in the centre could still be avoided. But Chloe and Nicolae continued, attracted like moths to the flame, through the crowd that increased in number as they approached the target. The air as well seemed to thicken, to gain a consistency, the muted whistle and alkaline taste of a storm wind. Their advance, over the course of hundreds of dreams spent under that dome, larger than the dome of heaven, encountering herds of people in strange clothes

from bygone eras, clawing their way through the crowds of immobile bodies, knocking them over in the end, as the crowd became denser. Over the course of the many dreams that melted into a single one, that became so haunting and concrete that Vaschide instantly forgot, that evening, on meeting Chloe, all he had done during the day, the shopping, reading, and studying, working in the lab, walking down Rue Mouffetard and Rue Morgue, as though his daily life were a disappointing line of necrotic dreams, Chloe's stomach began to expand, slowly, as though a magic fruit were growing inside. Although he had never been able to penetrate her, Nicolae had yet inseminated her, because the large naked redhead became, with each night that passed, heavier, more luminous, her stomach fuller, her gait more rocking, the impressions of her feet on the cool tile became wider and traced in a misty dew that quickly evaporated. When, after almost 300 nights of progress through the circular hall, of struggle with the centre-pointing crowd, the two of them broke into the front row of visitors, Chloe's time came.

In the centre of the hall was a hospital bed, with a white metal frame. On top of a sheet tucked firmly under the mattress was a brown, rubber mat, covering three-quarters of the bed. A child of about five years, on this bed much too large for him, was lying with his head on the pillow. He was not asleep. He looked at his fingers from time to time, he looked around him, he played with the buttons on his pyjamas printed with zebras and elephants. He didn't seem to see the people who had halted some 20 metres from the bed, as though around him there were a circle no one could cross. Vaschide, at least, felt this through all his body. The air beyond the unseen circle turned even denser, it transformed into a suffocating gelatine, and it cried out inaudibly like a bat or a cetacean in the depths of the sea. It repulsed you elastically like the identical pole of a magnet. Hundreds, thousands of gazes passed through it, however, from all sides, the barrier invested the central stage with an unbearable tension.

In the last dream, toward spring, the circle of spectators had been unexpectedly broken by a naked, pregnant woman, who, abruptly separating from her tall and saturnine husband, walked through the empty space and came to the bed. The child saw her immediately, and betraying no surprise, he sat up on the brown mat. The woman sat next to him, on the edge of the bed, looking intensely, with motherly love, into his black, dreaming eyes. There on the bed, a girl emerged from her stomach, clean and pink, with her eyes open like a living doll, and she rose into the air above them, tethered only by her umbilical cord, like a balloon filled with gas lighter than air. Vaschide looked around himself in amazement and saw the immense crowd give a shout of victory and utter happiness, their eyes full of tears. The girl levitated, moving her gentle limbs in the amber space like an infant in the ocean, swimming without being taught, like a supple and agile seal. The boy grabbed the cord connected between the mother's thighs, where no drop of blood flowed, and he moved the girl like a kite, raising and lowering her over the heads of the crowd. Finally, he leaned down, and with

shining teeth, sharper than you would have thought, he cut the cord, revealing, like in a piece of insulated cable, the two arteries and single vein, whose ends poked out of the wet skin wrapper. Then he released the girl; she rose and rose toward the apex of the dome, until she melted into the amber mist of the heights. The totemic woman and the child embraced, pressing their cheeks together and looking up at the girl, and then, when she was no longer visible, they stayed like that for a time, like a statue of maternity or perhaps like a Pietà, covered in the snowfall of thousands of blue, green, and brown gazes, until Vaschide decided to cross into that living space of quiet moaning, the psychic space of obsessions and phobias, to take his woman home. He threw himself toward the hospital bed in the middle of the hall, as though he was leaping from an airplane, without a parachute and without hope of reaching the ground unharmed. The musty, dense air scraped against his skin, it rippled against his ribs, it fluttered behind him like the palpitating plates of a stegosaurus, his gaze was ground against his cornea and turned back inside his ocular globes, blotting his retinas. But the man pushed forward through the emotional current, as though he was confronting a depression, as though he dared defy hallucinations without the help of medication, like jumping from one trapeze to another without a net, twisting and tumbling virtuosically in the air. When he reached them, he desperately clasped the metal frame near the child's feet, like a drowning man, and he tried to embrace Chloe around her waist. But the red-haired woman had emptied herself of her own substance, as though, like an insect, the baby had occupied her entire body and emerged through a longitudinal split in Chloe's skin, pushing her head out of the woman's head, her body from her body, her legs from her legs, her arms from her arms, leaving behind her a nude exuvia, a lifeless simulacrum, a translucid shell meant to be shredded and scattered in the wind. Chloe was now as motionless and empty inside as a sex doll. And yet only now, much too late, her image powerfully excited the man, who finally, finally, felt his sex erect, stronger and harder and more rigid than ever. Since this had never been possible around Chloe, and as he knew already that an erection always accompanies a dream, whatever its content, Nicolae knew that he was in the other realm, and he decided that it was time to wake up. He leaned on the bed frame and gently kissed the inflatable doll, and under the wondering-enchanted eyes of the boy, he slapped himself in the face, he hit his head against the frame, he threw himself to the floor and writhed, rolling around and hitting himself without mercy, until he finally opened his eyes, at dawn, in his apartment on Rue Saint-Denis. Chloe was not beside him, and she would never be again.

POCKET THEORY
FRANCIS WHORRALL-CAMPBELL

ESSAY

'I would go so far as to say that the natural, proper, fitting shape of the novel might be that of a sack, a bag.'
Ursula K. Le Guin, 'The Carrier Bag Theory of Fiction' (1986)

In 1986, the science-fiction writer Ursula K. Le Guin declared herself tired with the existing narratives available to her and her audiences: 'We've heard all about all the sticks and spears and swords, the things to bash and poke and hit with, the long, hard things, but we have not heard about the thing to put things in, the container for the thing contained. That is a new story.' This new story was set out in her essay 'The Carrier Bag Theory of Fiction', in which the titular bag provides a metaphor for the form of the novel. She argued that a book holds words like a bag holds things, and just as sacks allowed for the cultivation of grain and thus ensured the permanence of the community, the book enables the passage of culture between hands and the transmission of a collective imagination across time. Le Guin's essay is an act of revisionism, a rereading of human evolution and the emergence of early communities. The story of the lone hunter with his spear is superseded by tales of mothers with babies on their backs placing oats into womb-shaped receptacles. Collective care is prized over individual derring-do, a shift that dismantles the masculine heroism of the stories we are used to seeing in books and on the news.

Le Guin's theory is primarily a feminist retelling of origins – of human society and of narrative. She speculates on the various futures that might emerge from this new starting point, where a womb-bag takes the place of a phallic spear, a chamber in which fictions gestate. This essay attempts to think queerly about Le Guin's carrier bag. It imagines a new starting point, a different shape – a container that is less biologically determined, and has more ambiguous bodily resonances and erotic qualities. This receptacle, I suggest, is a pocket.

In its intimate smallness the pocket holds understandings, techniques and experiences inadmissible to 'proper' society. The pocket has long been a source of vulgar insinuation. The details of its contents are visible only as raised outlines: a swelling near the crotch, or on a breast pocket. It is a space that troubles the neat edifice of normality: suggestive and secretive in equal measure. Its promises are ambiguous – it cannot make the grand claims of sustenance that the bag is capable of – but tucked inside we might find weird lives and weird literature, where the games of gender and genre are played by new, tricksy rules.

The stories that are contained in this pocket of an essay are outsiders. Derek Jarman's personal chronicle *At Your Own Risk: A Saint's Testament* (1992); Sophia Al-Maria's genre-bending collection *Sad Sack* (2019); the fragmented poetics of Anne Boyer's *Garments Against Women* (2015); Jordy Rosenberg's meta-historical novel *Confessions of the Fox* (2018); and dreamlike memories of Mattilda Bernstein Sycamore's *The Freezer Door* (2020): all are strange, estranged from the mainstream. They find themselves in a discreet space, stitched from offcuts and leftover stories: the literary equivalent of this indecorous sartorial construct. They form a fragmentary and diminutive anti-canon, a pocket theory of literature.

If the carrier bag theory finds its application in the novel, a pocket theory of fiction sweeps up texts less easy to categorise, its small form drawing together all sorts of marginal and misfit works. The novel's authorial integrity makes it naturally a bag, unlike these chimerical narratives written by those whose multiplying identities make them slippery and ambiguous. Gender-deviants, sexual-miscreants, climate-antagonists, capitalism-survivors and border-crossers: the authors' multiple identities

and creations jostle together in the pocket – a handful of genre-less collections, uncategorisable poems and meta-textual novels. This essay itself is full of joins and seams, proceeding through a series of small arguments stitched together. Just as Le Guin's bag exists as a literary form, here the pocket provides both animating metaphor and structural device. Inserting different objects will change a pocket's shape: as the texts are placed inside this essay, the metaphor also alters.

The interior of a pocket is hidden away – *secreted* on one's person – but it is also a space of 'secretion' in a more bodily, glandular sense. The pocket is close to the skin, its folds and seams suggestively fleshy, like the guts of the garment to which it is stitched. Pockets are deeply private – so much so they take on the aura of a surrogate bodily orifice, charged with an ambiguous erotic transfer from the wearer. Its ability to carry many different surprises is part of the pocket's delight. It instigates an imaginative process of deciphering that stimulates as many misreadings as correct matches.

The sexual and quasi-hidden nature of the pocket encourages desirous eyes to assess its contents in ways that skirt the erotic and the criminal. In this coded exchange of gaze and display, a deviant community is formed – a fact long understood by queer people who developed among themselves complex gestural and sartorial codes as a way to safely identify each other and signal a shared desire. Like the misfit language of 'flagging' – a mode of communication that became popular among gay men in the 1970s, where coloured hankies worn in different pockets indicated various sexual preferences – the coded exchange is a way of hiding in plain sight, by carrying on necessary conversations that risk being submerged. The flagger's knowingly placed handkerchief might be a kind of real-life shorthand for how the pocket theory of fiction operates: defining a shifting group of communicators and readers who exist and speak in society's seams.

THE POCKET AND THE CLOSET

In *Epistemology of the Closet* (1990), Eve Kosofsky Sedgwick attaches a narrative of potential emergence to the named item of furniture. According to Sedgwick, queer culture is permanently marked by the closet's edges and by the decision to stay hidden or to come out. The storyline of the pocket, however, confuses the distinction between in and out. The material can fold both ways: turning a pocket inside out leaves its shape intact – emergence merged with entering. This paradoxical and shimmering potential was noted by Walter Benjamin in a passage in his memoir *Berlin Childhood around 1900* (1932–8). In one striking vignette entitled 'Cabinets', Benjamin recalls his childhood bedroom in the family's home in Westend in Berlin, where he would amuse himself with a simple game. Reaching into his wardrobe, Benjamin would pull out a sock 'piled in traditional fashion – that is to say, rolled up and turned inside out. Every pair has the appearance of a little pocket.' Nothing excited the little boy more than thrusting his small fist as deeply as he could into each bundle, seeking the 'little present' rolled up inside: a knot of woollen fabric which he would curl his hand around and begin attempting to 'tease' out of its hiding place.

But what started as pleasure would quickly unravel into confusion and concern. In the unveiling, Benjamin remembered that 'something rather disconcerting would happen: I had brought out "the present", but

the "pocket" in which it had lain was no longer there.' As the pocket is inverted and unrolled into the sock, it vanishes inside this other form. Within Benjamin's 'Cabinets', the closet and the closeted, the pocket and the present, appear like simultaneously occurring states of the same material, hinged by a back-and-forth movement in and out of the woollen hole. This motion is sensual: the author's fingers around the hard nub where the socks are joined, his gentle teasing to invoke the vanishing pleasure, suggest a sexual act.

The erotics and secrecy of the pocket are explored by the artist and filmmaker Derek Jarman in his 1992 memoir *At Your Own Risk*. Tony, a man whom Jarman encountered one night on Hampstead Heath, is moved to leave notes in the pockets of other cruisers by a need to communicate. The connection he forms is tenuous and fragile, made possible only in thought, constrained by a society that presumes and rewards heterosexuality (what Jarman calls 'Heterosoc'). One night, Tony slips one such note into Jarman's back jean pocket. Recounting this meeting, Jarman lets the sting of Tony's desperation ring out hollowly across the text. Tony is a walk-on part, and Jarman's response to his note provides no narrative closure, no 'solution' for his isolation. When the pair finally meet on the Heath, Jarman leaves with one of Tony's friends.

The ephemerality of Tony and Benjamin's gestures belies the fact that what is important is not what is held, but how things are passed: it is not the details in the note, nor the present inside the sock, rather the method of communication itself that defines the experience. These shy slips of paper and cloth shuttle between in and out: a hidden revelation of (gay male) desire that blurs the closet's threshold. The pocket is the manner in which Tony's notes are conveyed, but it is also the substance of what he is communicating: the erotic longing associated with sliding a note into someone's back or breast pocket. There is no stable frame in which these messages operate; it exists only in the fluttering fingers that tuck the paper (or sock) away into its pocket. The object of desire slips away – home, to another bar – much like Benjamin's own vanishing little present. Whether from the privacy of one's own bedroom, or publicly in a community of others, the pocket facilitates participation in a game of secret intimacies and misdirection.

THE BAG WITHIN A BAG

In the beginning of her collection *Sad Sack* (2019), the artist and writer Sophia Al-Maria describes how the carrier bag has become woven into our biology. 'Every year 300 million plastic bags escape us' into the sea, she writes, where they are eaten by fish, slowly making their way up the food chain and into the water cycle, with terrifying results. 'We end up with our hormones disrupted. / Endocrine-fucking phthalates lacing our blood.' In her essay, Le Guin made an analogy between the womb and bag. Here that analogy becomes literal: chemicals such as phthalates, used in plastic production, are transferred into the body via the consumption of microplastic particles, resulting in the interruption of 'natural' hormonal production and development of reproductive organs.

In the swallowed carrier bag, *Sad Sack* shows the limits of Le Guin's metaphor in a world more constructed through pollution than evolution. Al-Maria's 'sad sack' is a queer reading of the womb as a social and political construct – not determined by biology so much as medicine and economics, racism and misogyny.

The collection of writing includes prose poems performed as part of her residency at the Whitechapel Gallery in 2018, as well as marginalia, fan-fiction, art writing, short stories and memoir. Full of energetic digressions and cryptic tangents, *Sad Sack* could be described as 'seamy', not least because of the sex (Sigmund Freud is invited to eat pussy), but because of the way Al-Maria stitches together an array of sources – illustrations, letters of complaint, quoted poetry, song lyrics – offering the reader a consciously patchwork experience.

Al-Maria's book, her 'sad sack', is able to hold all sorts of pockets of ignored histories and voices. A Qatari-American, she considers the way in which white feminism has been complicit in the oppression of Black and brown bodies. In a text titled 'We Ride and Die with You', she addresses philosopher Julia Kristeva's fetishisation of the veiled Muslim woman, which appears in Kristeva's book, *The Severed Head: Capital Visions* (2012). 'Some people (especially French people) think that to cover one's face is to disappear to be without a name', Al-Maria writes, citing Kristeva. 'Some see this as being "buried alive" in an unmarked grave'. This is not just a problem with white feminism. In the poem, 'We Share the Same Tears', she recounts passing through immigration on a return trip to America:

I approach Homeland Security in a cunning disguise.
It's an experiment.
A Blonde One.
White hair bleached in to show shock.
And sure enough, for the first time ever, I am not pulled aside
 for extra screening.

Chemically stripping her hair of its colour helps Al-Maria to be perceived as closer to 'unthreatening' whiteness; the new ease with which she passes through the border is a testament to how white femininity is a racial category one has to aspire to, cosy up to, in order to be seen as a person, to be read as a citizen.

In the introduction to *Sad Sack*, curator and writer Taylor Le Melle describes Al-Maria's process of making herself faux white, non-visible, as creating a 'bag within a bag', which they express with the formula: '((race) gender)'. It allows the artist to occupy a secretive sphere, where she is doubly hidden, while at the same time revealing the fiction of femininity – the same fiction on which Le Guin's original metaphor rests.

THE POCKET DENIED

The cover of poet Anne Boyer's *Garments Against Women* (the Mute Books edition, 2016) shows the inside of a pocket. The image is not immediately recognisable for what it is: at first glance it appears as an abstract topography. The pocket is made from woven fabric, perhaps a rough cotton. Its raised texture, clearly visible in the image, focuses our attention on the garment's material condition. This close attention is carried through inside the pages. Boyer presents a self-portrait of the artist as indebted – not intellectually, but financially. *Garments Against Women* ties together literature, the domestic and the economic, charting Boyer's attempt at, and refusals of, writing and household chores: her participation in work that doesn't pay, or pay enough.

Without the time and inclination to tidy and arrange (or resources to hire someone else to do the work) there can be no order. As Boyer

explains, as much as she tries to give her life shape, she lives in the mulch, surrounded by receipts, tissues, shopping lists, cigarette papers, unpaid bills, junk mail – useless bits of tree pulp that keep piling up in the purse, the cupboard drawer, the pocket. This is the residue of the daily accounting that goes on in the household. In her unruly collection – made up of poems, sparse prose, lyric fragments, as well as sewing instructions, the recipe for a chocolate cake – Boyer shows that political and poetic economies are always intertwined: the substance of one is the material of the other, though the aesthetic trace of this connection is often denied. Boyer's attempt to corral these forlorn papers into the pages of her book demonstrates the futility of collecting – of gathering as a means to make sense. Poetry turns away from itself, towards aphorism, towards a repetition of small things that together try and plot the line between politics and poetics. Accumulation is a strategy of non-sense. As if to prove the failure of Le Guin's vision of a bag that will hold things together, the pocket on the book's cover is empty. It is as if all the notes, lists, instructions, receipts, unfinished poems and desperate musings that might comprise the contents of this pocket have been spread out on the floor in an effort to find the material that will enable survival.

A spread of loose objects also suggests that there is no place for their owner to put them. The absence of pockets from feminine clothing is well-noted by fashion historians, and this phenomenon has a long history. Pouches were one of the unfortunate causalities of the French Revolution. In Napoleonic France and Regency England, the 'Empire line' emerged, a new style of dress where the curved corset was replaced by a narrow fitting bodice. For the fashionable upper classes, clingy silhouettes were in and bulky pouches out. The new bodice-lined clothing to the wearer's body – the bust emphasised by the high waist, and hips blossoming beneath the flowing skirt – an idealised silhouette, considered 'natural'.

The association between pocketlessness and femininity cuts any potential link between womanhood and work: making sure that only men can carry the tools ensures that labour becomes the preserve of the masculine. Workers, regardless of gender, are coded as male, and feminine work is rendered invisible and not remunerated. Boyer considers how clothing conspires against certain bodies. The poem 'Garments Against Women', which closes the collection, connects the circumstances that determine Boyer's inability to support herself through writing alone to the whalebones inside corsets:

> a catalogue of whales that is a catalogue
> of whale bones inside a catalogue of garments
> against women that could never be a novel itself.

The constriction of the female form through clothing is intimately linked to the formal restrictions of writing Boyer tries to push against. But Boyer's anger does not settle on the narrow representation of her sex, but connects this constriction to physical ability, work. The whalebones that are pressed close to the woman's body, lying in channels made in the garment's interior, replace the tools that could be carried in their pockets: her body is made to be decorative rather than useful. The whale's trajectory from living creature to desiccated consumer object is knitted into the slow death Boyer experiences under capitalism, a death (rather than a way of life) that also has a history as long as the whale. Boyer is attuned to how both poetry and clothes are made from history – that is, the labour of those who stitched the textile or shaped the language. In attempting

to add to the cloth or canon, the seamstress and the poet are drained: their bodies and lives truncated, squeezed by the weight of wearing and writing.

It's not the pocket itself that is important, but the material conditions of history that allow people to have (or not have) one. Le Guin imagined the bag as a feminine container that could replace masculine tools, like the spear. But a bag is no match for a weapon. Guns and spears and knives and bombs can strip you bare, can slice through cloth, can take away what you own, can take away the means of carrying these things with you. Bags cannot.

THE PICKED POCKET

What is the etymological connection between stealing and stealing away? In his neo-historical romp, *Confessions of the Fox* (2018), novelist and historian Jordy Rosenberg proposes that this link is not just a matter of linguistics, but a similitude of desire, a sympathy of bodies. He demonstrates this via the figure of Jack Sheppard, a legendary rogue and subject of a memoir that forms part of this novel. Jack was a real-life thief and jail-breaker, first immortalised in an autobiographical 'Narrative' (allegedly ghostwritten by Daniel Defoe) that appeared shortly before his execution in 1724. This was followed by further fictional incarnations: most famously as the robber-captain Macheath in John Gay's *The Beggar's Opera* (1728) and cutthroat seducer Mack the Knife in Bertolt Brecht's *Threepenny Opera* (1928). In Rosenberg's tale, Jack appears under his own name in the role of a pickpocket and master of escape, capable of unlocking a thousand women into an 'ecstasy of Trespass'. Stealing (from the rich merchants) and stealing away (from the Thief-Catcher General's crooked gaol) are aligned through the pleasure of liberation: the joy of freeing one's body and other objects from commodification.

Jack, as imagined by Rosenberg, is a trans man. In his attempt to physically transition, Jack wanders into a criminal plot involving an illicit hormone substance. Named in the text as a 'Strength Elixir', this proto-Testogel has liberationist origins, crafted from pig's urine by a band of renegade pirates. However, the elixir was stolen by the Thief-Catcher General, who, sensing a profitable opportunity, sets about producing a commodified copy to be sold as a stimulant to city merchants. His method of production is far grislier: extracting the raw materials from the testes of dead criminals – a body count to which he is desperate to add Jack.

The problem of co-option and commodification also troubles the second protagonist of *Confessions*, a professor named Dr Voth, who speaks to us through the footnotes. After discovering Jack's memoirs in a clearance pile of his university library, Voth begins the arduous process of interpreting the manuscript – in annotations which appear, like a live commentary, within the manuscript. In the course of his work, Voth is approached by a corporation with an interest in the book; he recounts its sinister advances in sprawling footnotes. P-Quad (as the corporation is known) specialise in the rather surprising combination of publishing and pharmaceuticals, and it wants to use Jack's confessions to advertise a new product: 'natural' testosterone. Its desire for the memoir is an elaborate marketing gimmick, where Jack's story will act as the stamp of authenticity for its product. Having the manuscript under their trademark is a way to control access to the elixir recipe, ensuring that the hormone is unable to be replicated – effectively privatising this technology.

Both the Thief-Catcher and P-Quad's agenda is appropriation. From a distance of several hundred years, both are engaged in the same endeavour: bagging up the market and creating a closed loop through which a resource is stolen from the community in which it originated before being sold back. But the pickpocket breaks this cycle: cutting the string, the purse falls into his waiting hands in an act of restitution.

Yet the line between owning and being owned by remain blurry. *Confessions of the Fox* is aware of the power that commodities wield in human lives. Jack's relationship to the fantastical 'strength elixir' is a kind of addiction narrative. He is possessed by a desire to consume this substance – in either form – a wildness that parallels the Thief-Catcher's insatiable (indeed, murderous) greed in selling it, and colours Dr Voth's paratextual tussles with his supervisors at P-Quad. For the modern trans person (who wants, chooses or is able to chemically transition) the dilemma remains. Is there a way to get hormones without lining the pockets of Big Pharma? Is there a way to buy that doesn't mean you are also bought? Are we breaking the cycle or reinforcing it?

Total escape is impossible: sometimes the only way we can resist the society that we live in is to participate in its logics, creating a new world with the (limited) tools on offer. What the pickpocket – and its literary equivalent – offers, is a recombination of strategic scraps in the knowledge that they are scraps: a necessary partial and complicit redistribution of resources, bodily and linguistic.

THE POCKET AS SOURCE

'Firstly, you must provide swine a pastured area with heavy ground cover of the Amorphophallus plant, upon which they are very fond of rubbing their hindquarters as it appears to give them many hours of rude pleasure. From the deep pockets of this plant, gather stray urine. It is not recommended to extort the swine of their urine by force (or cajoling), but rather to come by it naturally.'
'Recipe for Luxuriation', Jordy Rosenberg, *Confessions of the Fox*

Up until this point, the pocket has been largely empty or else full of junk, pessimistic cast-offs from valued society. But it can also be a well spring. Not just an enclave, but a source – of redistribution perhaps, or exploitation. (It depends who's paying.)

In her memoir, *The Freezer Door* (2020), Mattilda Bernstein Sycamore tells a story of a school trip to a living history museum as a child. For three days Sycamore and her classmates lived a parody of the Pilgrims' lives, dressing in burlap and sleeping on hay. During the trip, the children were instructed to sew their own pockets out of burlap to tie at their waists – just like the ones the colonisers wore. Sycamore recalls how she proudly decorated hers with lace, only for her elegant handiwork to be met with horror: 'my teacher tore it out of my hand, and said "a big tsk and a boo for you," because no male colonist would ever wear a pocket like that, and she handed me a plain one to replace it.' In this anecdote, Sycamore finds the fundamental lesson of her education as an American child: that colonialism is something honourable, something to be honoured in ways that made invisible its continued violence against land and bodies – even her young white one. The teacher's grabbing hand, attempting to reinstate appropriate gender and sexual norms, is a parody

of the Pilgrims' greed and the insoluble myth of American manhood that continues to justify these actions.

In *The Freezer Door*, the pocket and the book itself are places for dreams: for wishes that have never, but may ever, come true. This 'may ever', this hope, prompts a search – reaching downwards (into the warm bed of sleep or sex) and backward (into the pocket of memory and national history). Throughout the book, Sycamore is constantly searching – for a flat that won't make her sick from chemicals in the shared laundry supply, for a lasting erotic encounter, but above all for the right words. The words that will dispel Seattle's chilly disposition, with so many communities frozen out by gentrification, which ensures homemaking is a practice only accessible to a certain few. The words that will create a space for her to exist, to live in – despite the lack of healthcare, the persistence of gentrification, the violence of masculinity and the tyranny of nostalgia, which together create the contemporary urban experience in America.

The problem with words, though, is that they are always multiplying: words diverge into many meanings, dissolving not solving, leading Sycamore deeper into more complex tangles of longing. 'Do you see how language hurts? How the lack of language hurts more? How both of these things can be true at the same time. How language isn't everything, And how it is. Inside longing, there is more longing. Why do I always end up here?' Sycamore is invited to participate in this world, but she cannot pass easily within it. Her sick and trans body cannot exist in Seattle's inhospitable climate, so she resists, finding pockets of resistance in sex, dancing, loose encounters with friends and strangers, and above all writing, as a way to avoid being pinned down.

What emerges is a book of these pockets, a book of fragments about anti-normativity and survival. In searching for her American dream – for a return to the possibilities of her hand-sewn pocket – Sycamore realises (and we realise along with her) the fact that this dream is not returnable, or at least not returnable whole. But what she discovers through writing is that while these dreams cannot be materialised intact or entirely, they might be gained as fragments: the dream of a home found in a rented apartment, of love in a blow job in the park, of health in the half hour of energy that is enough to go out and dance. And they can also be gained in fragments – in Sycamore's sumptuous, seamy prose, sentences cleaving hard to the sticky lining of the book, pulling loose threads with them as they emerge onto and out of the page.

CROOKED PLOW
ITAMAR VIEIRA JUNIOR
tr. JOHNNY LORENZ

FICTION

1

When I opened the suitcase and removed the knife wrapped in a grimy old rag tied with a knot and covered in dark stains, I was just over seven years old. My sister, Belonísia, there beside me, was about a year younger than me. We'd been playing outside of our old house with dolls made from corn harvested the previous week. We transformed the yellowing husks around the cobs into dresses, pretending the dolls were our daughters, the daughters of Bibiana and Belonísia. When we noticed Grandma Donana in the backyard, walking away from the house, we turned towards each other to give the signal: all clear. It was time to find out what she'd been hiding in her leather suitcase among threadbare clothes that smelled like rancid lard. It wasn't lost on Grandma how quickly we were growing up; curious girls, we'd invade her bedroom and interrogate her about conversations we'd overheard and things that piqued our interest, such as the objects buried in her suitcase. Our parents would reprimand us constantly, but Grandma only needed to give that firm look of hers, and we'd shiver and blush as if we'd drawn too close to the fire.

So when I saw her walking into the backyard, I immediately looked over at Belonísia. Determined to rifle through her things, I tiptoed over to her room and opened the suitcase, its worn leather tarnished and covered in a layer of dirt. That suitcase, for as long as we could remember, had remained hidden beneath her bed. From the doorway I spied Grandma making her way to the woods past the orchard and vegetable garden, beyond the old roosts of the chicken coop. In those days, we were already accustomed to the way Grandma would talk to herself, asking the strangest things, like when she'd ask someone – someone we couldn't see – to stay away from Carmelita, the aunt we'd never met. She'd utter a jumble of random, disconnected phrases. She'd talk about the ones we couldn't see – spirits – or folks who were strangers to us, distant relatives and comadres. We were used to hearing Grandma ramble on like that in the house, at the front door, on her way out to the fields and in the vegetable garden, as though in deep conversation with the chickens or withered trees. Belonísia and I would glance over at each other, laugh under our breath, and draw closer to her without her noticing. We'd pretend to play with whatever was at hand just to eavesdrop on her, and later, in the company of our dolls and the plants and animals, we'd repeat what Grandma had said with great seriousness. We'd repeat, too, what our mother whispered to our father in the kitchen. 'She was talking up a storm today, she's been talking to herself more and more.' Our father was reluctant to admit that Grandma had been showing signs of dementia, claiming she'd always talked to herself, she'd always repeated her prayers and incantations aloud with the same distracted air.

On that day, we heard Grandma's voice fading into the backyard amidst all the clucking and birdsong, as though her prayers and chants, meaningless to us, had been chased off into the distance by our own excited panting, triggered by

the wicked thing we were about to do. Belonísia squeezed herself under the bed and pulled out the suitcase. The peccary hide covering the rough, earthen floor was bunched up beneath her body. I opened the suitcase now lying beneath our shining eyes. I pulled out a few articles of old clothing, mostly threadbare, but a few were still quite vibrant and made more brilliant by the sunlight on that dry day, a light I could never describe accurately. Among the dishevelled clothes, there was something mysterious covered in a filthy rag, and it caught our eye like a precious stone. I was the one who undid the knot, listening for Grandma's voice in the distance. I saw Belonísia's eyes flash before its radiance, as though she'd been presented with a gift forged in a metal recently extracted from the earth. I raised the knife, neither particularly large nor small, and my sister asked if she could hold it. I wouldn't let her; I wanted to look at it first. I sniffed the blade. It didn't have the rank odour of the other objects in my grandmother's suitcase; it wasn't stained or scratched. In that brief moment what I wanted was to study my grandmother's secret thoroughly, not squander this chance to discover the meaning of the resplendent blade in my hands. I saw part of my face reflecting back at me, as if in a mirror, and I saw the reflection of my sister's face behind me. Belonísia tried to wrench the knife from my hand, but I recoiled from her. 'Let me hold it, Bibiana.' 'Just wait,' I said. That was the moment I put the metal in my mouth, so intense was my desire to taste it, and just a moment later the knife was pulled violently away. My eyes grew perplexed, fixed on the eyes of Belonísia, who was putting the blade into her own mouth. Along with the lingering taste of metal was the flavour of the hot blood that began to run from one corner of my half-opened lips and drip from my chin. The blood darkened once more the grimy, blotted cloth that had been covering the knife.

Belonísia pulled the blade from her mouth, too, then brought her other hand to her mouth, as if trying to hold something back. Her lips blushed, and I wasn't sure if it was from the excitement of tasting the silver blade or from wounding herself, for she was also bleeding. I swallowed as much blood as I could. My sister was wiping her mouth frantically with her hand, her eyes squinting with tears as she tried to dispel the pain. I heard my grandmother's slow steps drawing near as she called out to me, and to Zezé, Domingas, and Belonísia. 'Bibiana, can't you see the potatoes are burning?' I became aware of a smell of burnt potato mingling with the smell of metal and the blood dampening our dresses.

There was a curtain separating Grandma Donana's room from the kitchen, and when she opened it, I'd already picked up the knife from the floor and wrapped it haphazardly with the soggy cloth, but I hadn't yet pushed the leather suitcase back under the bed. I saw the startled eyes of my grandmother, whose heavy hand struck the side of my head and Belonísia's as well. I heard her voice asking what we were doing there, why her suitcase was out from under the bed, where did all that blood come from? 'Say something!' she demanded, threatening to tear out our tongues. Little did she know that one of us was holding her tongue in her hand.

2

Our parents returned from the fields to find Grandma out of her mind, plunging our heads into a large bucket of water and screaming: 'She lost her tongue, she cut her tongue.' She kept screaming it over and over so that the first thing Zeca Chapéu Grande and Salustiana Nicolau must have thought was that their two daughters had deliberately mutilated themselves in some obscure ritual that, with their religious beliefs, would've required a lot of imagination to explain. The bucket was a red well. The two of us kept weeping, and the more we wept, embraced by our parents and wanting to plead for their forgiveness, the more difficult it became to figure out which of us had lost her tongue and needed, urgently, to be taken to the hospital many miles from Água Negra. The manager of the plantation showed up in the Ford Rural, green and white, to drive us there. The landowners would use the Rural when visiting the plantation; otherwise, Sutério, the manager, would drive it on errands into town or, when he wasn't on horseback, to get around the vast fields.

To soak up the blood, my mother grabbed blankets and towels from various rooms in our house. Impatient, she cried out to my father, whose trembling hands were gathering herbs in our garden. My mother's bulging eyes and shrill voice betrayed her growing despair. The herbs my father gathered would be used during the ride, along with prayers and incantations. Belonísia's eyes were red from weeping; as for my eyes, I couldn't tell, and my mother, bewildered, kept asking us what had happened, what had we been playing with, but we'd only answer with long moans impossible to decipher. My father was holding the tongue, wrapped in one of the few shirts he owned. Even then, what I feared was that the tongue would cry out on its own to tell on us. That it would turn us in for our meddling, our stubbornness, our transgression, our lack of concern and respect for Grandma and her things. And worse, our irresponsibility in putting a knife in our mouths, knowing full well that knives bleed the beasts we hunt and the animals in the pen, and they kill men.

My father dressed the tongue with the herbs he'd collected. From the car window, I saw my siblings gathered around our grandmother while Dona Tonha, our neighbour, held her by the arm to lead her back into the house. Years later, I'd come to regret that day, regret what I did to leave my grandmother in tears, with a mind so confused, thinking herself incapable of looking after anyone. On our way to the hospital, we could hear my mother's anguish in her whispered prayers, and her calloused hands, usually so warm, felt as though they'd been soaked in a bucket of water left out in the cool evening air.

At the hospital, we sat waiting for someone to attend to us. Our parents huddled in a corner of the room. I looked at my father's pants, caked with soil, which he hadn't had time to change. My mother was wearing a brightly coloured kerchief wrapped around her head, the same one she'd wear in the fields under a hat to protect her from the sun. She wiped our faces with random

items of clothing, constantly pulling out musty articles I couldn't identify. My father was still holding the tongue, wrapped in the shirt. He hid the herbs in the pockets of his pants, ashamed, perhaps, of being singled out as a witch doctor in a place so unfamiliar to him. It was the first place I'd ever been where I saw more white people than Black. I noticed people looking at us with curiosity but without drawing near.

When the doctor led us to the room and my father showed him the tongue like a wilted flower in his hands, I saw the doctor shake his head no. He gave a long sigh when we opened our mouths for him almost in unison. This one's much worse. She'll have difficulty speaking and swallowing. There's no way we can reattach it. Now I know the words to explain what was happening, but at the time, it made no sense to me; it could hardly have made sense to my mother and father. While the doctor was speaking, Belonísia wouldn't look at me, but I knew we remained united.

Our wounds were sutured, and we spent two more days at the hospital. We left with an assortment of antibiotics and painkillers. We'd need to return in a couple of weeks for the stitches to be removed. We'd eat only porridge and purees, various kinds of mashed food. My mother would abandon her work in the fields for weeks and devote her time to caring for us. Only one of her girls would have serious problems with speaking and swallowing. Nevertheless, both of us grew silent.

Before the accident, we'd never ventured beyond the plantation. We'd never seen such a wide road with cars traveling in both directions. A road leading to the most distant places on earth, that's what Sutério said. On the way to the hospital, we were overwhelmed by our own suffering, by the smell of clotting blood and the prayers of our stunned parents. Sutério just laughed, telling my parents that kids are like cats: one minute they're here, the next they're off somewhere else getting into all sorts of trouble, giving their parents headaches. He had children, he explained, so he knew all about it. On the ride home, the two of us were still in terrible pain, one in even more pain than the other, both of us exhausted, though our lesions were distinctly different. One of us had cut off her tongue completely; the other had a deep wound but wasn't in danger of losing her tongue.

We'd never travelled in the Rural before, or in any automobile. How different it all was, the world beyond Água Negra! How different it was, the city with its houses crammed one against the other, sharing the same walls. And the roads paved with stones. The roads around the plantation and even the floors of our houses were just flattened earth. Made of mud, nothing else, the same mud we'd use to make pies for our corncob dolls, the same mud from which the plants would grow, the plants that fed us. The same mud in which we'd bury the placenta and umbilical cord of each newborn child. The same mud in which we'd bury the earthly remains of our dead. The same mud into which we'd all descend one day. No one escapes. We only noticed that new world outside our

window on the way back home, sitting on separate ends of the back seat, our mother between us absorbed in thought after the mess we'd made of things.

When we arrived at the house, Zezé and Domingas, the little ones, were there with Dona Tonha. My father asked where Grandma was, while my mother stood at the doorway holding our hands. Tonha said it had been a couple of hours since Grandma headed down to the river. By herself? Yes, and she was carrying with her a small bundle.

3

My mother, Salu, once told me I was the eldest of four living children and just as many who didn't survive. Belonísia arrived shortly after me when my mother was still breastfeeding, proving false the theory that a woman couldn't get pregnant while nursing. My mother gave birth to me and then to my sister without any stillbirths in between, unlike what would happen later. After Belonísia, my mother gave birth to one dead child, then another, and then, two years later, my brother Zezé arrived, and Domingas was last. But between Zezé and Domingas my mother had two babies who didn't make it. Grandma Donana helped my mother each time she went into labour. She was a midwife, or what people around here call 'a mother who grabs'. In a sense, Donana was both a grandmother and a mother to us. When we left the womb of Salustiana Nicolau, all of us – the living children, the dead ones and those who would die so soon – were welcomed by Donana's small hands, the first space we occupied outside of Salu's body, those cupped hands I'd often see filled with earth, with shelled corn and picked-over beans. Small hands with clipped nails, just as a midwife's hands should be, Dona Tonha would say. Hands small enough to enter a womb and skilfully turn a baby who was breech or otherwise facing the wrong way. Grandma would help the pregnant women on the plantation when it was time, and she kept delivering babies until she was quite old.

When we were born, our parents were already working in the fields of Fazenda Água Negra. My father had gone to fetch Grandma Donana weeks before my birth. I grew up listening to Grandma grumble about being so far from the plantation that had been her home, betraying a longing which she'd never admit to. She wouldn't demand to go back, she understood her role at her son's side, but she'd continue muttering her lament. The day my father went to get her, making his way back to the place where he was born, Grandma was alone in that old house. Her children, one by one, had left in search of work. My father was the first to leave, then Carmelita. She ran away one day without telling anyone where she was headed, just after Grandma had become a widow for the third time. Grandma wouldn't have tried to stop her.

By then, the fields of Fazenda Caxangá, so abundant with fruit trees, had been carved up by ambitious men who took possession of large tracts of land.

The tenants, long established in that area, were being evicted, and recent arrivals had also been told to pack up and leave. The big shots, accompanied by armed thugs, would show up bearing obscure documents and announce that they'd bought a section of Caxangá. Some of these transactions, not all, were confirmed by the foremen. After my father had arrived at Água Negra, he'd occasionally go back to visit his mother. Salu told us these stories as we grew up. They'd allowed Grandma Donana to stick around the plantation out of respect for her advanced age; they'd grown attached to her presence. But there was another reason: word had travelled from house to house, from tongue to tongue, about the strange powers of the old witch, her cycles of marriage and widowhood, the cross she had to bear in life, and about her son, the boy who'd lost his mind and for weeks hid himself in the woods in the company of a jaguar.

Belonísia and I were the closest of Salu's children, and maybe for that reason we quarrelled the most. We were almost the same age. We'd walk together through the backyard of the house, gathering flowers and scooping mud, picking up stones of various shapes to build our stove, collecting branches to make our jirau – a sort of outdoor kitchen counter, very primitive – and tools to till our imaginary fields, imitating the movements our parents and ancestors had handed down to us. We'd argue about what goes where, what we'd plant or cook. We'd quarrel over the shoes we made from wide, green leaves gathered in the surrounding forest. We'd mount wooden sticks we'd pretend were horses. We'd collect the extra firewood to make our furniture. When our disagreements turned into full-fledged fights, our mother, who didn't have time for foolishness, would intervene, refusing to let us out of the house unless we behaved. We'd promise not to fight, then go back outside and start playing our games again, inevitably scuffling and scratching and pulling each other's hair for good measure.

But during those first few months while we healed from our wounds, we felt between us a strong bond, immune to quarrels and infantile squabbling. A great sadness had descended upon our home. Our neighbours and godparents would visit, wishing for our speedy recovery. The women in the community would look after our younger siblings while my mother made a special porridge for us, or a salve to help with the scarring, as well as purees of yam, sweet potato, manioc. Our father continued going to the fields at daybreak. He'd leave with his farm tools, but first he'd put his hand on our heads, whispering prayers to the encantados, the spirit beings. When eventually we went back to our children's games we forgot all about our past quarrels, for one of us would have to speak for the other. One would be the other's voice. From then on, when we interacted, one of us would need to become more perceptive, read more attentively a sister's eyes and gestures. We'd become one. The sister who would lend her voice would study the body language of the sister who was mute. The sister who was mute would transmit, through elaborate gestures and subtle movements, what she wanted to communicate.

For this symbiosis to occur and endure, our quarrels had to be put aside. We devoted our time to gaining a new understanding of our bodies. At first, it was hard for both of us, very hard – the constant repetition of words, picking up objects, pointing here and there so that one sister might grasp the other's intention. As the years passed, this shared body language became an extension of our individual expressions until each of us almost became the other, without losing herself. Sometimes, one of us would grow annoyed with the other, but the pressing need for one sister to communicate something, and for the other to translate it, made it so that we'd both forget what had annoyed us in the first place.

That's how I became a part of Belonísia, just as she became a part of me. In the meantime, we were growing into young women, learning to cultivate the fields, studying the prayers of our parents, caring for our younger siblings. And so the years went by, and we felt like Siamese twins, sharing the same tongue to make the words that revealed what we needed to become.

4

Grandma Donana came home with the hem of her dress soaked. She said she'd gone to the riverbank to leave the wickedness there. I understood 'the wickedness' to mean the knife with the ivory handle, and even from a distance its radiance blinded me to what had just happened. Grandma returned downtrodden and pale, her eyelids drooping, swollen. She drew close to us to pet our heads with the same hand with which she'd struck us. After her knobbly fingers had caressed our faces, she went to her room without a word. She didn't come out until the next day.

My father headed to the room where he kept the saints, and he lit a candle. My mother led us into her bedroom, asking us to remain quiet in her bed. She tied up the curtain at the entrance to the room so she could keep an eye on us, wary that we might try something else. She told us she was going to wash the pile of clothes, soaked with blood, that she'd taken to the hospital. From the bedroom I heard Tonha asking for the clothes so she could wash them herself. My mother was a tall woman, taller than our father, with strong limbs and large hands. There was something distinctive about her that people admired, making her very dear to them. But on that day, slouching and exhausted, my mother seemed to have lost her noble air.

Belonísia extended her hand toward mine and held it tightly. We weren't able to talk, so we began learning, in an instinctive way, that our gestures could communicate what couldn't be said. We fell asleep in that position.

Grandma Donana never recovered from the events of that day. She hardly left the house to spend time outside. She'd sit on the edge of her bed, packing her old leather suitcase and then unpacking it. She'd take out all of her things, her clothes, an empty bottle of perfume, a small mirror, an old hairbrush, a

missal, sheets of paper, documents of some sort. She regretted not having a single portrait of her children. It no longer annoyed Grandma when we entered her room, even during those private moments when she'd pack and unpack her suitcase. It was her way of killing time. It had been ages since she'd gone out to the fields; she'd limit herself to puttering around our vegetable garden. But she was showing little enthusiasm even for the garden, one of her few pleasures toward the end of her life. She lost all interest in her plants, in the root tinctures she used to prepare for us and for the neighbours. My mother took charge of the domestic tasks Grandma had once considered her responsibility. She tried to stir Grandma's interest, calling her into the backyard to see how big and strong a certain plant had grown, to check if the umbu tree had blossomed yet or if any pests had appeared amidst the chaos of our garden. Grandma, indifferent, would glance at the garden and mutter something under her breath, then return to her room, picking up where she left off, removing things from her suitcase, putting them back in, as though at any moment an invitation might arrive asking her to return to the plantation where she was born, the only place that held any interest for her.

In the months that followed, while the two of us were recuperating from our wounds, as one learned to express the desires of the other, and the other made those desires legible through her facial expressions, only one thing could draw Grandma Donana out from the realm of memory and from her daily ritual of packing and unpacking her suitcase: a crippled dog that Belonísia had found by the road. The dog would wag his tail like the frond of a palm tree and hop around on three legs because one of his hind paws had a broken bone. It was heart-rending, watching the dog hold one leg off the ground and struggle to walk. Something about this animal had broken through the silence that, for months, had descended upon our family. We noticed how Grandma would call one of us over to point out any slight change in the dog's movements. For a time, she forgot all about her suitcase and spent her days looking out the window at Fusco. She was the one who named the dog, and it was only Fusco's company she seemed to want.

Soon after, she asked Belonísia and me to sleep in her small room so she wouldn't be alone. We agreed. Grandma would tell us stories that never ended. Before she'd finish, she'd fall asleep. Knowing that those stories wouldn't ever reach a conclusion, I'd sometimes fall asleep before Grandma did. In the early morning, I'd hear her get out of bed and open the back door while it was still dark, and she'd go and talk to Fusco, almost whispering, but I could hear her voice. Grandma had never raised her hand against us – except on that day when we'd violated what she considered sacred, intruding into her past, bringing back what she didn't wish to remember. She didn't want our innocent hands touching the source of her anguish; at the same time, she didn't want to let go of her memories completely – they were keeping her alive. Those memories gave meaning

to the days left to her; by the same token, they reminded her that she had never surrendered to the difficulties life had put in her way.

One morning, Grandma Donana woke up and started calling me Carmelita, explaining that she'd come up with a solution, I shouldn't worry, I wouldn't have to leave. At the time, I was 12 years old; Belonísia would've been almost 11. Later, I'd sometimes hear Grandma call Belonísia, too, by Carmelita's name. My sister would merely laugh at the mix-up. We'd glance over at one another and make fun of the confusion that had taken hold of her mind. In Grandma Donana's eyes, Fusco had transformed into a jaguar; she advised us to be careful. She'd ask us to walk the trails with her to look for my father, who could be found, she'd heard, at the foot of a jatobá tree, sleeping beside the tame jaguar into which, apparently, our dog had been transformed. We knew that our father was working every day in the fields, so the things my grandmother was saying didn't make any sense. Even so, my mother asked us to go with her, to keep an eye on her so she wouldn't get hurt or lost in the woods. 'Don't let your grandmother step into the stream. Watch out for snakes. And don't laugh at your grandmother.' We'd walk with her and, as it was already December, stop here and there to collect ripened fruit. We'd end up forgetting all about Grandma, sometimes we'd lose sight of her completely, but then we'd keep quiet, and soon her voice would ring out from the middle of the woods calling for Carmelita and her other kids to find Zeca, and we'd run to meet her.

When my father would return home from the fields and we'd try to explain to Grandma that Zeca was standing right there in front of her, she'd say it wasn't true, that the only thing she wanted from that man was his hat.

One afternoon in February, while we were nodding off in the summer heat, Grandma slipped out. When my mother, farming a plot of land closer to the house, came back home to drink some water, she noticed that her mother-in-law wasn't there. She told me to find her. I wanted Belonísia to go with me, but I didn't know where she was. I went down the path Grandma usually took with her other 'kids' when searching for my father. Along the way there was a large buriti tree, and the ground was covered with fallen fruit. Before resuming my search for Grandma, who should have arrived by then at her usual spot, I gathered all the fruit I could carry by lifting the skirt of my dress and improvising a basket. The copper-coloured fruit had thick, firm skin; you wouldn't guess it had succulent flesh whose juices stained the bodies of the women carrying the fresh pulp to sell in town. The money we made allowed us to buy the things we needed when our crops were destroyed by drought or flood. Carrying the buriti fruit in the fold of my skirt, I arrived at the shallow part of the Utinga River where it fed into a marsh near the path to the fields, and there in the shallows I found Grandma floating face down like an animal. Her white hair, like a luminous loofa sponge, reflected the sunlight in the clear water. I recognised the threadbare dress; it was so old, it might have been the same dress Grandma was wearing when she first arrived at our house in the back of a truck, my father at

her side, just before I was born. Terrified by the vision before me, probably the first time I'd seen death up close, I let all the fruit fall and roll into the shallows. I shook my grandmother – would she wake up? – and turned her small, fragile body over, then tried to pull her out of the water, but I wasn't able.

I ran home for help, suffocated by what I'd seen. Along the way, I found Belonísia crouching by the same buriti tree where I'd stopped just moments before. She was gathering the fruit I'd been unable to carry with me to the river. She looked up and saw the terror on my face. One of us would tell the others what had happened.

5

No one touched the suitcase Grandma Donana had spent the final months of her life packing. We were by then familiar with every item of clothing, every object, after watching Grandma conduct her daily ritual of removing the contents and putting everything back. My mother suggested that perhaps some passer-by, in search of work and in need of clothing for his family, might accept the suitcase as a donation, but my father didn't have the courage to give away what had belonged to his mother, so Salu didn't bring it up again. No one spoke of the knife; no one had any idea what happened to it or why there was so much mystery around it. No one ever got out of Grandma why the knife had been wrapped in that bloodstained rag, or why such a beautiful blade hadn't been sold when we were facing financial hardship. My father, with the knowledge he'd acquired on his travels, had judged the pearly-white handle to be real ivory.

My father went through a long period of mourning. He suspended the festive rituals he'd always organized at our house to honour the encantados. He continued attending to people who'd arrive at our door with their maladies, the ones in need of help, or a prayer, or a root tincture. Zeca Chapéu Grande only revealed his grief in subtle gestures, for people like my father didn't have the luxury of shutting themselves away to mourn. His eyes turned misty; he wouldn't say much. And he kept heading out to the fields to work.

A few weeks after the burial, I noticed my mother standing in the doorway, her face turning suddenly pale as she looked out onto the road. I walked up beside her while Belonísia and Domingas were in the front yard running around with Fusco, our crippled dog who, when playing with us, seemed to forget his infirmity. Something my mother saw made her say, 'Lord, have mercy.' Belonísia, Domingas and even the dog stopped what they were doing, alerted now by the strange howls that had reached their ears. A man was leading a woman by a rope down the road, the two of them accompanied by another woman. They were still some distance away, but I could see they were struggling as they headed toward us. The woman being pulled along was screaming the most disturbing and venomous words I'd ever heard.

'Isn't that Crispiniana I see there? Or is it Crispina?' my mother asked, referring to Saturnino's daughters, the twins. They were neighbours of ours at Água Negra. Saturnino was walking out in front of the crazed daughter who was tied up with rope and crying out across earth and sky things we couldn't make sense of. The other twin, either Crispina or Crispiniana, was walking behind her, helping her father on the journey, grabbing hold of her mad sister and no doubt suffering from the harsh blows she delivered, the sister's wild body lassoed as though she were some animal, her arms bound by knotted rope. Another piece of rope had been tied around her fists. She was barefoot, and her hair, dishevelled, wasn't tucked as usual beneath her kerchief.

My mother asked us kids where our brother Zezé was. 'He's with dad,' Domingas responded. 'So then you go, you and Belonísia, go find your father and bring him back. Tell him compadre Saturnino is here with his two girls. It's something for your father.' My sisters ran off while I drew closer to my mother's powerful body, dewy with sweat like the fields at dawn. From the doorway, we could see the young woman's red eyes, her contorted face, spit foaming at the corner of her mouth. The sight transfixed me with curiosity and dread. As the three figures drew closer, my mother asked Saturnino what had happened, and, again, which sister that was. He looked worn out, exhausted from bringing his daughter along the banks of the Santo Antônio to our house, near the Utinga. Taking off his hat respectfully, he replied, 'It's Crispina.'

'Ah, so you found her?' My mother's voice was trembling.

'She was hiding in the cemetery, they found her sleeping there,' Saturnino said as he stepped into our front yard.

Just the previous week, Crispina's father and siblings, including Crispiniana, had gone out searching for her. Years earlier, their family had been welcomed at Água Negra; in fact, the men who first arrived at the plantation looking for work were Saturnino, Damião and my father Zeca. Crispina and Crispiniana were the only twins in our community, the first set of identical twins I'd ever met. There was something mysterious in looking at these two young women, no longer girls anymore. A mirror wasn't easy to find in those parts. Grandma Donana owned just a shard of mirror, and once in a while we'd get the chance to admire it as she packed and unpacked her suitcase in that ritual of her delirium. But a real mirror, something we could see ourselves in? All we had was the calm surface of the iron-rich river where we saw ourselves black in a mirror also black, a mirror brought into being, perhaps, so that we could find ourselves. I'd not forgotten, after all that had happened, the shimmering mirror of the knife with the ivory handle. I'd caught a glimpse of our faces in that unyielding blade that in a flash sliced off a tongue and all the words it was capable of producing. Often, Crispina and Crispiniana would walk together, side by side, one the double of the other. Like a mirror but with depth, width and height, and without the broken edges of Grandma's mirror, or the sand and trees that framed our image on the water's surface.

As they drew closer to our front door, Crispina tumbled hard to the ground. She was dirty and emitted a foul odour of sweat, urine and dead flowers. I saw the terror in my mother's eyes. It wasn't the first, second or even the third time someone with a troubled mind had arrived at our door. And Crispina certainly wouldn't be the last to take up residence in our house, a house like one of those hospitals in the city, or so I'd heard, that take in people who've lost their minds. These people were neither guests nor visitors; they hadn't been invited. They were the ones who'd been unfastened from their own 'I', unrecognisable to family members and to themselves. They were possessed, at once familiar and strange. Their families put their hopes in the powers of Zeca Chapéu Grande, the Jarê healer, whose mission in life was to restore one's body, or mind, when there was need. From early on, we had to live with this magical aspect of our father's life. He was in most ways a father like any other we knew, but his role as a father was more expansive; he cared for the afflicted, the sick, the ones who required remedies not to be found at a hospital, who required the knowledge that medical doctors didn't have, the doctors who didn't exist. At the same time that I was proud of my father for the respect people showed him, I suffered from having to share our home with strangers who were in no way discreet, who'd bellow in anguish and bewilderment, while our house would fill with the scent of candles and incense, with coloured bottles of tinctures, with good people and bad people, people who were humble, others who were a nuisance, all of whom would install themselves in our modest home for weeks on end. My mother was the one who suffered most, for she'd have to stay home, administering remedies at specific times, serving as company to family members of the sick who would also take up residence with us – it was required, when someone was 'admitted' – to help tend to the needs of the disturbed.

The delicate order of our daily life would be disrupted, and you could see it in the way everyone involved became unbalanced, including us, the children, as we began fearing the nocturnal shadows of our house, illuminated by kerosene lamps and candles. We'd avoid sleeping by ourselves and huddle close to protect one another from the terrors entering our room before dawn with a hoarse cry or a slight trembling of the ground, caused by dark forces we believed were invading our home.

To look at Crispina there at our feet, her eyes the colour of fire, her kinky hair matted with dead leaves and flower petals – some of which still held a hint of colour and a lingering perfume – her lips whitened with threads of saliva, her flesh exhaling a nauseating odour while her sister Crispiniana stood nearby, was to experience again the misfortune that had devastated us the day we removed that knife from the suitcase and, eager to know the beauty of that strange, forbidden radiance, placed it in our mouths, feeling liberated, as though this were possible, from all the prohibitions of our parents' and neighbours' religious beliefs, from our own oppression as workers bound to the plantation. It was as if the broken piece of mirror in our grandmother's dusty suitcase had lost another

shard, for in the mirror of that blade we discovered a part of ourselves. Taking advantage of my distraction, Crispina grabbed my foot with such strength that she knocked me off balance, and my mother couldn't prevent my nasty fall, though I wept for other reasons.

Saturnino lost all patience and delivered a resounding slap to his daughter's face, but she didn't react. Crispiniana, who'd been watching, brought her hand to her own face as though her father's hand had struck her.

Through my tears I caught sight of Belonísia and Domingas returning from the path that led to the fields. It didn't take long for my father to show up, too, carrying his satchel and hoe. Zeca Chapéu Grande was different from the rest of us; he knew how to handle situations like this. He'd respond with such tenderness when the most unexpected problems arrived at our door. He immediately ordered Saturnino to untie his daughter, which he did without hesitation or fear. My father helped the young woman off the ground. From his thick lips came ancient prayers that created a sense of calm, a calm transmitted by the power everyone felt in my father's presence. He asked my mother and Crispiniana to give the young woman a bath. Belonísia and Domingas stayed close beside me. My father headed toward the room where he kept the saints, and there he unfolded a straw mat. Beside it he placed a small bench of worn leather.

He lit a candle, and everyone's attention turned toward the flame. If the candle stayed lit, the disturbed woman could remain in our home – but if, surrendering to the energy around it, the flame were to go out, it meant there was no cure.

MARY MUSSMAN

POETRY

LONGANIMITY FOR TRAUMA RELEASE

i.

you with the viscera;
 my ears, open.

how long until this future?

(not waiting for it, wanting for the omen of it)

ii.

the body's experience of the past as electrical currents now

and now:
to expect requires the same

 impulses as memory

iii.

expectation has

supplanted meditation, unravelling the former's detachment.

is it patience if it wears thin?

iv.

all the common words for moving through time calque bodily pain.

in search of a neutral equivalent, I encounter
longanimity.

 seduced
by it.

the soul, blown into the thinnest glass orbs

v.

our desires produce more desires

vi.

reading aloud:

> '...only when the most elementary form of human creativity, which is the capacity to add something of one's own to the common world, is destroyed, isolation becomes altogether unbearable. This can happen in a world whose chief values are dictated by labour...'

or:

> 'But the putting of labour-power into action – i.e., the work – is the active expression of the labourer's own life... One does not count the labour itself as part of one's life; it is rather a sacrifice of one's life.'

or:

> 'I feel your presence in the joint account / your expenditures and wages / I touch them'

the feel of intelligence,

>> pretending to make love in this way

vii.

my birthday:

> I suggest we invent new ways to have sex.

> you say *isn't that what we do* and then we get into it.

> I say *it's a different kind of eroticism than queerness, it is quantum: it seems that I am not with you but I am there.* then I go off and talk about re-defining the entire paradigm of intimacy through experimentation. you are tired: *long day.* I say *ok, next time.* and I'm actually fine with it.

looking back, this mindset resembled mania

 (later, you ask if I noticed how different I was from myself)

viii.

voicing hesitations to a friend in Brussels:

 why in love does patience need to be worn at all?

 a sexier question than I mean, the nakedness of
 the fear that accompanies certainty

the week before, we talked about an orange I had described, part of an oracle that reveals one's relations to things, the orange a relation to sexuality,

 then about the house: it is empty, has not fallen into disrepair, has witness marks of the care that has gone into it, there for anyone who needs it and whenever, there is a garden with herbs and vegetables,

my relation to home as the concept

 of space where material conditions are a given for everyone

ix.

in the future you build and mend everything yourself the way I do

 we fish
we cook

I write more often you design spaces

x.

it is the morning you remind me
 if I thread one foot through the other my body might open like a door

I love the metaphors you have given me for elongating the body

uncertain if they are warnings

xi.

I am waiting for you to show up.

you write out a list of what you think this means,
 it is clear that you know what this means

 and I trust you.

(your ears, open; I read tendencies in my own viscera)

xii.

an emerging scholarly argument about realism: that in dispelling fantasies
realism teaches its readers to derive good from what is there

 I accept this reading of realism but take issue with realism as ethic and
 here is why:
 realism dissuades us from
 revolution and eradicates
 the capaciousness of the imaginary,

to define the expanse of possibility rather than conform to it

xiii.

painting a room to match the fog

if I mention again how I have fallen in love with her
you will just
 you know

what, will your cells lyse?

 see, I don't know

then I am explaining my own aesthetic philosophy,

 the sensation
of realising that wanting to be like someone is erotic

xiv.

I am waiting for my mind to recalibrate.

 the word for what I desire is *euthymia*

xv.

come

xvi.

someone else is saying *it works for us by working against us*

> I go for a walk in the forest and sun comes through the branches and there are crickets at midday, you have been collecting St. John's wort for tincture, I dry elderflowers for tea, someone is pickling young seed cones from a pine tree near the horses
>
> *how is this for an alternative?*

xvii.

if my soul is long enough, it will open like a door

if I wait long enough, you will know what I mean

SPACE PROJECT

So I am tired, so I take a nap. I have looseleaf dreams. When I wake up, it is to owlsong in the afternoon. When I wake up, my skin is perforated: the halfway between sunwarmed and chilled by shadows, the penumbra around the leaves. When I wake up, I go for another walk.

I will turn on you again. I have been tired. I have been false. I have been. I have been.

I turn elsewhere, I measure everything out. I know the time of the sunset in this city and in Copenhagen and in Geneva. I know my position relative to the equator and the time relative to the prime meridian. I turn toward the shadows of buildings. I record the colour of the sky against the cyanometer I will paint. I am putting together a series of sunsets with you. On a few nights you forget that the sun goes down without you. On a few nights you go.

Sometimes I am on a plane that chases the sun. Sometimes you are on a train that flees the sun.

I am entranced by cities whose streets refuse grids. I ride a broken bicycle through the rain and the rain has more of a pattern than the streets. My friend who lives in Copenhagen says, 'you think that the streets are parallel and then they are not.' The uncertainty principle means that I know that I have stopped to wait for the light, but that's all. Not being lost means knowing when you are lost, and I am not lost. None of the cyclists are lost.

When I think, what I am doing is measuring everything out for 'a château made entirely of a single diamond or a very clear crystal' (Sainte Thérèse d'Avila), and that is all I am doing. I know that I will turn away from you. I will turn away from everything. I will turn on everything, I will turn you on in spite of my best efforts.

Prayer has not worked for a while now. When my neighbour leaves for morning mass is when I invite a man into my bed. She is singing laudate, laudate with the nuns. He is singing je vais, je vais.

I think about absent affects. J'explique. In Paris I do not think about transportation because it always takes me half an hour to get from here to here. In Berkeley I do not think about weather because for the entire year I carry a jacket and sweater and scarf with me and that is all I will ever need. In Chicago I do not think about hills because there are no hills, not really. In New York everything

is thought about, forces itself upon me. My friend who lives in New York says, 'here you struggle against everything.'

In New York, I leave aside space for you. In New York, I have left you.

When I mention how far we have walked throughout New York, my brother talks about my penchant for spatial orientation. I have bruises on top of my feet from walking through cities. A possible sign of stress fracture. I say, 'we have to take the subway.'

At night I wander from one party to another party. My skin is covered in a sheen from dancing. I am the only one dancing, turning about in the middle of a room. My friend who lives in New York says, 'you've gotten better at dancing.' I say that I've been dancing more often.

My orientation is spatial, so I turn toward spaces. I am detached from them; I am attracted to them. The physics of this attraction is a kind of cognitive science: preference that comes from repeated exposure to forms, proclivities toward vertical lines and forms found in nature. The metaphysics of this attraction is a philosophical effort: 'It is not *how* the world is that is mystical, but *that* it is' (Ludwig Wittgenstein).

Prayer does not work, so I read philosophical texts on the aesthetics of detachment. My friend who lives in Aubervilliers describes detachment as a form of mature female sexuality and I come to believe her after I've thought about detachment for a while. Letting myself dwell in detachment. Wittgenstein also says, 'ethics and aesthetics are one', so perhaps turning outward is a way to live. Or turning away is a way to live.

When I come over for breakfast you are leaning against the railing outside of your apartment building where people lock their bicycles. I see you in profile before you turn and see me. This is the moment I regret that I am leaving. You are leaving, too, but I am leaving first. So I am the one leaving you.

I speak in a mix of languages. I practice revising myself, inserting new phrases. Lexical sfumato.

A friend lets me stay at her house in Connecticut while I am there to look at the archives and she is in Argentina. I take my coffee each morning in the kitchen. A cat comes up to the back door and presses its head against the screen, mewing. I finish my coffee on the stoop. The cat refuses food, dances around my ankles, leaves my fingertips for the backyard.

I begin to experience vertigo. The spinning begins on a Sunday afternoon, and I make myself a pot of tea. So I sit down. I have some food. My symptoms do not dissipate, even over the next few days. There is a gap between my balance and my sense of balance. The manuscripts at the archive scatter themselves before my eyes: I can see them clearly and I can read them and still everything is farther away than usual.

I read affect theory to comfort myself. In part of a chapter on anxiety, Sianne Ngai discusses the spatial projection involved in the feeling of anxiety, and she discusses thrown objects, and vertigo, and the film of the same name. I find this soothing. A literary perspective on my disorientation. Yet my dizziness is not psychosomatic. The vertigo will last, it seems, until I dislodge the small crystals in my inner ear, or until they dissolve, whichever comes first. No language, no theory will change the position of objects in space: there is a dance I have to perform assiduously, turning and lying down and turning over and sitting up. Detachment mechanics.

After the vertigo dissipates, I remember that I have fallen on my left hip. A bruise has swollen, lasts for three weeks. I go home to California. I notice the bruise in the little square mirror I leave on my headboard. Not for its reflection of me but for light. Mirrors that refract brightness.

A month afterwards, I slip down half a flight of stairs, land on the same hip. Yet the fracture I worry over is the one in my foot, the one I thought was a bruise. Months later, my friend from New Zealand explains that our bodies fall according to imbalances that are already present. Falling just makes the invisible more visible.

Then I am in the same spaces and stop recording their details. The silk rugs beneath my feet, the velvet beneath my hands. Everything verdant, everything lost in books. The breeze quickens and sharpens at once. You are hours ahead of me, and the hours spread as in a pond, without incident.

Eventually, the pain in my foot subsides. I walk through the dark, make coffee as my cat slips around my ankles, drive friends to the airport, listen to birds, sleep through the darkness, through the light, go for other walks.

INTERVIEW BANI ABIDI

In the three-minute short *Mangoes* (1999) by Berlin-based Pakistani artist Bani Abidi, two women sit next to each other on a white table, each with a mango on a plate in front of them. Both women are played by Abidi. One character has her hair up in a bun, the other loose and flowing down her shoulders. One is Indian, the other Pakistani, both members of the diaspora of an unspecified country. They slice and pull open their respective mangoes, sucking the flesh clean off the skin. The fruit is an oblique symbol of their melancholy and wistful nationalism. As they eat, they speak about the mango-eating traditions of both nation states, but the conversation soon grows strained as they compete over which has more varieties of mango. It's an arbitrary, quasi-comic tension, but perfectly representative of the sentiments of animosity and hostility that have ruled Indian and Pakistani relations for over seven decades since the Partition of the subcontinent in 1947. Much of Indian/Pakistani difference is mediated and maintained by trivial, and often untrue, distinctions. But it is the myth of this difference that reinforces the border and fuels its continuing clashes. Abidi uses the mango to disturb the border relation: while the Indo-Pak border is a physical site of military presence, surveillance and catastrophe, it is also something a bit more intangible, something conjured and retained in the imagination of those that inhabit it.

Abidi is interested in the ways that we – more specifically, those of us from previously colonised countries with violent histories – internalise the grand rhetorics of nationalism. In film, drawing and installation works we watch as Abidi's fictional characters eat fruit, wait in line for visa appointments with plastic folders in their laps, or try and break Guinness book-style records on behalf of nation states through pompous, theatrical gestures. Abidi takes a wry, incisive look at these figures and how they perform their patriotism. She's also very funny, which is rare and thrilling, her humour producing an effective mechanism with which to undo the preciousness that surrounds political posturing.
SKYE ARUNDHATI THOMAS

THE WHITE REVIEW Your new work *The Reassuring Hand Gestures of Big Men, Small Men, All Men* (2021) is a series of re-photographed close-ups of the gestures made by political leaders of the twentieth century. There's Robert Mugabe, Che Guevara, Narendra Modi, Vladimir Putin. There are raised fists, pointed fingers, salutes and victory signs. Given how war has taken over our newsfeeds with the Russian invasion of Ukraine, it feels like this is a fitting time to talk about the pageantry of state leaders. What led you here?

BANI ABIDI The work is my way of looking closely at the body language of politicking. It began when we were all feeling trapped by Covid. Everyone had to look up to their governments for direction on how to deal with the pandemic. I was paying close attention to how state leaders acted. There were the patriarchs, of course, like Modi and Boris Johnson, but there was also Jacinda Ardern, who sat in her sweatpants on her bed and asked everyone to stay calm. In the middle of giving her address, she called out to her child to go to bed. I had never witnessed anything like that before: an egalitarian relationship with somebody who governs. As an artist and a mother, I have to constantly multitask. When I saw how Ardern conducted national televised addresses from home in between parenting, I was struck by how different things *could* be. I became preoccupied with public addresses by different leaders and started looking through them historically.

The work is a series of big and small images in three different sizes, and they cluster together according to gesture. There's the face, the finger, the victory sign, the salute and the wave. There's a single image of Muhammad Zia-ul-Haq's praying hands. I started looking at photographs taken throughout the twentieth century. First, I thought I would just do Pakistan because there are so many characters in our political landscape to work with, so many people and egos and personalities and testosterone. The whole history is so dark, and it's run by these male figures. I started with Zia-ul-Haq, which is our own personal trauma. And then it just grew, I went back to other presidents and prime ministers of Pakistan: Ayub Khan, Yahya Khan, Pervez Musharraf, Imran Khan. I slowly edged out and realised I wanted to do the whole world. I was looking at a meeting between Zia-ul-Haq and Ronald Reagan, and began following the route of their encounters – before I knew it, everyone was involved. I started categorising the gestures of these moments and their hollowness. The reprimanding raised finger, for instance, is repeated so many times that it loses its effect completely. Everyone is doing it. It becomes bogus: a learned act passed from one leader to another.

TWR On a surface level the gestures are meant to imply that we are in the 'safe hands' of political leadership, but you show the opposite – how they can be ominous, terrifying, a little bit silly. The work is also about a certain type of masculinity, perhaps one that is similarly both terrifying and silly.

BA The work isn't exactly about single ideologies. Its objective is to track men across a spectrum of ideologies. When I was watching the footage of the leaders' meetings, I was also thinking about the laughter that happens in these meetings, the kind of jokes they crack and what's being hinted at through them. Those moments are so tense, so charged – a lot is at stake.

I am keen to show how these gestures and performances betray the vulnerability and the traps of masculinity. Mine is not always a scathing critique, but a more subtle one. These politicians and people oppressively dominate our lives and dictate our futures, but they are also caught in their own traps. If I think about our female leaders, whether Benazir Bhutto or Indira Gandhi, they came into power as continuations of the dynasties of their fathers, of men. In the way the popular imagination dealt with them, it was as though they played the role of 'the son' in these dynasties, and, of course, they were never enough.

So yes, I keep returning to masculinity in my work. There is the series of drawings, *The Man Who... after Ilya Kabakov's 'The man who flew into space from his apartment'* (2015), I made about men who've tried to break Guinness book-style records. I fictionalise them: there's 'The man who clapped for 97 hours' or 'The man who could split a hair'. To me, these are men who, without fully realising it, are part of the nationalist project, this strange drive to be in *The Guinness Book of World Records* under the nation states that they are from. They are completely absorbed in this game of being patriotic, and their actions – like making the biggest lock in the world – put Pakistan or Punjab on the map. These are strange and tragicomic forms of patriotism, and they make these men fascinating and complex as characters. Men personify and occupy a certain kind of public life in South Asia,

so this world is where I like to play out these strange dynamics and try to unravel them.

TWR Your works show us a slow deconstruction of certain types of performative masculinity, and they do so with great humour. This feels important, as humour functions as a form of analysis and critique. Put simply, we are also able to laugh at the thing that we are otherwise wounded by.
BA It's about taking agency. I'm interested in the agency of the people who are doing the laughing. I always think of the Aurat Marches that have been happening in different cities across Pakistan – where women come together and they have very specific manifestos and demands around labour, wages and respect – and the young girls are just so funny. 'Mujhe kya pata tumhare moze kahan hain?', they ask the cameras, 'Why should I know where your socks are?' These statements are so ordinary and domestic, and so familiar. They are indicative of all the small ways in which women come to the service of the men in a household. But these girls are coming out and answering back with jokes and with sarcasm. In public debate, men couldn't deal with the fact these women were being funny. There were so many news TV shows with discussions about the Aurat marches, where the girls' statements were discussed and analysed by men. It really unsettled them.

I think that my motivation is not only to find the moments of humour, but also to identify and point out my solidarity, which is with fellow South Asians, and how we confront power. I'm interested in people who are being subjugated by regulations and pompous behaviours. The art world too is full of characters with a very masculine, expanded sense of self. I, for instance, don't think I am here to make long feature films on very spectacular things. I'm about stepping into the world, silently and with trepidation, not marching out authoritatively. I'm interested in expressing doubt and insecurity. I don't want to appropriate the language of megalomania as a way to exist in this world, as an artist or in the way I live. I think my terms are different. And I want to argue for another way of existing in this world.

The characters I write or make work about are cogs in a system that maybe they don't even believe in. There are compulsions to being part of a nation state, and I try to think through those. When I first conceived of the film *An Unforeseen Situation* (2015) I had just seen a photograph in a newspaper of thousands of empty white chairs arranged in rows in a stadium in Lahore. The University of the Punjab wanted to hold an event with the most amount of people possible singing the national anthem – the seating was for 150,000 people. When I saw the photograph there were no people in it, it was just of the preparation – an image of an empty stadium. I ran with that idea and in my film, I show that no one actually showed up because they haven't been bribed well enough. I propose that as citizens of Pakistan, we would have to be paid to make the effort to arrive at a stadium in order to sing the national anthem. At the end of the film, we see this young boy who – after the event is cancelled – starts training to break his own kind of world record to put Pakistan on the map. He practices breaking walnuts with his head. It's once again an obtuse gesture, but I wanted to deliver a sense of agency to all the people who resisted the call to sing the national anthem. I am very invested in undoing propaganda or the project of 'the patriot', and in the hollow constructs of patriotism. To me, this boy is an individual who takes on the failed project of the entire government. And that's very tragic. I think a lot of the people in my works are tragic characters. Differently, and in a more straightforward way, in *And they died laughing* (2016) and *The man who talked until he disappeared* (2019–2021), I make a series of drawings of activists that the state has deemed to be a threat, many of whom have disappeared, and I try to make a record of them.

TWR Your film *RESERVED* (2006) takes us through the small details that comprise the pageantry of state dignitary motorcades that run through South Asian cities: children in crisp uniforms look bored as they hold up flags, waiting on the pavement outside their school; the police set up barricades, bringing traffic to an indefinite standstill; a reception committee of men in suits pace around anxiously on a red carpet. There's a kind of futility to it – in the film, we never see the motorcade arrive, but watch as people must relent to the fact that the city has come to a total halt.
BA Certain small details stick with me. In *RESERVED*, the small-time politicians of the reception committee keep adjusting their badges on the red carpet. The badges are enormous and decorated with these long ribbons – you can buy them quite cheaply at a street market for 10 rupees, but when these men put on those badges you see

how their chests swell up. The badges, the red carpet, the barricades, the kids and their crumpled flags: these are the sets that are built around political power.

The theatre of the ubiquitous and quotidian moments of a city really draws me in, as do the emotions that are evoked just by watching people. An interesting constraint for me is that I never shoot a film live. South Asian faces and bodies are often treated as objects for photos to be taken of, while the chaos and the colours form a background noise as filmmakers try to capture the texture of a space. I don't want to engage in that type of gaze. I painstakingly recreate moments – like traffic jams or people waiting. I do it fictionally and produce it with permission and with payments. Ultimately, the small detail is what makes me follow a story. The empty chairs, say, or the badges with ribbons. My ability to recreate and fictionalise could come from the fact that I am trained as an object maker and a visual artist – I'm not strictly a filmmaker.

The other day I found an image from my studio archives. I am standing inside of the set that I built for my work *The Address* (2007). A blue curtain hangs behind a long wooden desk, a small painting of Muhammad Ali Jinnah is at one end of the desk and a large cloth flag of Pakistan at the other. It's a replica of a typical backdrop used for presidential speeches. In the prints that comprise the work, I place a floral bouquet on the table but leave the chair empty. I've installed the work in public spaces in Lahore and Sharjah, trying to invite viewers to think about the relationship they have to these kinds of sets, and maybe confront their literal emptiness. The set was sitting in my studio for a long time, and I would have breakfast in front of it, and sometimes just go into it and perform for the camera. I enjoy the control of the stage design and objects, in which I punctuate and mix these desires.

TWR The emptiness of the set in *The Address* is quite moving. Perhaps it's about what we, as viewers, bring into that emptiness. With early works, like *Mangoes*, for instance, you sit with how we hold these nationalisms, and the borders that they imply, in our imaginations.
BA Pakistan's foundation myth is a bit naked and obtuse, it's just over 70 years old. In many ways it's abstract, but in many ways, it's *in* me, and it lives in my mother. A lot of the scripting of the story happened before my eyes, and I've seen many of the stages. For me to imagine a pre-nation state geography is much easier, because that's the geography that my mother inhabited. And her relationship to the border is very simple – whether to travel or not. I think often about how Cyril Radcliffe came in and flew over the Indian subcontinent in a small Dakota military aircraft, and through this kind of haphazard dabbling in the landscape, he drew the line to divide it up. Men are not only writing our histories but literally drawing up the lines that we occupy.

I've been thinking about revisiting some of those early works, like *Mangoes*, but writing them in a fictional landscape around the border. It would be a post-nation situation where the borders are still there, but they are no longer functional, they are ruins. And in this new, no-border landscape people can commute again. In this new world, people talk about what we experience today – visas and surveillance and restrictions – as though they are from a bygone past. I find that the border is such a rich thing to extract from. I am interested in trying to look at the border as something that has happened and finished, rather than something that we are, and continue to be, defined by.

TWR I like this idea of using the border as the point at which we extract something, a ruin that is ready for fresh rewritings. Borders are starting to more aggressively define us with the rise of the right wing, and it feels important to resist them.
BA Some nights I wake up thinking that it's unforgivable that there are not more of us who are anti-border, and that we don't actively oppose it. And given the hideousness with which India is trying to erase Islam from both its history and present, it's all the more important that we remember that the border is so young. As people of the subcontinent, our imagination is so much closer to the rhetoric of the border. It's interesting that our nation states are so faltering and so young, their clumsiness is less finely tuned than Western nation states. It's precisely because the making of this border is so recent that we have to move to other forums to oppose it. And this opposition must be a part of a bigger intellectual movement that reminds everyone how young the Indo-Pak border is. As people who have been historically formed through each other, it's shocking that we are so ready to accept this strange and abstract hatred towards each other. My son is Hindu, Muslim, Pakistani, Indian, and everyone says how he's my biggest art project. We bring him up to see both

religions as legitimate, as beautiful, as expansive, and also as problematic. He's had the privilege of going to Delhi, Calcutta and Karachi regularly. His idea and experience of South Asia are exactly how I wish mine could be.

And I feel quite intensely about this. My friend the filmmaker Priya Sen and I conducted a workshop with Experimenter gallery in Calcutta. Called *In search of new names* (2021), it brought together 18 Pakistanis and Indians from 12 different cities. We located each other on Google Maps and took each other for neighbourhood walks. It was a simple premise, about introducing a geography and where everyone's homes were. It was emotional – we were all so sentimental.

TWR A friend of mine often tells me an anecdote about going to the Wagah border in the early 1980s and hearing the prayers from the Golden Temple while standing at its edge. It's a blurry border.

BA The border isn't the only injustice, it's also everything that we've been taught about it. In Manan Ahmed Asif's *The Loss of Hindustan: The Invention of India* (2020) he writes about the making of this history that we've inherited, which is primarily written by British historians. In *A Book of Conquest: The Chachnama and Muslim Origins in South Asia* (2016) he takes us to thirteenth-century South Asia and what cosmopolitanism in the subcontinent was like then. I'm just really struck by the amnesia, how quickly we have forgotten our own history. And that amnesia is so important for political control. Nation states rely on this amnesia: they want to control the memory of what we used to be.

Recently I went to the Christian graveyard in Karachi. I'd never been there before. It's in the centre of the city and was set up by the British. It shows the whole gamut of Christian ethnicities in Karachi, pre-Partition and all through the twentieth century. There were priests from Mangalore, Punjabi Christians, Chinese Christians, Bengali Christians. All these converts, along with Goans and British people, are buried there. There was such an abundance of different last names, and origins of where they were born, but they're all buried in Karachi. I had a moment of a material connection with how the soil I was walking on was the bones of these people. And that's what Karachi is – it's the material reality of those who have lived there before.

TWR This multiculturalism is key to understanding what we have inherited in the form of these nation states. In *The Dawn of Everything* (2021), David Graeber and David Wengrow show how early history was always diverse and defined by migration and movement. Pre-modern societies were structured around a flux, they were never static. There was a dense internationalism in pre-colonial societies, which was erased so that the colony could present itself as a modernising force. Kashmir is a great example. Even the language, Kashmiri, carries these incredible traces – it's so hybrid, it's Urdu but also a little bit Persian, a little Afghani, a little Arabic.

BA All of the languages of the subcontinent are like this, they are the culmination of so much difference and movement. It's astounding that we're so brainwashed not to appreciate the very, very complex effects that our history has been able to hold and process. I come from a multi-religious, multi-lingual society. I'm very aware that when Pakistan got created everyone had to learn Urdu, it forcibly became a national language, and my use of language is a direct result of this fact. But it was an injustice. Because there were hundreds of languages in use, and so many of them still are, and people find ways to get by. Europeans are rarely able to comprehend the level of diversity that we have always taken as part of our lives, that we negotiate every day. We embody a cosmopolitanism that Western constructs don't even begin to grapple with. And that's what is infuriating. As previously colonised subjects, we are still trying to prove ourselves to the world, or show how our knowledge of the world is so vast. Still, the greatest tragedy is in our own understanding of ourselves, that's where we need to put in the work, because that's the real grandeur of where we come from.

S.A.T.,
March 2022

WORKS

PLATES

XIV–XV	*Anthems*, 2000
XVI	*RESERVED*, 2006
XVII	*Mangoes*, 2000
XVIII–XIX	*Karachi Series I*, 2009
XX	*The Reassuring Hand Gestures of Big Men, Small Men, All Men*, 2021
XXI–XXII	*The Ghost of Mohammad Bin Qasim*, 2006
XXIII–XXIV	*The Boy Who Got Tired of Posing*, 2006
XXV	*...so he starts singing*, 2000

Jerry Fernandez – 7:45 pm, 21st August 2008, Ramadan, Karachi

XVIII

Chandra Acharya – 7:50 pm, 30 August 2008, Ramadan, Karachi

XIX

Jimmy's

Jimmy's

THE COURT CASE
GINA APOSTOL

FICTION

It's no surprise that in a country that exists on the argument of conquest, laws about the possession of land are murky. On All Souls' Day, how many Filipino families, bourgeois or not, but mostly bourgeois, light wax candles on the plots of the dead only to rant on and on about some long-lost, stolen piece of land?

The evidence of the existence of La Tercera is tenuous but not mythical.

Who knows where that land was – her hometown Salogó, or my city Tacloban, in Leyte, where she brought me up, or her burnished Manila, far-off and caught in the haze of its history and our illusions?

Of my mom's lawsuit over her intestate Lolo Paco's lands, I remember the outlines like vague crisscross shades produced by the nighttime gauze of mosquito nets, that shadow-roof of my childhood – though all my life my mother kept italicising the facts.

Lolo Paco had no will, he had no child, when he died who should inherit his properties but us – the children of his blood, of his only brother, Jorge Delgado y Blumfeld, my Papá's papa: your Lolo Jote! It should all have gone to us – the Delgados of Salogó!

I grew up with the incoherent details of Lolo Paco's life and times while I scraped out burnt rice at the bottom of the kaldero or slapped at bugs that got through the moskitero's gauze no matter how firmly my mom tucked me into bed. Minor acts or objects would set her off. Once, the particular lustre that day of her favourite – fresh hipon – the smelliest stuff on the table, I thought, though I was too polite and in awe of my mom's appetite to mention it – reminded her how much her Lolo Paco had loved the hipon of Salogó, which he called bagoong, and among the bundles that her father, Mister Honourable Mayor Francisco Delgado III, would take on his annual pilgrimage to her Lolo Paco at Greenhills in Manila were those jars of purple sheen, Salogó's hipon, wrapped in multiple layers of banig, so that if they spilled, the hipon smell would not ruin her father's clothes. Lolo Paco also loved danggit, dried squid, and all the most awful kinds of budo-bulad – basically, he had a taste for smelly things – and I see my grandfather, the Honourable Mayor, also the town's old music teacher, lugging the weight of his bounty from Salogó's dust to Tacloban's gangplanks to Manila's piers. I kept imagining, with a sense of my own humiliation, this proud man, my mom's Papá, arriving at his rich uncle the Senator's doorstep – stooped, sweating, and reeking of pusit – to deliver his homage of fermented shrimp fry and salted fish, the province's bounty before Manila's gods.

Every year, when she had to pay the school bills to the Divine Word Missionary School of Tacloban for my dumb education, my mom mentioned how *she* could have gone to high school in Manila, you know – and not just college at Far Eastern University in Sampaloc! Anyway, she never graduated from FEU because she refused to wear sneakers during P.E., but that's another story. If only her Papá had allowed her to live with childless Lolo Paco and his mean wife, Lola Chedeng, in Manila when he asked to take her – he wanted to adopt her when she was just a baby! Ah, instead, who got to be the child growing up at the Senator's dinner table?

Oh, that cripple, that orphan – that Madam Charity Breton!

That poliomyelitic!

'Oh my goodness, inday, how could she call herself a Delgado – she could not even walk! Just a polio victim. An American with no name, left behind by a G.I., a ward of the orphanage, a no-name cripple in the Gotas de Leche! Ay leche, *that* Gotas de Leche!'

And at that last word, that unholy *leche!*, my mom started laughing.

I can see my mom, lifting her head up from her usual occupations, pasting weeds on cloth canvasses or gluing baubles on homemade lampshades, her veined finger, sticky with her pastes, raised to her lips, laughing.

'Oh, inday, do not say that word *leche*, it is bad!'

And then she crossed herself because she had said the word again.

Listening to the way her holiness mixed with her prejudice, this troubling jumble of ethics that as a child I could not pinpoint as a portion of my malady, only that I felt it, I felt my mind skip over my unease the way I always moved the fish's eye, prominent in my mom's beloved tinola, to make it look away from me.

'Ah, inday, what would my life have been, if not for that orphan who took all of Lolo Paco's lands, that greedy woman, your Auntie Charity Breton!'

'Well, ma,' I said, 'if you had grown up at Lolo Paco's table, I think you would still be eating too much hipon and budo-bulad!'

It was the woman in the wheelchair, the cripple of Gotas de Leche, Auntie Charity Breton, who, in my mom's telling of the famous court case, won La Tercera. The wonders of Lolo Paco's money and the marvels of his generosity toward his poor relations in Salogó were equal parts torment and trophy for my mother. I once went with her to a musty government office in Manila – these were the times of her furious travelling, her flights from Tacloban, to become an 'artist-businesswoman, an inventor!' She used to abandon us to the mercies of Mana Marga, her all-around servant and loyal clone, but at the time I was already in college, and she arrived at my dorm with her frames.

To my shame I called them that – her frames – canvases of stretched katsa or velvet on which she arranged wildflowers and vagrant grasses into intricate spirals of ineffable symmetry, using her own made-up paste to stick them into place (the glue, another invention, was called *Adina EVERLASTING!*™). She was dishevelled but glamorous, wearing fuchsia high heels that almost matched her lipstick and eyeshade. On any other woman, that pink coordination could be fatal. Instead, my mom's boldness persuaded people her choices were correct. Even Salome, the malevolent night guard of Kamia Residence Hall, looked at the apparition of Adina an guapa, dressed in blue georgette, with the tact one offers movie stars or madwomen. Salome used to scare me with her dagger eyes if I arrived two minutes after curfew. But with her gun in her holster and pudgy in her tight uniform, Salome helped my mom carry her frames down to the basement, to Room B-12, where my two roommates, an accounting major

from Dagupan whose name I've forgotten, and Aurora, an anorexic neat-freak Ilongga studying for the bar in between being beaten up by her law-school boyfriend, were fortunately away. It was a few weeks before exams. Adina an guapa slept that night in my dorm. I did not. I was cramming Part II of *Don Quixote* for my finals in Medieval and Renaissance Lit, and I was groggy from that intense inertia and my resentment of my mom's sudden intrusion and my guilt that is the squire, the Sancho Panza of my resentment.

I sat up on the edge of Aurora's empty, well-made bed, listening to my mom snore, wondering where she had been, when had she arrived in the city, what she had been doing away from home, away from my brother Adino, sweet Adino, who was still in school, a child in Tacloban. She snored with a profound rattling, a heaving sound that made the cheap, metallic bed tremble, as if her entire body, her bones and her blood, her perfect heart and her healthy lungs, were unloading a misplaced weight, who knows who laid it, which in turn she was offloading onto me, onto my bed, onto my dorm room at midnight, onto the haunted, post-war spaces of Kamia Residence Hall, onto my placid reading life with *Sir Gawain and the Green Knight*, Proust, and *The Tale of Genji*, my life of books by which I had escaped from Tacloban, though I knew the sounds of my mother, her intakes of breath from her lungs that turned out to be not as perfect as she thought, would never leave me, no matter how far I fled.

I woke up to my mother in my arms, her moist smell of armpit and Pond's Cold Cream, the uncomfortable fabric of humid, filmy georgette, a cloth I hate because it does not breathe, stuck to my sweating palms. My face was wet, as if I had been crying, but it was only the sensation from the hollow of my mother's neck, phantom tears from her clavicle soaking her dress, the cloth soaking up the sweat.

At the movement of my hand across her shoulder, she bolted straight up, and she said – 'Is it Monday, inday, is it Monday?'

And it was on that Monday, a time in late February or early March (I measured time then by exams), that she took me to see my namesake.

Auntie Charity Breton.

She needed me to help carry her frames. One was three feet by four, a gleaming glass object with what looked like gold filigree at its centre, and I held it up on the four jeepney rides as if it were my doppelganger, the length of my seated body, held arm's length, tipped toward my knees. I could see my face in its dark, obscure mirror, veined by the grasses of my mother's gathering, with gold bunched at my chin like a stain or a puddle. How many hours had I spent in childhood watching my mother among weeds by the road, bent over and intent above wild grass, a high-heeled, hair-sprayed hunter-gatherer? From Diliman through Quezon Avenue, past Sampaloc where my mother did not go to high school, through the rotting, capiz-shelled homes of Malate toward Roxas Boulevard, I stared at the black canvas of my mother's labour. It never occurred to me then to call it what it was. Our destination, a low warren of buildings

backing into Manila Bay, turned out to be an outpost of the Department of Foreign Affairs.

She gave the guard a name I recognised – it was my own.

Rosario.

The consul, as the guard called her, was in. We had to leave the frames with the guard, sharp objects were not allowed in the bureaucratic halls, plus, the guard said, they look heavy, and I imagined the guard thinking, staring at our diesel-grimed selves and our burdens – how the hell did you carry those through the streets of Manila? In the government offices, my mother's beauty did not hold sway as it did in less malignant places. People looked chained to their desks, uniformed in funereal beige and wearing that candid smirk of official regard. No one looked expectant to see us. We passed through the cracked marble that paved the path to the consular dens, I watched out for my mother in her flowing blue dress (now I know why she wore georgette: it does not wrinkle, and in the morning she never looks as if she had been stranded overnight, caught far away from her city, without shelter, and bamboozling her way into a security guard's pity and a daughter's pride, to snore the night away without redress in unconquerable clothes in her child's college dorm), I felt my own figure diminishing, sliding away from my concept of myself, twisting along on pocked and antique floors without knowledge of my purpose through the dark cubicles of that Pasay office.

I was only a child, fearful and distressed about her mother.

How she carried herself, Adina an guapa, her bouffant hairdo and bright eyes. She had gone through her rituals even at Kamia, her steaming of her face in the morning, her scrubbing and scrubbing off of the dirt and the grime and the terror of the city I now called home, with an unfamiliar labakara that she found, maybe Aurora's, her application of Pond's Cold Cream, missing only her facial potage of pipino, sometimes pomelo, her dabbing of fuchsia lipstick and mauve eyeshadow, her slathering of her other translucent invented potion onto her feet, her calves, her knees – a lotion of her own she called *Adina PANTY-LESS STOCKINGS!*™ – her upright and sturdy, but also somehow frail and frightening, figure in her pink high heels. I heard them clack, clack, clack before me on the grim marble floor of the Department of Foreign Affairs, with its thick Georgian porticoes and the immortal stains of its cold halls. My mother never deigned to look down when she walked, her head held high as if by looking down she would misrepresent herself, fail the image in her mind somehow, so I looked down to make sure that my mother did not fall into some ancient gap.

I have shielded myself with books against the ugly reality of my day-to-day, and I remember that moment in Pasay because it seemed as I walked through the dusty, American-era corridors behind my mother that that partition between my learning and my life, so painstakingly set up in my college days in Diliman, had all of a sudden broken down. I was supposed to be at school, exposing Don Quixote to his illusions in harsh, critical examinations. But I was

back to being seven, dumped in a foreign country, which was in fact my own, and tasked to learn a strange tongue, which was in fact my primal one, and my only lifeline was my mom's self-image, her brave concept of herself in the face of her disasters. She knocked on the door that said, *Rosario Delgado*, and then without waiting she opened it. I realised in that gesture, that sure twist of the handle, that my mother had done this before. She knew exactly where she was going; she enacted a series of gestures with that terrifying optimism, her belief in an outcome as if it had already happened.

I stood beside her, with my feeling of a wreck, malnourished, sweating and sleep-deprived.

'Auntie Charity,' my mom said.

I did not know if she was addressing me or strangers in the room.

I was used to my confusion in my mother's presence, my sense that she was both protecting and careless, proud of my presence and also heedless of her action's effects. So I was not sure if she was introducing me to the phantom at the end of the room, or if she was warning it of her arrival.

Across from us at a massive desk, I saw it look up, the ghoul behind the name from my childhood.

Auntie Charity Breton.

So this was who she was.

A grey body in a wheelchair with insensible blue eyes.

I was surprised she was human.

It was the first and last time I saw her.

It looked up from some papers she was pretending to peruse. I had to adjust my lens to reconcile the poor lame ogre of the legendary court case with this ordinary sight of a basic government official with powdered face and scalloped lace collars, on the edge of retirement probably much awaited by her subordinates. I looked for signs of her Delgado lands and millions, gold on her fingernails and her teeth. Instead, she had traces of what looked like Johnson's Baby Powder on her neck, though her bulbous pearls and giant diamond earrings gave off an obscenity that satisfied me. The mahogany trimmings, the ample dimensions of the dank rooms were clearly appropriate to her privilege: she was a woman used to underlings enacting commands at one glance of her foggy eyes. I imagine, with the spare kindness of my hindsight, that sure, maybe she had risen from the ranks with the normal Manila combination of pedigree and incompetence, pedantry and connections – nothing so out of the ordinary or sublime. Her large face, the bulk of her image, had the fat smoothness of the customarily overfed, not so rare in the heights of bureaucracy, and so the vulgar blankness of lifelong satiety in her features was only somewhat repulsive.

As recognition dawned upon her when her own lens adjusted to the blue and fuchsia figure of my mom, the consul's disorientation was slight.

'Yes?' she asked, with the look of one in the midst of matters of importance she was still deciphering.

'Auntie Charity, it is I.'

It was at that moment that I noted the elegant calligraphy of the wooden nameplate that dominated the front half of her desk.

The Honourable Consul Rosario Breton-Delgado, Ll.B., J.D., Esq.

I realised the absurdity of it, one of the truths arising from my life as a daughter, that there was a past, an abyss between my mother's choices and mine, that I did not know.

Why had my mother named me after this stranger at the heart of her long, historical venom, her *durée* of hatred spanning decades before my time?

I had always thought I had been named after some religious devotion I could not share.

The consul moved her wheelchair backwards from the desk. For a moment I thought she was retreating from our presence, and she had a button she could sound in her unlit room, an issue of alarm. I admired, from the slant of light in the window, the revelation through the day's sunlight of her antique wheelchair's ornate detailing, the carved grisaille of the capiz and the ancient art of enlaced wood-and-wicker that the inlaid capiz framed. The motes of the day gleamed through the graceful ventricles of the chair. She turned so swiftly, expertly on her moveable throne. I did not have the time to register my mother bent toward her lap, the consul's entire body was now before us, in front of her desk and the plaque of her name, a lump of a diplomat dressed in jusi and constructed of base metal and carved wood, and I see my mother now – so long afterward, so many years past that morning in Pasay – in a gesture that my memory cannot bear.

My mom, Adina an guapa, lowered herself before the consul. She took the fat wrist of the woman, the lady's grey flesh the same dirty colour of the halls' long-tended marble, and she lifted the smooth, plump hand of Rosario 'Charity' Breton-Delgado to her forehead.

It was a surprising act of affinity, of formal ancestral reverence, one of those marks of relation that used to move me when I was made to learn it as a child, when I returned to Salogó from America.

Adina an guapa replicated that childhood ritual – lineal hand to bowed forehead – upon that pale ogre, whose response for a transitory moment, I thought, was to stiffen her fingers and withhold, but in fact the woman allowed her hand to be uplifted, her saggy arms an appendage of my disgust as my mother spoke.

'It is I, Adina, your niece. Adina Delgado, daughter of the mayor, Francisco Delgado III, of Salogó. Son of Lolo Paco's brother – Lolo Jote. The Delgados of Leyte. Remember? I called you the other day. So I am here.'

'The Delgados of Leyte?'

'Yes.'

'You still remember me?'

'Yes.'

'You remember what you did?'

'No.'

'You called me a cripple, a woman with no name. Right here. In my office.'

'That was not me. That was my aunt. I am Adina.'

'You called me a demon, a foreign devil.'

'It was my tita. Tia Pachang. Remember? Bonifacia Delgado, your cousin.'

'You called me a usurper, an orphan with no rights, a no-name child of the Gotas de Leche.'

'That was my cousin, the lawyer. Paquito. He is a US immigrant now, in Las Vegas.'

'You called me *leche*,' the woman growled. '*Leche!*'

It was a guttural anguish, the crippling sound, *leche!* I could hear buried in it a doubling of the decades, simultaneous degradations, crisscross of curses in misremembered courtrooms, perhaps nearby, in the dim circuit of the Supreme Court buildings, here, in Manila's arena of officialdom, near U.N. Avenue, what my mom still called Isaac Peral, leading toward Dewey, now Roxas Boulevard – this damned sliver of reclaimed land, with its merry-go-round of naming, that one day must drown into the sea.

For an absurd moment, it seemed, this was what I was heir to, a historical polemic of duelling blood that resided in the body and the tongue.

'What do you want?' the lady said, as if catching herself, as if some absurdity in the situation also occurred to her, and her deep-seated, childish cry was also embarrassing, and not suited to her position, a large-bodied diplomat in the Department of Foreign Affairs.

'Why, I've come to introduce to you my daughter,' my mother said.

I turned in fear to look at the high-pitched sound of my mom, her girlish tone of gladness. It was a gurgling pit in my stomach I was used to, when I heard this voice.

My sense of the world as a feint, the way my mom's voice constructed its own world, and my place in it was not fixed.

The blue-eyed woman glared at me.

My mother, smiling and shiny-eyed, stood beside the wheelchair, arms pointed at me, as if pulling me toward it, the chasm of her glad voice.

'Her name is Rosario. I gave her your name.'

On that day I could see myself stripped of my solidity.

I was a pawn in my mother's games.

She had not come to Manila to visit me at Kamia. I was not a mere bearer of goods on four jeepney rides. I was not named for this obese charlatan, this lame diplomat. I was a trick for this obscene ghost, my fake-tokayo aunt, this cunning woman with my name. But what was the trick for? For what was my mother's game? This woman locked in a wheelchair had lifelong experience in consular, diplomatic traps, she knew a con when it confronted her, she stared at me with my own disgust at my unwanted encounter with this cripple, yes, you're a cripple, I thought, *just a poliomyelitic!*, I hissed in my head at my namesake, this faux-Rosario. *Cripple*, I thought. *That is all you are.*

Leche, I heard in my brain, *leche nga yawa ka dida – ikaw nga gotas de leche!*

Laughter was trembling in my body, shame, hunger and embarrassment. So many of my trips with my mother became some kind of duel with her perceptions, which are part of me, inescapable.

'Come, inday, come to your Auntie Charity, I mean your Lola Charity, she is your great-aunt, the adopted – the ward of the – I mean the daughter of Lolo Paco, remember? The daughter of the senator, my Lolo Paco! Senator Francisco Delgado of the Commonwealth regime!'

'Oh hush,' said the woman, brushing away that past, 'the Commonwealth. We are a Republic now, Adina. And it is so long ago that we were together. Don't you see my diplomatic seal? Why talk about the past as if nothing has changed?'

Momentarily, my mom had that look of disorientation. As if she could not recall their shared past. But the glaze in her eyes was brief.

'Aren't you learning about it, the Commonwealth, in your history lessons, inday? You should learn about him in your history lessons! Lolo Paco – I mean Auntie Charity's – adopted – her father – he was a famous man, inday. An ambassador and a senator! Auntie Charity! My daughter is a student of the university, the University of Diliman!'

Just as I borrow my mother's prejudice, she borrowed my pride. It had been a coup to gain admission, given my morose high school self, to enrol in the state university. By some miracle that did not escape me, I had gained my reprieve from Tacloban through no great achievement. All I did was take a test and pass. But the cliché of maternal pride in the Diliman daughter was something even I could not resist.

I saw the woman's eyes shift.

'The University of the Philippines?' the woman said, considering me from a different angle.

'Yes! She is an English student at the University of Diliman! She is studying to be a scholar, just like her Lolo Paco. Reading so many books, all the time, all the time. Ever since she was a baby! Come, inday, bless! Bless your Auntie Charity – she's a Delgado, like you!'

The woman looked at me, her palms open, daring me to take them.

'That is a good school,' the consul said.

My body is an automaton that does what disturbs it. I feel even now how my pride was demeaning, that bloating sense of my importance at the woman's words. I saw my mother smiling, beaming at my school's intellectual graces that in the future she will not condone. I saw in my mind's eye Adina an guapa's forlorn labour, tipped against the guard's desk in the vestibular limbo of this American construction, my mother's glass frames – her works of art – eliminated from this meeting with the consul though I finally understood they were the point – the reason for my mother's visit to this smug, alien relation. I saw my mother's ploy. It was pitiful. I was here to help sell her art, her treasure to

one more rich woman that she knew. I saw my mother's gambit, her instinct to toss whatever bait she had – in this case, the miserable past that bound them. I saw that the consul pitied her. I saw that the consul's motives for receiving us might be dim even to herself. I saw at my feet the ancient dirt on this marbled hall of the American era that would never come off, no matter how much the uniformed minions of the Department of Foreign Affairs cleaned it. I saw that this woman was surprised that Adina, some dismal relation from a far-off town in a wild place Leyte, had a child who had even managed to get to college.

I felt dizzy, as if I were falling into something, a void. I stepped forward toward the wheelchair. I took the consul's hand. I steadied myself. I took her gross palm, I turned it to its obverse, its veined flatness with its heavy, pink and pointed diamonds aimed toward my forehead, I knew how not to twist the wrist, in that filial way that is the first expertise of children, and I feel the ice of that memory still, of the consul's monstrous flesh on my forehead, her diamond's sharp glass, frozen in my brain, and the figure of my mother standing by, dissolving, like the gold dust in her unsold, banished frames.

EDWARD DOEGAR

POETRY

ON US

Wanting a smoke
We make for the garden

That pebble-dashed
Seven square feet

Walled-in on all sides
Whose flagstones

Turn the eye back up
Through four storeys

Of Soho's intimate floors
To what we must imagine

Is the fresh night air
While down below

The moon's distant trial
We fit together

In an acute corner
Of this communal space

A glitch in the city's plan
Snug as a priest hole

Behind the toilet
And the two-yard bar

We admire the pigeon nets
That serve as our cage

And canopy
A constellation caught

Above us pulses
Its alternating colours

Of Yuletide titillation
Affecting our faces

With a leering green
An orange pallor or the slow-

Slow-red of anticipation
This slight seediness

Is what we come here for
Preferring 'the blue door'

To better places
Cheered by its tepid beer

And paper tablecloths
Its slovenly nonchalance

More belly-flop than dive
And so we find ourselves

Actor and audience
Talking into each other's

Sweet sambuca-breath
With the un-hesitating yes

Of Friday night beginning
To lose its sense

Of purchase on the week
Its purpose

Succeeding any notion of itself
The scale of time

Abandoned with abandon
In thrall

To the abstracting quality
Of *the same again*

Living in that perpetual now
We gibber happily

About how only the right
Word matters

How what counts
Is putting things down

Just as we intended
Finding a way to write

Precisely
What we meant to say

And so we parrot
Our betters believing

That saying things badly
Increases the unhappiness

Of the world
Just so each sentence

Commutes its meaning
Into the general

Verbiage of feeling
While every cigarette beckons

Its successor
One more becoming another

Ideas easing into ideologies
A drink to drinks

To someone asking
For a light

Interrupting us enough
To tune our ear to the excess

Of nearby conversations
The brag and blunder

Of men talking
Their voices all implied elbows

Their egos
Sitting knees-out

In this too-tight space
As someone opposite asks

This isn't a gay bar is it?
And is answered

By a fellow patron
Leaning loomingly close

Who supplies
His own answer for us all

It better not be
And in that slapped-still second

Of call and response
That threat of an answer

I wake up into myself
A thing cut loose

From the we we were
From that I I'd been with you

Whose gaze I now return
Surreptitiously

Suggesting an alternative site
Saying *I'm not sure*

This atmosphere's for me
As if I'd been called upon

For principled
Understatement

For a measured critique
Of the living decor

Just as your defeated *yeah*
Includes

The failure to respond
Adequately and in time

Because it is too late
Already

The elicited laugh
Has subsided to a shared

Conclusion
To everyone getting on

With the evening
They were having before

The wave never crashes
But is simply part

Of the ever-undulating sea
A hatred

Borne as if by nature
This remark unremarkable

As any other oak leaf
On the tree

So consciously uprooted
I follow you out

To continue elsewhere
To go over this slight

Incident
This almost nothing

In the meticulous detail
Of cold sober air

Where Soho luxuriates
In what it has become

The play pen
Of those who can afford

A good night out
And I think how odd it is

To also belong
To that claim of people

Those I can still elect
To like or dislike

But am like
By my being here

While I follow your path
Through the gangs

Of tourists
The after-work committees

And the crawling
Black cabs

In search of a quietness
To contaminate

A public privacy
That finally occurs

When you order two pints
Over a tinsel-trimmed bar

And nod towards
The standing room

By the dartboard
This is your aim then

A debrief
To assuage the burdens

Of shame and guilt
And all this

I implicitly understand
But I need you to start

To say something
I can't

Standing there silently
Has made me duty-bound

To remain so
As though to speak

Would only be to feign
Having spoken up

When it mattered
I didn't

I daren't
I don't

And so you do
Taking the lead again

You say *I should have*
Confronted them

Which I echo
Meaninglessly now

And yet meaning it
And yet meaning it

Differently from you
For your stress conveys

The *should have*
Where mine betrays itself

On the *I*
As if my entire concern

Were myself
My reflection since

Only as deep
As my own image

I touch your arm
To break the surface

Of distance
As if such a gesture

Falling somewhere between
Caress and clutch

Could pass
Through the natural law

Of distinct minds
And let me grasp you

But I cannot know
What you are thinking

What it feels to be
You now

You are altered into a part
Of yourself

Which I cannot presume
To imagine

If imagination is bound
By the leash of good faith

You repeat yourself
I should have

And my echo is as close
As I can be

To the shared first person
That we had been

LET THEM KNOW BY SIGNS
ROSA CAMPBELL
& TAUSHIF KARA

ESSAY

When Kenya was declared a British colony, stories began to circulate across cities and towns that firefighters were sucking the blood of Africans. What they were doing with it, however, remained a topic of debate. Some thought the drained blood was being used to treat weak Europeans suffering from anaemia, while others claimed it was to be converted into capsules and sent to America, where it would cure rare diseases. What was important in these narratives was not necessarily *why* the blood was being taken, or even for whom, but rather *how*, for the 'whites' would 'never let out the secret of what they were doing with the African blood.'[1]

One of the Swahili words for bloodsuckers is *wazimamoto*, which, always deployed in the plural, literally translates as 'the ones who extinguish the fire'. It's unclear when or why firefighters came to be associated with bloodletting, but by the early twentieth century the term had displaced older ones like *mumiani* (translated in one colonial dictionary as 'a fabulous medicine the Europeans prepare, in the opinion of the natives, from the blood of man') as well as *kuchinja*, which referred to the practice of slaughtering animals by cutting their throats and draining the blood. Many began to avoid fire stations and engines, whose blood-red paint and buckets filled with what was allegedly 'water' were always associated with death, destruction and the colonial state. Soon the term shed its incendiary origins altogether and came to mean something closer to vampire. Doctors and hospitals – which, like the fire brigade, represented another alien point of contact with the colonial state's bureaucracy – were equally dreaded. Amina Halli, a woman from Nairobi, recalled in an interview how, in the middle of the night, the *wazimamoto* would 'come into your room very softly and before you knew it they put something in your arm to draw out the blood, and then they would leave you and they would take your blood to the hospital and leave you for dead'. One could not even scream for help, Halli emphasised, because the *wazimamoto* would 'put bandages over your mouth' so that 'you would not wake up', bandages that were not unlike the cloths soaked with chloroform used to anaesthetise hospital patients at the time.[2]

Such vampiric narratives were not limited to the context of Kenya, but as they travelled, their contours and details shifted. In what is now Zimbabwe but was then part of Rhodesia, Catholic missionaries became bloodsuckers.[3] These men of God ostensibly marked their future victims with a secret cross, visible only to Europeans. After their identification and capture, victims would be drained of their blood and left to die on the side of the road or were repurposed into substitutes for pork and beef to be consumed later. In an inversion of a familiar racist trope about the 'natives', rumours began to spread that it was the missionaries who were, in fact, the true cannibals: *bakatolika balaya abantu* (Catholics eat people). After all, it was in *their* strange ritual that bread and wine were ostensibly transformed into the body and blood of a God-man, only to be ingested. It was therefore not unreasonable to suggest that 'Europeans who would eat the flesh and drink the blood of their revered leader', as Thomas Fox-Pitt wrote, a former colonial administrator and secretary of London's Anti-Slavery Society, 'would feel no compunction about eating Africans if they thought it would benefit them'.[4] Indeed, in 1932 the Catholic Monsignor at Chilubula, a region in today's Zambia, received a handwritten letter calling him a 'prince of demons, a serpent, and a sorcerer'. The letter was cordially signed, 'your good roast mutton [in] captivity, imprisonment, and bandages'.[5]

In her study of rumour and bloodsucking in colonial Africa, the historian Luise White argued that these stories do not represent some hangover from archaic pre-colonial superstition that stubbornly refused, like bones in a soup stock, to dissolve into the cold reason of modernity, though that was certainly how colonial administrators and officers saw them. They are also not only potent allegories and metaphors for the everyday violence and exploitation of capitalism, colonialism and racism – though they are of course those, too. For as the history of a term like *wazimamoto* demonstrates, the very idea of the firefighter-cum-vampire, unlike the figure of the witch, was already at its inception malleable and fundamentally modern:

> African vampires came to be talked about differently, in different contexts: they were a synthetic image, a new idiom for new times, constructed in part from ideas about witchcraft and in part from ideas about colonialism. These vampires might move about at night, but they did not go naked: they wore identifiable uniforms and used the equipment of Western medicine. Witches and vampires were different because they operated in different historical contexts.[6]

Wherever these stories came from, what emerges out of White's study is the curious but often overlooked power with which vampire stories were imbued, and the tendency of those rumours to drive history. Within anti-colonial movements in Kenya throughout the 1950s, bloodsucking was a common and powerful charge made against the white settler classes, who were often called mosquitoes. In post-colonial Tanzania, *magabacholi* – the Gujarati-derived term for a large, vicious parasite – was deployed against Indian traders in the Swahili press.

In early colonial India, another dietary rumour brought about one of the most significant anti-colonial revolts of the nineteenth century. In 1856, word spread that the ammunition cartridges on the East India Company's rifles (which had to be bitten in order to be used) had been greased with cow and pig fat. This seemingly insignificant detail, whispered through marketplaces, outraged both the company's Hindu and Muslim soldiers, as the latter group was forbidden from consuming the flesh of swine while the former's religion forbade the slaughter of cows. While the commanding British officers frantically tried to reassure their Indian troops that this was not in fact the case, and that the grease was made entirely from mutton or vegetable fats, many began to defy orders. Their revolt spread across the subcontinent, resulting in the so-called 'Indian Mutiny' of 1857, one of the most violent uprisings against the British Empire. The cartridge question that set it off was aptly named the 'bazaar rumour' because it spread through clandestine means which seemed to escape or at least evade the gaze of the colonial state.

News about the bloody revolt – which Karl Marx dubbed the 'Indian Insurrection' – was dispersed in a similarly oblique way. The account of Muin al-Din Hasan Khan, who described himself as being 'more than a witness' to the events, recorded 'the widespread distribution of chupattis' around markets and neighbourhoods. According to Khan, these otherwise common unleavened flatbreads began to change hands in unconventional and disturbing ways:

> Early one morning the village watchmen of Indraput came and reported that the watchmen of Seraie Faruk Khan had brought him a chupatti (which he showed me) and had instructed him to cook five

similar chupattis, and send them to the five nearest villages of the neighborhood, with orders that each village *chowkider* [watchman] was to make five similar ones for distribution. Each chupatti was to be made of barley and wheat flour, about the size of the palm of a man's hand, and was to weigh two *tolahs*. I was astonished, yet I felt that the statement of the watchman was true, and that there was an importance in an event which undoubtedly created a feeling of great alarm in the native mind throughout Hindustan.[7]

There may have been nothing peculiar about these particular chapatis save for their puzzling uniformity. But the coupling of an entirely ordinary, even banal, staple food with a bizarre and unsettling pattern of circulation seems to have transformed the chapati into something both alarming and ambiguous. A chapati where it did not belong, in the hands of village watchmen, was, as Khan put it, 'an ominous sign'. But a sign of what?

The British, who could not censure a flatbread, had little clue as to what was happening. But one captain, who also witnessed the revolt firsthand and was interviewed as part of a later inquiry, happened to question the revolutionaries directly about what it was they saw in the mysterious chapatis:

> I asked them what they understood in reference to them, and by whom they supposed that they were circulated: they described them to me as being in size and shape like ship biscuits, and believed them to have been distributed by order of Government through the medium of their servants for the purpose of intimating to the people of Hindustan that they should be all compelled to eat the same food: and that was considered as a token, that they would likewise be compelled to embrace one faith, or as they termed it, 'One food and one faith.'[8]

Through greased cartridges the British were understood to have betrayed their lofty claims to religious neutrality, preventing India's many communities from worshipping in peace. Now they were subtly declaring forced conversion to Christianity and an English breakfast for all. The chapatis travelled both as announcements of the duplicity of the coloniser and physical proof of his coming deceits, metabolising into encrypted incitements to revolt against the very colonial future they foretold. They were, it seems, both the medium and the message. The ambiguity of the chapati is encoded in history, too; its 'real' meaning remains unavailable to contemporary academics despite consistent attempts to retrieve it. Maybe it is this fundamental ambiguity, the desire to be in on its secret, that continues to attract, provoke and even irritate scholars, once prompting the literary critic Homi Bhabha to write an essay in which he posed a crucial question: *What is the vertiginous chapati saying to me?*[9]

Colonial officials dismissed rumours of vampires and errant flatbreads as totemic superstitions and irrational beliefs, expecting dissent to take more bureaucratic or banal forms: letters to the editor, petitions to the Crown. And while they may have anticipated dissent to surface as violence, such revolts were usually labelled as 'fanatic' and written off as the 'traditional reaching out for sticks and stones'.[10] They might have looked for strikes and peasant uprisings, but if these were inflected with the religious, they would have dismissed the actors as 'primitive rebels'.[11] But they certainly did not expect roaming chapatis. How could they have? Colonial administrators tended to locate power in the visible and

the evident. If they sought to 'reveal' society and its functions, they did so through colonial tools of statistical gathering like the survey and the census. And so, blindsided by the ability of rumour and conspiracy to aid and even generate political revolt, they missed the point. They overlooked the way concealment itself was crucial to what was dismissed as rumour and conspiracy, a shrouding that accelerated, rather than diluted, its potency.

Indirect modes of communication came long before colonial states, of course. But something about the nature of the colonial state, in particular its outsized need for surveillance and censorship, reopened the realm of the concealed and created new political languages.

When Indian soldiers fighting on behalf of the British during the First World War wrote letters to their family and friends back home, the censor in charge was baffled. He'd been tasked with ensuring that no controversial news of the war was sent back to the colonies, but soon found himself out of a job. The soldiers, already fearing that their letters would be destroyed or defaced by censors, wrote in codes and signs, deliberately obfuscating with poetry and allegory in order to deny the censor the full picture. In 1915, one soldier received the following message from his family in Quetta, a city in today's Pakistan:

> As soon as you see this letter write and let me know all about your affairs and how you are getting on so that I may have consolation. If you are allowed to write then tell me all about the war, if you are not allowed to describe it then let me know by signs.[12]

Along with state censorship, colonial laws against speech and sedition sought to dismiss political discourse but only managed to displace it. Political critique was transposed into the ostensibly apolitical realms of image, myth, symbol and religion, making these into the unanticipated vehicles of what the art historian Christopher Pinney called a 'fugitive politics'.[13]

The censor himself noted to some extent the futility of his own endeavour: 'how almost impossible it is for any censorship of oriental correspondence to be effective as a barrier.' 'Orientals', the censor continued, 'excel in the art of conveying information without saying anything definite.'[14]

*

Encoded and steeped in bizarre allegory, conspiratorial thinking today is likewise seen as both irrational and dangerous, as outside the realm of 'real' politics. It is usually assumed that such fictions prey on ignorance and exploit the weak, who are far too stupid to understand what is really going on. Yet with their assertive claims to illumination and revelation, conspiracy theories seem to preempt this criticism. Today's conspiracy theories ripple plentifully with facts, knowledge and their own kind of reason; they make lofty but categorical connections across time and space and offer clear prophecies of the world to come. Contemporary conspiracy theories, then, may not be about a lack of adequate information, or a lack of access to it, but an excess of it, and a sense that all this complex information – from arbitrary coincidences to high politics – is somehow secretly connected.

This is different from before; the *wazimamoto* of the twenty-first century seem to be everywhere, all the time, listening to your phone calls and reading your messages, draining your blood without even making a

mark. Everything is paranoically connected, as in the meme of the actor Charlie Day with the noticeboard, a crazed look in his eye, lost in tangles of string.

All conspiracy theories – from the bloodsucking *wazimamoto* to the Illuminati – tend to begin with the idea that something unspeakable has been hidden from view. They assume the existence of a grand secret and then traffic in its revelation. As with the stories of bloodsucking, conspiracies are often far more concerned with the *how* rather than the *why* and obsess over deciphering the ways deliberate concealment has taken place. Sometimes conspiracies gain power from taking a spectacular, public, political event – 9/11, the assassination of JFK, the Iranian revolution of 1979, the moon landings – and reveal that they were in some way fake or staged. On other occasions, they take something mundane and ubiquitous, and so profoundly democratic – food, for example – and pervert it with its imagined opposite. In both instances, what is 'revealed' is a betrayal hidden in plain sight. The Washington DC pizza establishment implicated in one of the past decade's most perplexing claims provides a toothsome example of the latter.

Comet Ping Pong, an innocuous suburban restaurant awarded two and a half stars out of four by the *Washington Post*, is central to the popular conspiracy theory known as 'Pizzagate'. This theory began in 2016, after the personal email account of the chair of Hillary Clinton's election campaign was hacked, and the emails were published in full by WikiLeaks. Initially they did not seem to reveal very much, besides Clinton writing to her aide Huma Abedin, 'Should we be bad? Should we get a crème brulee? Let's split a crème brulee!'[15] But those sympathetic to the alt-right, as well as conservative journalists, felt things were not as they seemed. They pored over the emails and concluded that they were in fact written in a complex code. References to pizza and pizza restaurants were not read as banal after-work plans for Clinton's staffers but evidence of a global child paedophile ring in which the Democratic Party was deeply involved. Comet Ping Pong was at the centre of this terrible secret, described in an early and since deleted Reddit post as a 'disturbing hub of coincidences'.[16] Frightened children were apparently kept trapped in the restaurant's basement, where 'elites' like Clinton would prey on their 'adrenochrome-rich' blood in order to become immortal. Its 'bizarrely polarized' online reviews, observed Redditors, offered clear proof of the plot, while its staff were accused of 'making semi-overt, semi-tongue-in-cheek, and semi-sarcastic inferences towards sex with minors'.[17] Even former employees, who were now artists, had produced artwork that was 'nothing but cultish imagery of disembodiment, blood, beheadings, sex, and of course pizza'.[18] Inspired by Pizzagate, Edgar Madison Welch from North Carolina drove to Comet Ping Pong in December of that year and, after texting his girlfriend several Bible verses from his Toyota Prius, opened fire in the restaurant. No one was hurt, and Welch was sentenced to four years in prison, he got out in early 2021.[19]

Pizzagate is the germ out of which the more popular conspiracy theory and alt-right social movement QAnon developed. The latter's appeal is often linked to our moment of intense disappointment with the failed promises of liberal democracy and free-market capitalism. A critique of neoliberalism is indeed palpable in QAnon's manifesto, *Invitation to the Great Awakening* (2019), written by supporters of Q, both anonymous and named. Instead of low taxes for the rich and social mobility for the poor, 'The world collapsed into darkness [...] Destroyed factories, declining job numbers, sicker people, opioids, destruction of Iraq, Syria and Yemen

with pointless war [...] poverty and genocide'.²⁰ But putting the appeal of QAnon down to a subtle critique of capitalism is akin to seeing the parasitic *wazimamoto* as a clear metaphor for colonialism. Certainly it was, but this is only half the story. That capitalism is in crisis is not the only thing the vertiginous pizza is telling us.

Part of the appeal of QAnon lies in the group's constant claims of 'truth' and 'revelation', its trafficking in secrets and codes. As the manifesto declares, the reason for global degradation was not systemic or bureaucratic but due to a 'cabal', who 'ascended to the top of the banking system, to the oval office, to the Vatican, to the crown', as well as agricultural and pharmaceutical companies. The 'cabal' 'deliberately weakened us [...] good people [who] just want to get married [...] and enjoy their liberty' in ways that 'would turn your stomach'.²¹ This conspiracy theory is resolutely anti-Semitic, relying on tropes present in many historic and contemporary conspiracy theories of a Jewish 'cabal' and of blood libel, where Jewish people were falsely accused and persecuted for murdering non-Jews so they could use their blood ritualistically. But followers of QAnon also believe that the elites who control the world have the power to cover up a huge, transnational paedophile ring. As Lori Colley, a 'blogger, researcher and wife', outlined in her piece in the QAnon manifesto titled 'The Day I Knew Q Wasn't a Hoax': 'we have been lied to by the people we trust the most.'²²

Followers of QAnon devote hours to decoding anonymous, cryptic messages supposedly left by a man code-named Q on 8chan, a message board favoured by the alt-right and popular amongst white supremacists and neo-Nazis. Q, according to believers, is an anonymous source. He is likely, the manifesto declares, 'Military Intelligence with a close connection to the White House' and a direct link to Donald Trump.²³ Q's messages include strings of numbers (could they be Bible verses?) and motivational patriotic phrases such as 'You, the PEOPLE, have ALL the POWER. You simply forgot how to PLAY [sic].'²⁴ These messages, the manifesto suggests, 'have been cryptic, but at the same time insightful and full of foresight.'²⁵ For believers, it is up to 'the brilliance of our serious decoders to help us see what's there that we didn't know about'.²⁶ These include the likes of Jake Angeli, the self-proclaimed 'QAnon shaman' who came dressed in a distinctive horned fur hat and face paint to the Capitol attack.

The growing popularity of QAnon encouraged Trump, its hero, to play up to it. On 29 January 2018, the night before Trump's state of the union speech, a user on 8chan requested that Trump work the phrase 'tip top' into the speech – as evidence of Q's connection to the president. When Trump failed to do this, QAnon supporters figured it must have been because the request came in too late. Three months later, however, Trump included the phrase when he addressed the nation on Easter Sunday, accompanied by Melania and a human-sized Easter Bunny: 'We keep the White House in tip-top shape, we sometimes call it tippy-top shape.' To QAnon devotees this seemed a clear signal from Trump of the supposed veracity of the conspiracy, while to others this was not legible as anything more than wacky poetics from the man who brought the world 'covfefe'.

*

One year prior to Pizzagate, the French psychoanalyst Anne Dufourmantelle suggested that paranoid conspiracy theories would

continue to grow in popularity because they exploited a desire for secrecy inherent to modern life. 'Paranoia', she wrote, 'is obsessed with the secret: It idolizes it (for itself) as much as it hates it (in others).'[27] In the case of Pizzagate and its heirs, believers loathe that secrets have been kept from them, but they are also seduced by the idea that they have cracked the code and so hold a secret themselves. Initiates spend their lives online, poring over emails and encrypted messages. Colley reports that it is 'slow, but intriguing and fun... we wait for clues and put the pieces together... helping people wake up, and remaining p-a-t-i-e-n-t.'[28] They bond and become closer over the idea of a shared secret, which suspends otherwise disparate elements and fragments in a delicate equilibrium. Like mozzarella cheese.

The notion that secrecy is a fundamental and necessary part of social life was articulated by the German sociologist Georg Simmel, who also found the spread of secret societies during his lifetime to be uncomfortably out of step with the zeitgeist of equality that was popular in the late nineteenth century. Like our own new millennium, the *fin de siècle* was defined by unprecedented access to knowledge and a new feeling of connectivity, particularly due to innovations like the telegraph, camera and telephone. In this context, the renewed popularity of underground, secret groups like the Freemasons appeared anachronistic and curiously anti-modern to Simmel. But he soon realised that the secrecy they relied upon and trafficked in was in fact an abundant theme across history, and it was the modern obsession with transparency and visibility that was the true anomaly.

In his classic essay 'The Sociology of Secrecy and of Secret Societies' (1906), Simmel claimed that the function of secrecy was that it enabled crucial concepts like trust, confidence and unity to emerge, making 'the secret' itself into a kind of sociological necessity.[29] While we might imagine secrets to be divisive or isolating, in reality they tend to unify and hold groups together. Simmel also noticed that members of secret societies tended to place authority in gut feelings of trust and sincerity, and in flushes of affect that would otherwise evade verification. Their need for secrecy compelled them towards a charismatic authority or totalising framework to make sense of it all. Secrecy and concealment also assumed the existence of an inner life that was invisible to the watchful eye of the state or that of the church and its orthodoxy, and so immune to surveillance, persecution and censorship.

For Simmel, modernity brought with it the urgent and widespread desire to unveil the concealed and to name the indeterminate. To reverse the lie or reveal the secret had become a democratic obsession. We ought to draw the curtains on all dusty rooms because as Supreme Court Justice Louis Brandeis declared in 1913, 'sunlight is the best disinfectant and electric light the most efficient policeman.'[30] Living together in a democracy requires, as we often hear, complete transparency, while the contemporary focus on visibility – as well as the celebration of the 'leak' as a necessary site of politics and the 'dox' as one of its most notorious anarchic manifestations – is, in a way, the logical conclusion to this modern need to unveil. By now we have all but disposed of that old canard called privacy, too, with Mark Zuckerberg himself calling it an anachronism that young people didn't really care about anyway (a 'social norm' that has simply 'evolved over time'). Today secrecy is not only politically nefarious and increasingly impossible but also totally *undesirable* for many people, who constantly seek to make public all aspects of a once private life.

Of conspiracies, Simmel might have said that they too offer their believers a unique sense that they are in on a secret at a time where none are left to be found. Like rumours of unlikely vampires and mysterious chapatis, they seek to evade the surveillant gaze of the state as well as the watchful corporation, leaving plenty of room for imagination and an inner life. Perhaps the only thing more seductive than a world based on secrets, is a sense that you (you!) might be the one to decode them.

1 Anyango Mahondo, interviewed by Luise White, cited in *Speaking with Vampires: Rumor and History in Colonial Africa* (2000), p. 106.
2 Amina Halli, interviewed by Luise White, cited in *Speaking with Vampires*, p. 106.
3 Until 1979, Rhodesia was a British colony named after the notorious Cecil Rhodes, whose statue continues to stand erect over Oxford's Oriel College despite claims that it must fall.
4 Thomas Fox-Pitt, 'Cannibalism and Christianity' (1953), cited in *Speaking with Vampires*, p. 190.
5 Cited in *Speaking with Vampires*, p. 277.
6 *Ibid*, p. 29.
7 Muin al-Din Hasan Khan, *Two Narratives of the Mutiny in Delhi*, trans. Charles Metcalfe (1898), p. 39.
8 Cited in Faisal Devji, 'The Mutiny to Come', *New Literary History* 40, no. 2 (2009), p. 416.
9 Homi Bhabha, 'In a Spirit of Calm Violence', *After Colonialism: Imperial Histories and Postcolonial Displacements*, ed. Gyan Prakash (1994), pp. 326–344. See also the blog by Manan Ahmed, chapatimystery.com.
10 Dipesh Chakrabarty, *Provincialising Europe: Postcolonial Thought and Historical Difference* (2007), p. 262.
11 We are indebted here to the work of Dipesh Chakrabarty and Ranajit Guha, who critique Marxist historian Eric Hobsbawm's category of the 'pre-political' in Hobsbawm's *Primitive Rebels: Studies in Archaic Forms of Social Movement in the 19th and 20th Centuries* (1959). Chakrabarty, *Provincialising Europe* (2007); Guha, *Elementary Aspects of Peasant Insurgency in Colonial India* (1983).
12 Cited in Shahid Amin, 'Some Considerations on Evidence, Language and History', in *Recording the Progress of Indian History* (2012), p. 96.
13 Christopher Pinney, *'Photos of the Gods': The Printed Image and Political Struggle in India* (2004). See also Shruti Kapila, *Violent Fraternity: Indian Political Thought in the Global Age* (2022).
14 Cited in Amin, 'Some Considerations', p. 97.
15 Kerri Jarema, 'Huma Abedin is Reportedly Writing a Tell-All Book', April 13, 2017, https://www.bustle.com/p/hillary-clinton-aide-huma-abedin-is-reportedly-writing-a-tell-all-book-51017.
16 Quote from a since deleted Reddit sub-thread. This material is also reproduced in Aaron John Gulyas, *Conspiracy and Triumph: Theories of a Victorious Future for the Faithful* (2021), p. 131.
17 *Ibid*.
18 *Ibid*.
19 Spencer S. Hsu, 'Pizzgate Gunman says he was foolish, reckless, mistaken – and sorry' *The Washington Post*, June 14, 2017, https://www.washingtonpost.com/local/public-safety/pizzagate-shooter-apologizes-in-handwritten-letter-for-his-mistakes-ahead-of-sentencing/2017/06/13/f35126b6-5086-11e7-be25-3a519335381c_story.html.
20 WWG1WGA, *Q-Anon: Invitation to the Great Awakening* (2019) p. 6.
21 WWG1WGA, *Q-Anon: Invitation to the Great Awakening* (2019), p. 5.
22 Lori Colley, 'The Day I Knew Q Wasn't a Hoax' in WWG1WGA, *Q-Anon*, p. 49, 31.
23 WWG1WGA, *Q-Anon: Invitation to the Great Awakening* (2019), p. 15.
24 *Ibid*, p. 51.
25 *Ibid*, p. 1.

26 *Ibid*, p. 51.
27 Anne Dufourmantelle, *In Defense of Secrets*, trans. Lindsay Turnder (2021).
28 Colley, 'The Day I Knew' in WWG1WGA, *Q-Anon*, p. 32.
29 Georg Simmel, 'The Sociology of Secrecy and of Secret Societies', *American Journal of Sociology* v. 11, no. 4 (1906).
30 Louis Brandeis, 'What Publicity Can Do', *Harper's Weekly* (20 December 1913).

INTERVIEW SIRI HUSTVEDT

Very few writers in the twenty-first century are polymaths of the sort that previous centuries sometimes spawned – those who knew about all the subjects that mattered at the time, while still producing original work. Specialisation and the multiplication of fields and subfields of research, in both the humanities and the sciences, has rendered such breadth nearly impossible. Siri Hustvedt, however, is an exception: she is a polymath for our times, fluent in multiple specialised discourses, but whose mode is artistic.

Hustvedt, who lives in Brooklyn, is primarily known for her seven novels. Her first, *The Blindfold* (1992), about a poor graduate student negotiating the social-psychological maze of New York City in the late 1970s, established her as a novelist. Her most recent, *Memories of the Future* (2019), returns to New York in the same era, this time with dual narration – an older self in 2017 reflects on the journal of her younger self. *What I Loved* (2003) turns on the friendship between Leo Hertzberg, an art historian narrator, and an artist called Bill Wechsler. In *The Blazing World* (2014), a neglected female artist enlists three male artists to show her work for her. The book was longlisted for the Man Booker Prize and won the *Los Angeles Times* Book Prize for Best Work of Fiction.

Hustvedt's novels are imbued with passionate philosophical concerns about the self, memory, identity and aesthetics. While her roots are in literature, less widely known to her fiction readers is her exceptional grasp of the sciences – especially the life sciences, from neuroscience and psychology to genetics and embryology. She has written groundbreaking essays on the embodied self, and the lasting influence of mind/body dualism on Western thinking, culture and social structures.

Science is a remote territory for most non-practitioners, and it is unusual for people who aren't trained to immerse themselves in specialised scientific literature. The scientific world has long been her second home, and scientists have taken her in as one of their own. Hustvedt and I first met through our mutual interest in philosophy and science, soon after her interdisciplinary, exploratory memoir *The Shaking Woman or A History of My Nerves* was published in 2010. As a philosopher and historian of ideas concerned with the mind/body relation and the scientific theories that turn on it, I found in her a fellow traveller.

Hustvedt is politically committed, and a feminist who understands the roots and ramifications of patriarchal reflexes. She reads everything about topics that interest her, and distills her readings into her novels and essays, in her own creative, narrative, poetic voice. She teaches Narrative Psychiatry to psychiatric residents and junior faculty at Weill Cornell Medicine in New York City: in her work mind, art, and the power of narration meet, all in the service of understanding the self in its relation to other selves, of connecting past and present, the invisible realms of being with those that language can shape. And so there is no discontinuity between her passions, as she explains in this conversation, which we held remotely during a hot August in 2021, Atlantic coast to Mediterranean coast. NOGA ARIKHA

THE WHITE REVIEW You have written seven novels and published four books of essays. One of them, *Mysteries of the Rectangle* (2005), is on visual art. Other essays were first published in science journals such as *Neuropsychoanalysis*, *Seizure - European Journal of Epilepsy*, and *Clinical Neurophysiology*. You also have an appointment as a lecturer in psychiatry at Weill Cornell Medical College. You've had an unusual intellectual trajectory. Obviously, writing fiction, writing about art and writing science articles are different, but what are those differences exactly?

SIRI HUSTVEDT The conventions involved in writing a novel, an art essay and a science paper are clearly different, but I think what appear to be unconnected interests are actually linked. For example, when I was still in college, I got interested in Christian mystics – Hildegard of Bingen, Saint Catherine of Siena, and Saint Teresa of Ávila. Reading them led me to explore connections between religious experience and neurological illnesses such as epilepsy and migraine.

TWR You had migraine yourself, didn't you?
SH I've had migraine with aura since childhood. The strange feelings and visual disturbances of auras have been part of me for as long as I can remember and, as I grew older, I began to wonder how these perceptual states relate to the becoming of what we call 'a self'. My great love was always literature, but I majored in history in college and then got a PhD in English literature at Columbia. I wrote my doctoral dissertation on language and identity in Charles Dickens, which turned in part on his play with pronouns. For example, in *Our Mutual Friend* (1865), one of the characters describes his near drowning by saying, 'There was no such thing as I.'

Another character, a drunkard, never uses the first-person pronoun, and a police inspector refers to a fresh corpse by saying, 'I still call it him you see.' In my research, I came across a paper by the linguist Roman Jakobson, 'Two Aspects of Language and Two Types of Aphasiac Disturbances' (1956). In it, he notes that children learn to use the *I-you* pronouns last and in some types of aphasia they disappear first. This fact went off like a bomb inside me. The shifters, *I* and *you*, are difficult to master, and children often reverse them. After all, why is a person 'I' one moment and 'you' the next?

TWR Personal pronouns arrive late, and even later in kids on the autistic spectrum.
SH Yes, and some schizophrenic patients also make the reversal error. My broader point is that literature, linguistics, philosophy, developmental psychology and neurology merged in Dickens's use of pronouns as signs of cohesive and disintegrating selves in a thesis I defended in 1986 – a seed that had already been planted continued to grow. Jakobson spurred me on to read more neurological case studies. I discovered Oliver Sacks, whose two best books, in my view, are *Migraine* (1970) and *Awakenings* (1973) – the ones he wrote for his colleagues, not a general audience. Sacks led me to Russian neurologist Aleksandr Luria's case studies, *The Mind of a Mnemonist* (1969) and *The Man with a Shattered World: The History of a Brain Wound* (1972). Then I bought Luria's *Higher Cortical Functions in Man* (1962) – dull title, brilliant book – with the best history and analysis of location in brain science I have ever read. Luria never fell into the trap that neuroscience fell into when it became a latter-day phrenology, imagining as it did a one-to-one correspondence between a function and a part of brain. Dickens opened a door, but then for me literature has always been a form of knowledge.

TWR It could be said that all art is a form of knowledge.
SH Yes, but in the US, fiction is not regarded as important knowledge. STEM fields are serious, essential and masculine. The arts are expendable, feminine fluff, which doesn't mean people aren't transformed by reading fiction. They are.

But what does the novel have that an academic article, art essay and scientific paper don't? It doesn't rely on theory, experiments, findings and facts. It isn't teleological as arguments are. It ends, but it doesn't have to solve. The great theoretician of the novel is Mikhail Bakhtin. My favourite quote from him sums up his idea of the dialogic: 'Every word is half someone else's.' Bakhtin would call much that comes out of the academy 'monological' because the discourses are univocal and culturally dominant. He doesn't say this – I do – but the third-person authoritative voice of the scholarly and scientific paper annoys me. Who is speaking? A great rumbling voice from on high? I use the first-person in all my texts. Bakhtin maintained that language is relational, and monological discourse distorts the underlying linguistic reality. Class, power, historical context, unique personal

experience with other people collide in our words. Truth isn't singular but plural. The best novels have a polyphony of voices, which do not agree with one another. *Wuthering Heights* (1847), *The Brothers Karamazov* (1879) and *To the Lighthouse* (1927) are sublime examples of polyphony, of multiple perspectives that dance and crash inside a single work.

That doesn't mean I don't spend lots of time reading science papers. I've been hugely enriched by learning about brain science, genetics and, more recently, embryology and immunology. I've come to understand scientific methods and ways of thinking. I've also realised there are benefits to reading not just what attracts you but what repels you. Symbolic logic alienated me, but I forced myself to get a handle on it so I could read analytical philosophy papers about 'the mind'. They sent me back to the origins of that philosophy in the Vienna Circle and Gottlob Frege, the German mathematician, logician and philosopher of language who was so important to Anglo-American analytical philosophy. I'm no expert on Frege, but I read enough to solidify a perspective on, and develop respect for, his thought and its later incarnations.

When I began studying brain science, I felt like a student in Neuroscience 101. Learning the parts of the brain and rudimentary neurochemistry was hard, but over the years, I began to see serious flaws in the paradigm at work in neuroscience: the scientists had no idea how 'the psychological level' of experience related to 'the physiological level'. How are thoughts related to neurons?

TWR It's the old mind/body problem.
SH Like Descartes, most neuro- and cognitive scientists divided mind from body, but they were oblivious Cartesians. They modelled the mind as an algorithmic computational system of symbols, a kind of software that could be enabled by hardware made of either living cells or silicone. This model, now called 'classic computational model of mind', led me to Alan Turing's dream of a thinking machine, cybernetics, information theory and arguments about whether the brain was digital or analog at the Macy Conferences held in New York City between 1946 and 1953. John Dewey, Margaret Mead, Gregory Bateson, John von Neumann, Norbert Wiener and Roman Jakobson all participated. Those debates sent me back to the origins of mechanical philosophy in the seventeenth century. I reread Descartes, Hobbes and others who believed nature, including the human body, was a machine. Then I discovered Margaret Cavendish, the Duchess of Newcastle, who opposed Descartes's mind/body dualism but also Hobbes's materialist mechanism. She argued that nature is all material, but matter is not dead and not mechanistic. All I knew about the Duchess before had come from Virginia Woolf, who, in *A Room of One's Own* (1929), described Cavendish as a 'giant cucumber [that] had spread itself over all the roses and carnations in the garden and choked them to death.' Woolf was not well informed about seventeenth-century natural philosophy.

TWR That was the premise of my PhD – a historicised look at the mind/body relation through reactions to Descartes and his dualism in the late seventeenth century. We are both advocates of the paradigm change in cognitive science that you discussed at length in your essay *The Delusions of Certainty* (2016).
SH This is your territory and, as you know, the debates over Descartes's substance dualism were intense. Cavendish and another hero of mine, the Italian philosopher Giambattista Vico, offered a path out of dualism. They are philosophers of embodiment who anticipated the current paradigm change in cognitive science, not because they were clairvoyant, but because the same problems that plagued philosophers in the seventeenth century continued to plague philosophers in the late twentieth and early twenty-first centuries. The foundational assumptions of cognitive science ignored the natural body and emotion, and AI ran into one dead-end after another when it tried to replicate general human intelligence.

The big question is: What are we? As the turn to embodiment has made clear, what we call mind can't be confined to brain or body. We are embedded in an environment that acts on us and which we act on, and we become ourselves through others. Understanding that becoming entails more than studying what the founder of phenomenology, Edmund Husserl, called *Körper*, the anatomical, third-person view of the body seen from the outside: it means exploring what he called *Leib*, the lived experience of a body-subject in the world. Cognitive science has revived the phenomenological philosopher, Maurice Merleau-Ponty, but he has become important in the humanities too because social constructivist thought, so popular

when I was a graduate student, also neglected the body and feeling.

TWR From *The Blindfold* on, your fiction has had a philosophical tone. In line with writers like George Eliot, Fyodor Dostoyevsky, Robert Musil, and Thomas Mann, you stage ideas in your novels, giving voice to characters' embodied consciousness. There is keen awareness in your novels of the gaps between words, the pre-verbal meanings in images and the silences around expressions of feeling. Near the end of *What I Loved*, the narrator, Leo Hertzberg, writes, 'The story flies over the blanks, filling them with the hypotaxis of an "and" or an "and then". I've done it in these pages to stay on a path I know is interrupted by shallow pits and several deep holes. Writing is my way to trace the hunger, and hunger is nothing if not a void.'

SH Every book, painting, piece of music comes alive in its reader, viewer or listener, and is animated by her embodied responses – thoughts, but also sensations and emotions. When I write a novel, I feel the characters inside me as if they are part of my memory, but when they speak on the page, I'm often surprised by what they say. Composing a sentence means measuring it against a sense of rightness and wrongness. Sometimes the words come out 'right'. Other times I'm stuck – the words feel 'wrong' – but if I stand up and move around, the sentence appears. There is a powerful motor component to writing that is conveyed to and felt by the reader. The sentence but also the book as a whole, must have a rhythmic construction, must walk, run, leap and tumble. Suspense generates staccato sentences, meditation generates legato continuums, and the reader feels this music along with the semantics. But every narrative leaves out as much as it puts in. Leo knows the same story can be told in many different ways from many points of view, but he also knows his need to tell is an urge to fill up what he's lost with words. And, every novel is written for someone else, an imaginary reader. Mine gets all my jokes, understands every reference and can parse every irony.

TWR A double? A doppelgänger?

SH I'm afraid it's true. I felt embarrassed when I realised it. Somewhere Vladimir Nabokov said that he wrote for a crowd of little Nabokovs. Still, much of what I write comes from unconscious places I have little access to. Every once in a while, a scholar points to something in a book of mine I had never thought of before. This rarely happens with reviewers, but when *The Blindfold* was published, a Jesuit priest reviewed it for a Catholic publication. I took the piece with me on the subway and, as I read it, tears rolled down my cheeks. His understanding went deep. After *What I Loved* was published, several people approached me to tell me that they, like my narrator, Leo, had lived through the death of their child, and the book had described their experience. They were grateful. Somehow my fiction about a loss I had never experienced spoke to their grief. After a reading from the same book in Iowa, I was approached by a woman who told me she had a message from her father, a Jew, who, as Leo did, left Berlin as a child when his family fled the Nazis and then, as Leo had, lived in Hampstead. He was now an old man in Florida. Her message from him was: 'I am Leo'. These are the sometime miracles of literature, which turn on what Aristotle called catharsis in the *Poetics*. Art is part of life experience, but it isn't the same as living life. We don't enjoy crying over the death of a beloved friend, but inside what I call 'the aesthetic frame', we can experience safely what would be terrible in our own lives, not because we are having 'quasi-emotions', as the analytical philosopher Colin Radford has argued. The emotions are real. The context is different.

TWR What do you think of the use of mirror neurons to account for empathy in art? [Mirror neurons are cells that fire both when an animal executes an action and when another animal simply watches the same action being performed. They were first discovered in macaque monkeys by the team of neuroscientist Giacomo Rizzolatti in Parma in 1992 and later confirmed in human beings.] It's an example of how non-scientists may adopt a scientific concept to understand what's going on in aesthetics.

SH No one is better on this subject than our mutual friend, Vittorio Gallese [a neuroscientist who took part in the discovery of mirror neurons], because he is philosophically minded, cares deeply about art, and avoids crude reductionism. His idea of 'embodied simulation' posits that a shared neural, mirroring state in two bodies allows us to understand the other person, not as a mere object, but as another self. We have physiological access to the meanings of other people's actions and emotions, and to art, through those same neural connections.

I've been surprised by the push-back against mirror neurons – an enormous scientific discovery. The countless papers that have been written to discredit and undermine the original findings are partly due to the overselling of mirror neurons in the media and by people in the humanities who are dim on the science, but it's ideological as well, a resistance to the idea that we are bound to our fellow creatures in biological ways that belie the fantasy of individual autonomy. There's no such thing as a single brain, only a brain in relation to other brains. The very idea of a perception-action loop threatens mechanistic, atomistic science.

TWR That resistance is on the wane, though.
SH Yes, because we are living through a devastating pandemic and ecological catastrophes and must let go of the human-beings-are-monads approach and accept that we are interdependent creatures that belong to eco-niches that can't be severed from larger ecological realities. We can either change what we are doing or die from our neglect. But ideas change slowly. Your book *Passions and Tempers* (2007) on the endurance of the humours makes this eminently clear. The language may change; the ideas don't. We are still haunted by the mind/body problem in the West. Plato and Aristotle are still making up our minds.

TWR For Aristotle, matter is inert and female, and form is active and male.
SH And for Plato, the body was a prison weighing down the soul: his sullied body influenced both Judaism and Christianity, as did Aristotle's form and matter hierarchy. The associations live on. The masculine is tied to purity, intellect and culture and the feminine to the polluted body, passion and nature.

TWR In your writing on art, you have emphasised that art is fundamentally intersubjective. Meaning is created between the viewer and the object viewed and, unlike other objects in our lives, art is 'a quasi-you' that holds the traces of another consciousness and unconsciousness. Your fictional art historian, Leo, makes this point: 'A picture becomes itself the moment it is seen.' In your essay, 'Embodied Visions: What Does it Mean to Look at a Work of Art?' (2010) you further argue that perception is biased, that we often see what we expect to see. In the essay 'A Woman Looking at Men Looking at Women', you argue that the association between masculinity, and high intellect and femininity with low corporeality, has led to the denigration of art by women. This feminist theme appears in your essays and fiction. In the novel *The Blazing World*, a title borrowed from Margaret Cavendish's 1666 magnum opus, a woman artist stages her own work behind the living bodies or masks of three men. If all vision is biased, can anyone see well?
SH Expectation fuels perception. Once I was walking down a corridor in a hotel and saw a stranger coming toward me. Only when the person came closer did I recognise my own image in a mirror at the end of the hall. Past experience, orientation and context are crucial to perception. This is true in gender bias as well. The expectation that women should be nurturing, caring, self-sacrificing, should behave in stereotypical maternal ways even if they aren't mothers remains pervasive. Women are supposed to cater to the needs of men, not behave in authoritative ways. Why do so few heterosexual men read books by women? They don't want to put themselves in the humiliating position of submitting themselves to the voice of a female author.

TWR But this has changed. Men are increasingly active as fathers, for instance.
SH That's definitely true in the developed West, but unlike many women, few men identify themselves as fathers first, and when they are the primary caretakers of children they're viewed as heroic characters or emasculated wimps, rarely as people fulfilling their 'natural role'. Harriet Burden's experiment with her three male personae in *The Blazing World* plays on these cultural expectations. Her male masks elevate her work, but the works are further interpreted through the men's varying identities – a white boy straight out of art school; a biracial, gay performance artist; and an art-world superstar. That's the book's fairytale structure, but Harry's game isn't simple. The male masks she adopts change her and her art. The fact that 19 narrators reflect on the same story blocks a single truth. The novel is intended to do what Søren Kierkegaard wanted his pseudonymous texts to do – throw the reader back on herself. You decide your truth.
 Is there a way out of the biases we all have? Time. If you take time with anything or anyone, automatic assumptions and stereotypes disappear. While writing about the Italian artist Giorgio

Morandi, who painted bottles over and over again, I made a simple phenomenological experiment. I stared at a San Pellegrino water bottle for five minutes. The first thing that dropped away was the word *bottle*. I noticed how the light changed the colour of the green glass and changed again with a passing cloud. I studied the drops of condensation inside it. I do the same thing with paintings and sculptures, park myself in front of one for a couple of hours and see what happens. The artists' names, famous or obscure, and their gender or ethnic identities vanish pretty quickly.

TWR In *The Shaking Woman or A History of My Nerves*, storytelling and science merge. You tell about your shaking symptom and pursue several possible explanations for it by marshalling evidence from philosophy, psychoanalysis, neurology, neuroscience and the history of medicine. Your first-person phenomenological account blends with third-person scientific investigation. What is the significance of this double approach? What role does narrative play in medicine?

SH Actually, I think you do something similar in your book, *The Ceiling Outside* (2022), which I read and loved. You explore the science behind the diagnoses of particular neurological patients whom you witnessed being evaluated, but you also tell their stories and integrate the intimate experience of your late mother's Alzheimer's into the book. Because the shaking was my symptom, I could tell my story and then view it from various disciplinary angles, acting as patient, physician and researcher all at once to create epistemological pluralism. There are many avenues to knowledge. Not one doctor or neuroscientist friend of mine had a clue about what caused my shaking, but that was part of the fun, the mystery. I think of the book as a funnel that keeps circling the same problem as it gets closer and closer to what in the end is a non-diagnosis. Nevertheless, the journey through the book is one of increasingly focused knowledge. Every illness is lived in the first person, and every illness is temporal – from the sudden fatal heart attack to the drawn-out debilitation of some cancers. Every story is a symbolic representation of time and change and makes meaning through connections. Diagnosis, X-ray, blood tests, MRI are vital tools in medicine, but they're static representations of illness. Stories represent its personal, dynamic and meaningful reality. I realised the act of writing had a therapeutic effect. The last sentence is: 'I am the shaking woman.' I integrated the alien symptom into myself and my story.

TWR In *The Delusions of Certainty*, a 200-page essay on the mind/body problem, you offer a scathing critique of first-generation cognitive science and its neo-Cartesian position as we have discussed. It was published as part of the larger collection *A Woman Looking at Men Looking at Women: Essays on Art, Sex, and the Mind* (2016). It won The European Essay Prize 2019 given in Lausanne, Switzerland. It ends with a celebration of doubt. How is doubt important to your work? And why do you think most people don't want to think about the mind/body problem?

SH Are you telling me there are people in the world who aren't as obsessed with the mind/body problem as we are? [Laughs.] Doubt is the engine of thought; certainty its enemy. Failures in science – and the model used in first-generation cognitive science is surely one of them – are often due to thoughtless acceptance of inherited assumptions. The mind/body problem isn't solved, but I think it should matter to everyone. We routinely divide sicknesses into mental and physical, but what does this mean? Mental illness is still stigmatised as 'all in your head' – an unreal, non-physical ailment. At the same time, depression is called 'a chemical imbalance in the brain'. Psychiatric illness involves the brain, of course, but 'balancing' chemicals is a meaningless concept. No patient should be treated as a biomedical object for the simple reason that her situation affects the course of her illness. For example, whether or not a person 'has social support', a dry term for 'is loved by others', has powerful effects on her immune system. Loneliness, poverty, sexism, racism, a miserable job, marital trouble, a violent neighbourhood create 'stress', implicated in countless illnesses, depression among them. Stress affects gene expression and has wide-ranging implications for many conditions. With rare exceptions, Huntington's and PKU [Phenylketonuria], for example, disease is not genetically determined. Like mind and body, nature and nurture are not separable – they don't 'interact' either. They are *of the same process*. Just as the repulsive slogan, 'your genes are you', touted by companies selling you DNA tests for disease risk, is political and the information dicey at best, reducing depression to neurochemicals has political meaning. It suggests your circumstances play no role in your illness, a convenient idea for neoliberal ideology and part of

our new eugenics. The philosopher Mark Fisher aptly called this 'the privatisation of stress.'

TWR Who are the audiences for your essays? What would you like the impact of your writing to be? Are you happy that some scientists have welcomed you as a colleague? We are in an interdisciplinary group I set up during the first lockdown, and which we collectively named the WoWs, made up of neuroscientists, philosophers and a political theorist. You have lectured at psychoanalytic, neurological, psychiatric and neuroscientific conferences. How do you perceive yourself in those contexts? Do you lose your novelist self or is she always present?
SH She's always present. And yet, in a world of specialists, it's hard for people to figure out someone like me who crosses borders. I'm deeply grateful to my scientist friends who have taken me in. I love our group, and it has helped ease my intellectual loneliness – reading and reading with no one to talk to about it. Audiences for the essays? I try to write lucidly, but I know there are people who don't understand me. This is clear from some reviews. I would like to prompt my readers to question the crushing platitudes and clichés that make up so much of what we hear and read. I would like to open new avenues for thinking about a problem. That said, an essay, a peer commentary and an academic article are all easier to write than a novel, which is the freest form of all and where I can play out truly risky ideas. In *Memories of the Future* I did this – danced all over the place. But even in my scientific papers, I break the rules and get published because people know who I am. Bias plays its part. Winning prizes, the Asturias Prize [Hustvedt won the 2019 Princess of Asturias Award for Literature], for example, creates a bias *for* you, at least in the countries where they know about it.

TWR Perception makes up reputation and frees up territory to pay attention.
SH Exactly.

TWR Despite the variety of themes, sources and forms, I detect a coherence in your work that revolves around the idea of the between – an intersubjective, intercorporeal basis of life. Leo says, 'The longer I live, the more convinced I am that when I say "I" I am really saying "we."' You published a paper, 'Pace, Space, and the Other in the Making of Fiction' (2018) in an issue of the journal *Costellazioni* devoted to 'Narrative and the Biocultural Turn'. You write about the embodied rhythms that unfold between mother and infant as the pre-linguistic roots of narrative. In 'Umbilical Phantoms', which you gave as the opening lecture of The International Psychoanalytical Association's Congress on 21 July 2021, you started outlining a highly innovative theory of the placenta as the mediating-between organ of prenatal existence, and how the literal connection between the fetal and maternal should reshape our ideas about origin as interconnection. Why do you think the placenta deserves attention, not only as a scientific but a philosophical object?
SH The degree to which this organ has been neglected in Western science and philosophy is spectacular. Only recently has the placenta become an object of serious study in embryology. The well-funded Human Placenta Project started in 2014. From the Greeks onward, there has been queasiness about the simple fact that everyone begins inside the body of someone else and is wholly dependent on that body during pregnancy. There are no images of natural birth in Greek art, only unnatural birth. As the classicist Jean-Pierre Vernant put it, 'The dream of a purely paternal birth never ceased to haunt the Greek imagination.' Other cultures have birth art. Death is the great subject of Western philosophy, but gestation and birth, with important exceptions, have been largely neglected. Although in many cultures and in Western folk traditions, the placenta is treated with reverence as twin, double or spirit of the fetus, the transient organ of pregnancy lost significance with the widespread medicalisation of birth. Why? I think it's about boundaries and misogyny. In 1857, the American doctor Jesse Boring insisted that the fertilised ovum was already an independent being and, despite it being an established medical fact, maintained there was *no attachment* of the placenta to the uterus. A body part connected to mother and fetus blurs the borders among them, an uncomfortable fact in any culture that champions male autonomy. We also remain in the grip of static taxonomies in biology. Linnaeus's classification system in his famous tenth edition of the *Systema Naturae* (1758) boxed the living world into rational categories, but much of temporal reality went missing. As the philosopher of biology, John Dupré, has repeatedly written, 'Organisms are not things but processes.' I think he's right. In our

eagerness to fix and name *things*, we lose the truth of flux.

Much remains unknown about the placenta. Unlike the brain, heart, liver and lungs which look alike in mammals and function similarly, the placenta is species-unique. A mouse placenta isn't particularly helpful in understanding a human one. Leonardo da Vinci's famous renderings of a fetus in utero [*Studies of the Fetus in the Womb*, c.1511] have a cow's placenta. Speculation is that he dissected only one pregnant woman and relied on animal dissections to fill in the blanks. We know the placenta is made from both maternal and fetal tissues, is an organ that joins and separates maternal and fetal systems and grows in tandem with the fetus. It orchestrates hormone, oxygen and nutrient delivery to the fetus, gets rid of waste, is involved in cellular exchange between mother and fetus, which creates DNA microchimeras of both, and keeps their two blood systems apart. My questions are: Isn't reproduction itself about mixing two beings? How are we to understand both prenatal and postnatal between-realities? After birth, the between space once filled by the placenta becomes social space, between the infant and others, who take over the jobs of feeding, rocking and supervising the baby's growth. This has never been framed or elaborated in this way. I think it's important.

TWR What are you going to do next? In our group we've discussed ideas for facing current political and ecological crises. How important is thought for creating change?
SH I have a book of essays coming out, *Mothers, Fathers, and Others* [published in 2021]. I am writing a novel, *The Haunted Envelope*, in which I hope to address some of these urgent issues. Then I'm going to write my placenta book. Ideas shape human perception. Change happens only when collective assumptions are successfully challenged, and the world begins to look like a different place.

N.G.,
August 2021

CONTRIBUTORS

BANI ABIDI was born in Karachi, Pakistan, and now works between Berlin and Karachi. She uses video, photography, drawings and sound to tell stories about performances of power and ordinary people, often through quotidian details and absurd vignettes. Abidi studied visual art at the National College of Arts in Lahore, and at the School of the Art Institute of Chicago. Her work has been exhibited widely in solo and group shows internationally. Solo exhibitions have taken place at Museum of Contemporary Art, Chicago; Sharjah Art Foundation, UAE; Gropius Bau, Berlin; Kunsthaus Hamburg, Hamburg; and Experimenter, Kolkata, amongst others. Selected group exhibitions include 'WALK!', Schirn Kunsthalle, 2022; Asia Pacific Triennial, 2021; Seoul Mediacity Biennale, 2021; Lahore Biennale, 2018; Edinburgh Art Festival, 2016; 8th Berlin Biennial for Contemporary Art, 2014; 'No Country', Guggenheim Museum, NY, 2013; dOCUMENTA (13), 2012; Kochi-Muziris Bienniale, 2012; 10th Lyon Biennale, Lyon, 2009.

SARA AHMED is an independent scholar and author of *Complaint!*, *What's the Use?*, *Living a Feminist Life*, and other books published by Duke University Press.

FAHAD AL-AMOUDI is a poet and editor of Ethiopian and Yemeni heritage based in London. His work is published in *Poetry London*, *bath magg*, *Butcher's Dog* and *Magma*. He is an alumnus of the Obsidian Foundation, graduate of the Writing Squad and member of Malika's Poetry Kitchen. He won The White Review Poet's Prize 2022, run in partnership with CHEERIO.

MONIRA AL QADIRI is a Kuwaiti visual artist born in Senegal and educated in Japan. In 2010, she received a PhD in inter-media art from Tokyo University of the Arts, where her research was focused on the aesthetics of sadness in the Middle East stemming from poetry, music, art and religious practices. Her work explores unconventional gender identities, petro-cultures and their possible futures, as well as the legacies of corruption. She is currently based in Berlin.

GINA APOSTOL's fourth novel, *Insurrecto*, was named by *Publishers Weekly* as one of the Ten Best Books of 2018, selected as an Editors' Choice in *The New York Times*, and shortlisted for the Dayton Prize. Her third book, *Gun Dealers' Daughter*, won the 2013 PEN/Open Book Award. Her first two novels, *Bibliolepsy* and *The Revolution According to Raymundo Mata*, both won the Juan C. Laya Award for the Novel (Philippine National Book Award). Her essays and stories have appeared in *The New York Times*, *Los Angeles Review of Books*, *Foreign Policy*, *Gettysburg Review*, *Massachusetts Review*, and others. She lives in New York City and Western Massachusetts and grew up in Tacloban, Leyte, in the Philippines. She teaches at the Fieldston School in New York City. Her fifth novel, *La Tercera*, excerpted in this issue, will be published by Soho Press in January 2023.

NOGA ARIKHA is a historian of ideas and a philosopher. *Passions and Tempers: A History of the Humours* (Ecco, 2007), was a *New York Times Book Review* Editors' Choice and a *Washington Post* Best Non-Fiction Book for 2007. *The Ceiling Outside: The Science and Experience of the Disrupted Mind* was published by Basic Books in Spring 2022. She is an Associate Fellow of the Warburg Institute and an Honorary Fellow of the Centre for the Politics of Feelings (London), and a Research Associate at the Institut Jean Nicod (Paris).

ROSA CAMPBELL is a doctoral candidate in the history department at the University of Cambridge. Her work explores global histories of feminism. She is an editorial fellow at the public history magazine *History Workshop Online* and writes on a range of platforms for both adults and children.

MIRCEA CĂRTĂRESCU's many books of prose, poetry, and essays have made him a leading figure of Romanian literature and have been translated into 20 languages. He is the winner of numerous prizes, including the Leipzig Book Award for European Understanding, the Austrian State Prize for European Literature, the Premio Gregor von Rezzori, the Thomas Mann Prize, and the Prix Formentor. His novel, *Solenoid*, excerpted in this issue, will be published by Deep Vellum Press. He lives in Bucharest.

SEAN COTTER is the translator of many works of Romanian literature, including an award-winning edition of Nichita Stănescu's poetry, *Wheel with a Single Spoke and Other Poems* (Archipelago Books, 2012) and the first volume of Mircea Cărtărescu's *Blinding* (Archipelago

CONTRIBUTORS

Books, 2013). A recipient of a PEN/Heim Translation Fund Grant and two fellowships from the National Endowment for the Arts, Cotter is Professor of Literature and Translation Studies at The University of Texas at Dallas.

EDWARD DOEGAR is a poet and editor based in London. His collection *For Now* was published by Clinic in 2017, and later this year a text written in collaboration with the artist Shakeeb Abu Hamdan will be published by Kelder Press as part of their 'In the Round' series.

RHODA FENG is a freelance writer in New York.

SIRI HUSTVEDT is the author of a book of poetry, seven novels, four collections of essays and two works of non-fiction. She has a PhD in English literature from Columbia University and is a lecturer in psychiatry at Weill Cornell Medical College. She is the recipient of numerous awards for her work, including the Princess of Asturias Award for Literature. Her fifth collection of essays, *Mothers, Fathers, and Others*, was published in 2021.

TAUSHIF KARA is a postdoctoral research fellow at the University of Cambridge, where he teaches and writes on the history of Muslim political thought. He is currently working on a collection of essays about waiting, futility and confinement titled *Waiting for Revolution*.

JOHNNY LORENZ, son of Brazilian immigrants to the US, is a professor of English at Montclair State University. He translated Clarice Lispector's *A Breath of Life* and *The Besieged City* for New Directions. His book of poetry, *Education by Windows*, was published by Poets & Traitors Press. His research has appeared in *Luso-Brazilian Review*, *Modern Fiction Studies* and *Latin American Literary Review*. He has received a Fulbright and a PEN/Heim Translation Fund Grant. His translation of Itamar Vieira Junior's *Crooked Plow* received support from the National Endowment for the Arts.

MARY MUSSMAN is a poet and researcher interested in the semiotics and somatics of queer experience. A PhD candidate in comparative literature at the University of California, Berkeley, she lives and works on unceded Ohlone homelands.

ARIEL SARAMANDI is an Anglo-Mauritian writer living in Mauritius. Her fiction and essays have been published by *Granta*, *Los Angeles Review of Books* and *Brooklyn Rail*, among other places. She is represented by Lisa Baker at Aitken Alexander Associates. She is working on her first novel.

IZABELLA SCOTT is co-editor of *The White Review*.

SKYE ARUNDHATI THOMAS is co-editor of *The White Review*.

ITAMAR VIEIRA JUNIOR was born in Salvador, Bahia, Brazil. He received his master's degree in geography from the Universidade Federal da Bahia, and received his PhD in Ethnic and African Studies from the same institution. His doctoral research focused on the ongoing struggle of *quilombos*, the Afro-Brazilian communities organised by escaped slaves and their descendants. In 2018, his debut novel, *Torto arado* (Crooked Plow) received the Prémio Leya, a prestigious Portuguese literary prize. In 2020, the book received the Prêmio Jabuti, Brazil's most important literary prize, for best novel, as well as the Oceanos Prize for any literary work written in the Portuguese language. He has published three collections of short stories, *Dias* (2012), *A oração do carrasco* (2017) and *Doramar ou a odisseia* (2021). *Crooked Plow* is forthcoming from Verso Books.

FRANCIS WHORRALL-CAMPBELL is a British writer, researcher and artist. Their writing on art and culture can be found in *Art Monthly*, *Art-agenda* and *The Architectural Review*, with creative work published in anthologies by Prototype, Pilot Press, and Ugly Duckling Presse. They have produced work with Manchester International Festival, Wysing Arts Centre, Catalyst Arts and the Centre for Contemporary Art Derry-Londonderry, where they are a Research Associate (2021–23). Francis is currently working on a project re-evaluating the place of doubt in knowledge production – speculatively entitled 'Confusion as Trans Method'.

PLATES

Cover	Monira Al Qadiri, *Diver*, 2018, video still. Image courtesy the artist.
p. 37	Monira Al Qadiri, *Wonder*, 2018, hand-carved natural pearl, aquarium, dimensions variable. Image courtesy the artist.
p. 39	Monira Al Qadiri, *Future Past*, 2021, two rotating sculptures, 175 × 175 × 175 cm each. Image courtesy the artist.
I-II	Monira Al Qadiri, *Amorphous Solid Ghost* (detail), 2017, seven hand-blown glass sculptures, approx. 30 × 30 × 30 cm. Photo: Francesco Allegretto. Image courtesy the artist.
III-IV	Monira Al Qadiri, *OR-BIT 1-6*, 2016-18, six levitating 3D-printed sculptures, automotive paint. 30 × 30 × 30 cm. Photo: Raisa Hagiu. Image courtesy the artist.
V-VI	Monira Al Qadiri, *Divine Memory*, 2019, video still. Image courtesy the artist.
VII-VIII	Monira Al Qadiri, *Travel Prayer*, 2014, video still. Image courtesy the artist.
IX	Monira Al Qadiri, *Muhawwil / Transformer*, 2014, four-channel video installation with structure. Photo: Uwe Wruck. Image courtesy the artist.
X-XI	Monira Al Qadiri, *Feeling Dubbing*, 2017, theatre performance. Photo: Catherine Antoine. Image courtesy the artist.
XII	Monira Al Qadiri, *Wonder*, 2018, hand-carved natural pearl, aquarium, dimensions variable. Image courtesy the artist.
XIII	Monira Al Qadiri, *Holy Quarter*, 2020, video installation with 46 glass sculptures, dimensions variable. Photo: Maximilian Geuter. Image courtesy the artist.
XIV-XV	Bani Abidi, *Anthems*, 2000, video still. Image courtesy the artist.
XVI	Bani Abidi, *RESERVED*, 2006, video still. Image courtesy the artist.
XVII	Bani Abidi, *Mangoes*, 2000, two-channel video still. Image courtesy the artist.
XVIII-XIX	Bani Abidi, *Karachi Series I*, 2009, Duratrans light boxes. Image courtesy the artist.
XX	Bani Abidi, *The Reassuring Hand Gestures of Big Men, Small Men, All Men*, 2021, Inkjet prints. Image courtesy the artist.
XXI-XXII	Bani Abidi, *The Ghost of Mohammad Bin Qasim*, 2006, Inkjet prints. Image courtesy the artist.
XXIII-XXIV	Bani Abidi, *The Boy Who Got Tired of Posing*, 2006, Inkjet prints. Image courtesy the artist.
XXV	Bani Abidi, *...so he starts singing*, 2000, video still. Image courtesy the artist.